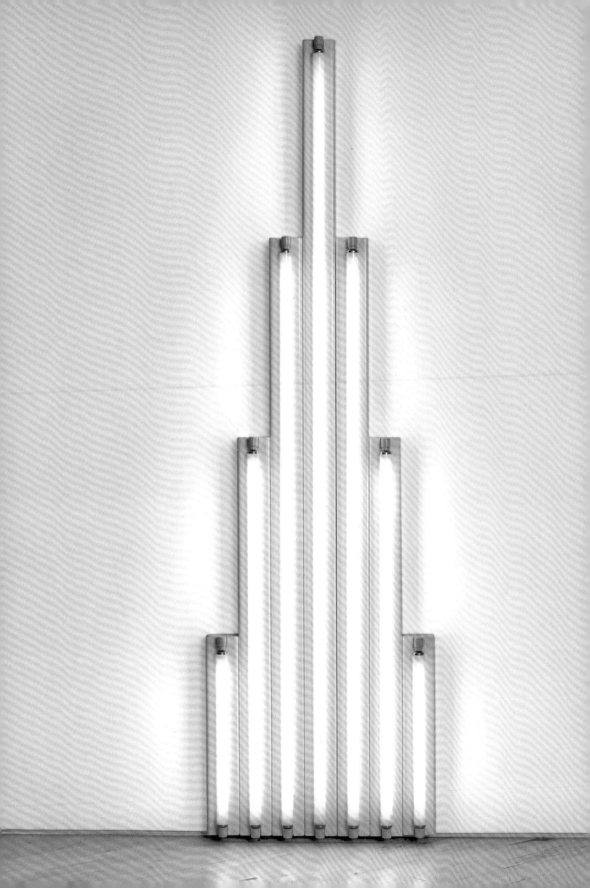

Alexander Nagel

MEDIEVAL MODERN
ART OUT OF TIME

with 134 illustrations, 104 in color

Thames & Hudson

'Historicism is content with establishing a causal
connection between various moments of history. A fact
can be a cause but it is not therefore historical. It became
historical posthumously, through events that may be
separated from it by thousands of years. A historian
who starts with this no longer passes the sequence
of events through his fingers like the beads of a rosary.
Instead, he grasps the constellation into which his own
era has stepped together with a very clearly defined earlier
one. In this way, he reforms his conception of the present
as one of the now-time, shot through with slivers of
messianic time.'

Walter Benjamin

Designed by Phil Cleaver and Jenny Penny
et al Design consultants

First published in 2012 in hardcover in the
United States of America by Thames & Hudson Inc.,
500 Fifth Avenue, New York, New York 10110

thamesandhudsonusa.com

Library of Congress Catalog Card Number 2012933047

ISBN 978-0-500-23897-4

Printed and bound in China by
C&C Offset Printing Co., Ltd.

CONTENTS

NOT A LONGER HISTORY, A DIFFERENT HISTORY

In reputable art history programs and art schools throughout the world, students of contemporary art are brought up on the story of modernism and its aftermaths. Typically, the history begins in the eighteenth century, with the Enlightenment or the French Revolution or with the rise of the Paris Salon. Sometimes it is made to start in the second half of the nineteenth century, with Édouard Manet or Paul Cézanne, and then continues through the avant-garde movements up to postmodernism and the present. Whatever the starting point, the eighteenth century remains the practical horizon for teaching contemporary art. And yet it is also widely taught that critical and artistic developments since the 1960s have thrown this story, the modernist story, into question. Artistic practice, we are told, no longer follows an avant-gardist logic. Some people even believe that contemporary art does not adhere to any kind of historical progression at all. We are in a culture of artistic pluralism and highly adept reenactments. A lot of this has been acknowledged for some time, and yet the basic historical framework for discussing modern and contemporary art to a large extent stays in place.

It is also clear that the story of the "end of art," a recurring theme in modernism and a battle cry in the 1960s, is itself at an end. Or rather, it has just quietly receded from view. Young artists now have to be taught that people once believed in the end of art—that this belief was itself part of a historical formation, a logical endgame of an avant-garde conception of art and history. Artists are making art still, a lot of it, and it is largely unaffected by the modernist/postmodernist syndrome of "I can't go on, I'll go on."

This persistent art-making cannot simply be waved away as a grotesque re-playing of art rituals that are in fact long dead but kept going for the sake of a hungry market. Art-making continues and will continue, but it is art-making under an expanded definition. Premodern artistic modalities—that is, forms of creating art that were prevalent in the Renaissance and in earlier periods—have become naturally relevant, and once they are recognized, it is possible to see that they have been relevant right through the history of modern art. This is not to say that we are in a new era of "post-art" or "non-art," a dissolving of art-making back into larger social processes of image

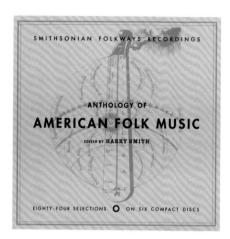

production, a return to artisanal anonymity, and so on. That was itself a myth of modern art from William Morris through the Russian avant-garde to Fluxus and beyond. Art and art-makers exist; they are not going away, in part because what they are doing was not invented in Enlightenment France or in Romantic Germany. Art and artists existed in premodern times, as did the awareness that there were rules of the game, and traditions, in art. And yet before the eighteenth century there was no conception of fine art, there were no art museums, and art history was not taught in universities. Art production mingled with a whole array of material production, and it was often bound up with larger institutional identities. We are in a position now to see that encounters with medieval art mark the whole history of modernism and its aftermaths.

During the week I wrote these paragraphs, I received an invitation to the opening of an exhibition of work by Mark Manders involving effigy parts and bone replicas; I read about Spencer Finch's technological re-creations of cloud effects and walked past his tinted windows on New York's Highline; I saw an exhibition of *drôleries* (or are they grotesques?) by Sue Williams, and a show by Matthew Day Jackson that takes its cue from fifteenth-century Burgundian tomb sculpture, which brought to mind similar, and equally retrospective, projects by John Baldessari and James Lee Byars; I also leafed through my current *Artforum*, where I read an appreciation by Rachel Harrison of Paul Thek's "ritualistic spaces about salvation, deliverance, and cyclic renewal," and a meditation by Adrian Piper where she writes that

1.2
Tom Friedman, *Untitled (self-portrait)*, 1998, Lambda print, 24¼ × 46 in (61.6 × 116.8 cm), edition of four. One vertical slice of an image of the artist is taken and extended laterally with the aid of digital technology. It is an abstract work, and yet the array derives from the articulations of an individual body, now distributed.

Minimalism "recalls to us the modesty and humility—actually the awe—in the presence of the object evinced in the work of those anonymous medieval artists before Cimabue, who declined the chance to be celebrities." I finally bought my own box set of Harry Smith's 1952 *Anthology of American Folk Music*, with its cover carrying Theodore de Bry's engraving of the "Monochordum Mundi" from Robert Fludd's 1617 treatise *History of the Microcosm and Macrocosm*, an image Smith believed to be of direct relevance to this far-flung corner of modern-day folk culture. I found myself comparing Tom Friedman's articulations of objects in multiple phases to Platonic theories of form. A student proposed a paper comparing Gerhard Richter's and Sigmar Polke's divergent interpretations of the stained-glass tradition at Cologne and Grossmünster cathedrals. Whenever I come into contact with contemporary art, I find references shooting in all directions, well beyond the framework of modernist histories, and often they go in the direction of medieval and early modern art.

I am not saying, as Umberto Eco did thirty years ago (and Marshall McLuhan twenty years before that), that we are living through a new Middle Ages. Despite some of the rhetoric surrounding them, these examples remain art-world occurrences, not restructurings of society as a whole. I am also not particularly moved by a new prevalence of overt religious content in contemporary art, a development that has caused excitement among curators and theorists in recent years. What is called spirituality or mysticism is a mode of experience and not a historical relationship. This is

a book about the way in which modern and contemporary art has put pre-Enlightenment modalities back into operation, sometimes deliberately, sometimes not. It is rife with anachronisms, but is not particularly interested in perennial philosophies. Many of the artists studied here subscribed to defined spiritual beliefs, while some had none at all—this is true of both the premodern and modern artists who appear in the following pages. Religious interests, even overtly Christian themes, do not in themselves suggest a connection to medieval art. Robert Mapplethorpe is, arguably, a deeply Catholic artist, but I do not think he is a particularly medievalizing one. Felix Gonzalez-Torres, less clearly religious, produced an art (which continues to be produced after his death in 1996) that speaks strongly to medieval Christian patterns of sacramental authorization, replication, and dissemination, exploring an "impersonal intimacy" that has its strongest parallels in medieval devotion.

This book steers clear of loudly iconographic medievalism—Georges Rouault's *Christs*, say, or Chris Burden's *Trans-fixed*, or the neo-medieval trappings of activities such as satanism, alchemy, kabbalah, and goth culture. It focuses instead on deeper structural analogies, sometimes acknowledged, sometimes not, that come into view when considering issues that are fundamental to the art of both periods: questions regarding the generation and dissemination of images; site-specificity and mobility; fetishism and iconoclasm; memory and anachronism; and authorship and authority. To find one's way through these issues in the last hundred years of art-making it is helpful, I believe, to spend time with the art of the earlier periods. Sometimes twentieth-century artists intended viewers to see the reference to the earlier art, a joltingly unfamiliar encounter. At other times, the recourse to modalities of the sort also known in premodern art was designed to effect a defamiliarization at a structural level. The premodern element comes into the work without necessarily being widely recognized by viewers, or fully recognized by the artist.

If we take the "graphic" in historiography to include visual production, then the medievalism that runs through twentieth-century art is a dimension of the historical study of medieval art. The artists' engagements with the history of art are often enough not congruent with those of the historians. At times the artists were "ahead" of the scholars, and at others they took lessons from them—literally, in the case of the artists who listened

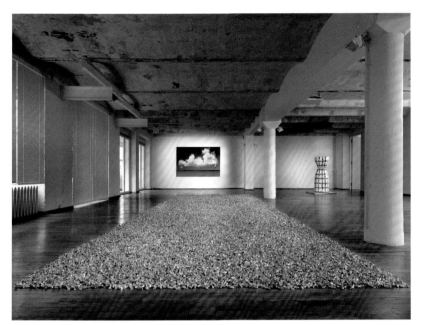

1.3 and 1.4
Felix Gonzalez-Torres, *"Untitled" (Placebo – Landscape – for Roni)*, 1993, candies individually wrapped in gold cellophane, endless supply, overall dimensions vary with installation, ideal weight 1,200 lb (544.3 kg), shown at the Hoffmann Collection, Berlin, 2010 (top) and Museum of Contemporary Art, Los Angeles, 1994 (bottom)

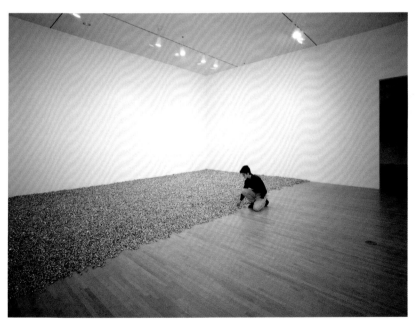

1.5
Josef Albers, *Park*,
c. 1924, glass, wire,
metal, and paint,
in wood frame,
19 × 15 in
(49.5 × 38 cm)

Opposite
1.6
The rose window and
lancets of the north
transept of Chartres
Cathedral, France,
thirteenth century

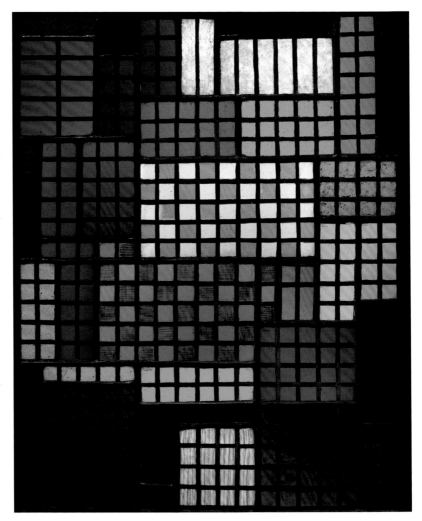

Only some of the episodes just mentioned will be pursued in the follow-
ing chapters. But this book is more than a collection of episodes. It looks
above all for patterns and themes that structure the connection to medieval
and early modern art in the twentieth century. If the story can be told at
this level, then we are beyond individual encounters and are talking about a
relationship that is woven into the texture of twentieth-century art. Below
are some of the areas that will be traversed repeatedly in the coming pages.

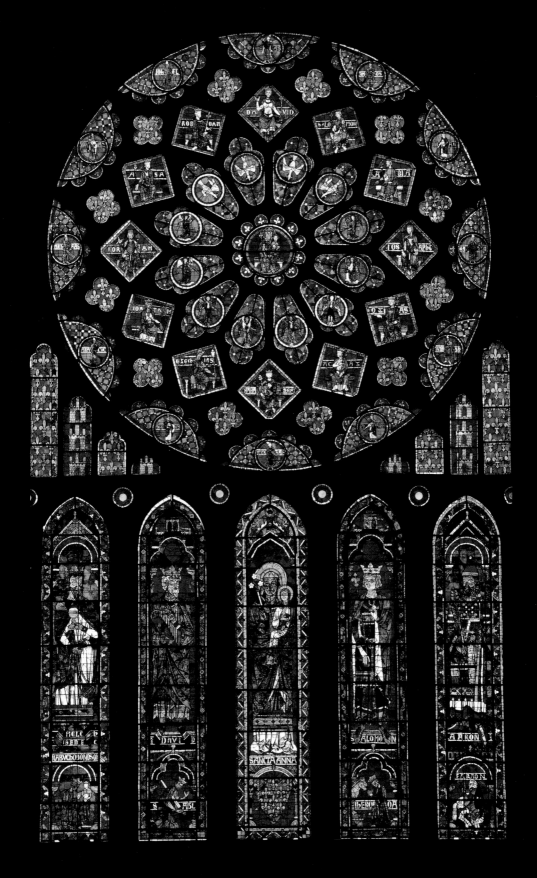

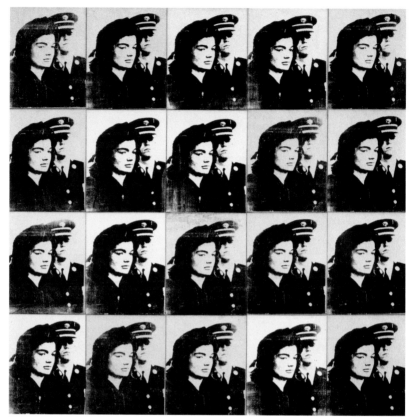

1.7
Andy Warhol,
Twenty Jackies, 1964,
acrylic and silkscreen
ink on canvas, twenty
panels: each 20 × 16 in
(50.8 × 40.6 cm),
overall 80½ × 80½ in
(204.5 × 204.5 cm).
In 1975, writing about
Warhol's series "Ladies
and Gentlemen,"
Pier Paolo Pasolini
wrote: "The apse of the
cathedral that Warhol
builds and then throws
to the wind in multiple
cut-outs of isocephalic
and repeated faces is
in effect Byzantine. It is
the quality of American
life that would seem
to be the equivalent
of the authoritative
sacredness of the
official Christian
painting of origins:
namely, to provide a
metaphysical model
of every possible
living figure."

Installation. Within the expanded field of artistic practice considered here, installation art is the norm and easel painting is the aberration. Before the dominance of the picture gallery, there were works of art, of various media, intervening in and transfiguring what David Summers calls "real spaces," for example in chapels, tomb architecture, and domestic decoration. Rather than see the easel picture as something that was extracted from these multimedia environments, is it possible to envision a longer history of interactivity whereby art works alternately internalize and project out into their environments? To bring into focus this longer history of alternations is to begin to see the museum as one episode in a larger history of installation and display?

Indexicality. Modern European painting is traditionally understood as the triumph of visuality and of the image as "iconic" sign. Some, such as

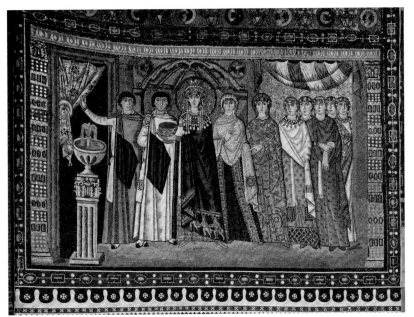

1.8
Mosaic in the basilica
of San Vitale, Ravenna,
showing Empress
Theodora, wife of
Justinian I, with her
retinue, c. 546–7,
104 × 144 in
(264.2 × 365.8 cm)

Didi-Huberman, have argued that this victory involved a massive repression of the "indexical" modes of premodern art, in which the image is understood not merely as a resemblant image but as a sample or impress, a sign physically linked to or caused by its referent. The resurgence of interest in indexicality notable in the work of Marcel Duchamp and the Surrealists, and in a good deal of the art of recent decades, encourages a renewed investigation of medieval indexical modes and of medieval theories of vision. Such an investigation reveals that the visual was itself conceived in highly indexical terms in the earlier period, thus destabilizing the opposition between a modern "visual regime" and the bodily indexical modes that prevailed in the premodern period, an opposition that has structured so much of the modern and postmodern discourse of art.

Replication and the multiple. The conception of the work of art as an original, unrepeatable performance became dominant after the Renaissance and was enshrined in the modern art gallery and in its attendant institutions, such as the artist catalogue. Out of such a conception arose the modern art market in the sixteenth and seventeenth centuries, and now it is the market that most powerfully reinforces and perpetuates the conception. In the premodern

period, by contrast, images lived under conditions of repetition and replication, and authorship was understood to be distributable. The image was routinely recognized as a substitutable vehicle transmitting referential content. How does the unearthing of this model allow a rereading of Walter Benjamin's essay "The work of art in the age of its technological reproducibility," which has played such a powerful role in thinking about the problem in the postwar period? Is the substitutional logic of medieval art similar to that which operates in twentieth-century experiments with seriality—in photography generally, and specifically in artists such as Andy Warhol, Sol LeWitt, Ed Ruscha, Allan McCollum, Sherrie Levine, and others?

Collage. Reliquaries and altarpieces presented non-unitary assemblages, intended to fracture apparent real-world continuities and produce associations across spatio-temporal boundaries. In opposition to theories of the unity and autonomy of the work of art that developed after the Renaissance, modern collage thrives on the collision of heterogenous materials, producing what Ernst termed "alchemical compounds." Are there conceptual affinities between what Schapiro called the "conglomerate" nature of medieval art works, which are often stylistically "heterogenous" in part because they accumulate over generations, and what Eco in 1962 described as the "open work" of assemblages and mobiles?

Conceptual art. Warnings against the sensual seductions of works of human art are a central feature of theological polemics against idolatry—especially the polemics of Christian theologians, who had to contend with a widespread and ambivalent practice of image-use within their religion. The critique of the fetishism of the art object and the skepticism toward visual experience form the basis of conceptual art. Are they episodes within this critical tradition? Would such an analysis offer a reframing and an effective critique of the political and philosophical claims made in support of conceptual art?

Other categories of production—abstract art, the readymade, land art, body art, and performance art—provoke similar questions. The point of such an investigation is not to reduce one set of practices to the other. I am not interested in showing that the Christian chapel is installation art *avant la lettre*, or that Saint Francis was a performance artist. I am not interested in trying to naturalize the radical interventions of modern art by showing that they belong to long and well-established traditions. The final consequence, I hope, is that the modernist historical schemas themselves will break down.

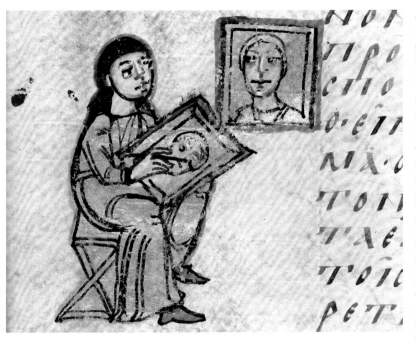

1.9
Detail of an artist copying a painting, from the *Sacra Parallela*, ninth century, black, red, and brown ink on parchment, 394 folios, 14 5/16 × 10 7/16 × 5 7/8 in (36.3 × 26.5 × 15 cm). This illumination illustrates a passage of the *Sacra Parallela*, a compilation of biblical excerpts and sermons devoted to the moral and ascetic life ascribed to the eighth-century Saint John of Damascus, possibly made in Constantinople. The text inadvertently reveals the centrality of "image transfer" in the practice of painters within a discussion of the imitation of saintly virtue: "As the painters when they paint icons from [other] icons, looking closely at the model, are eager to transfer the character of the icon to their own masterpiece, so must he who strives to perfect himself in all branches of virtue look at the lives of the saints as if to living and moving images and make their virtue his own by imitation."

Perhaps the much reviled middle period between the premodern and the twentieth-century experiments—the era of the picture gallery and the museum—will turn out to have been a convenient fiction, convenient above all to the writers of modernist manifestos. Perhaps as a result of working through the connections between before and after, that middle period will be criss-crossed to oblivion. The episode of the museum picture might turn out to be a moment in a larger alternation between works of art and their environments, a pattern that will come up in various ways throughout this book.

Postmodernism, it is clear enough now, overestimated the power of the modernist myths—in fact, needed to overestimate them. As the flimsiness of those myths was exposed and other models have come into play, the postmodern critique has faded with its success. And part of the reason the modernist myths were never very powerful is that the modernist avant-gardes themselves had seriously overestimated the stability of their precursors: the academy, the salon, the museum, the easel picture, "naturalism," etc. Some modernisms were wiser about this fact than others, as we will see in the following chapters.

LEARNING TO LIVE WITHOUT ARTISTIC PERIODS

To return to the classroom for a moment, I am not saying that the story of modern art has to begin earlier, that it needs to be a *longer* history. The object is not to deepen the register of historical influences or to retrieve a new set of legitimating precursors for modern practice, thus rendering it traditional and familiar after all, but to activate a wider set of reference points that cannot be arranged chronologically. The practitioners of modern art themselves provided some good tools for dealing with these relationships. Sergei Eisenstein, for example, imagined a critical loop, whereby the new structures of film helped to illuminate Johann Sebastian Bach and El Greco, and conversely their montages—that is what Eisenstein called them—served as "propadeutic models" for the analysis of film.

The juxtapositions are often counterintuitive, but when effective they provide an analytic context in which both similarities and differences are meaningful and provoke new ways of thinking about the two terms. Most of this book is spent looking at cases where we find a sustained, documented engagement with premodern art on the part of modern artists and theorists. There are numerous instances of deliberate medievalism. But this book also stages collisions of sorts between medieval and modern materials, with no other purpose than to have one work open new critical insights into the other. There may be nothing in Duchamp's writings that justifies setting the readymade into structural comparison with the relic, and yet that encounter has productively defamiliarizing effects. The point of the comparison is not merely to find a precursor or "reference" for the modern intervention; the effect of the encounter goes in both directions. The relic's structural role in the medieval image economy, for example, comes into view differently when the logic of the readymade is brought to bear on the question. The two methods, historical and heuristic, are not necessarily harmoniously joined.

In these encounters, moments of medieval art leave their time to speak to the present. Different elements are made to speak, and to speak differently, to different times and settings. Those elements come into view, are constituted

as features of the art, as a result of those dialogues; medieval art became medieval through its modern recuperation. The modern works, too, are taken out of their time, falling out of mere historical sequence. Their radicality consists in being more than something new. "*Il faut être absolument moderne*," Rimbaud enjoined, and artists of the twentieth century heard him clearly, but they also discovered that the "now-time" of art was, as Benjamin wrote, "shot through with slivers of messianic time." To say that art is taken out of time is not to say it is timeless but that its relationship to time and history becomes multiple—shot through. The artists were not alone in rethinking words like "modern" and "now," "past" and "memory," "progression" and "simultaneity." Progressivist and historical time—secular time—was being reconceived by some of the greatest thinkers of the early years of the century, from Einstein to Bergson to Proust. Whether informed or not by the writers, the artists' dialogues with medieval art were real cross-temporal encounters, acts of material resistance to historical logic. Moreover, those encounters exposed modern art to figurations of a premodern temporal consciousness untouched by Enlightenment rationalism, nothing less than alternative models of time. Historical distance was an enabling condition of these moments of exposure, even as timelines were undone by the interactions.

Attentive readers will have noticed that my terms shift around quite a lot. Sometimes I speak of "premodern" or of "medieval," but I also invoke "Renaissance" and "early modern." This is in part a consequence of the fact that the terminology available for use has not caught up with this line of investigation. From the point of view of the modern and contemporary artists who have turned to the earlier material, the dividing lines between medieval and Renaissance, or between Renaissance and Baroque, lose relevance, in open violation of art-historical protocols. In the pages that follow, I choose to follow the artists in thinking through time. Parmigianino and Caravaggio will come up in unseemly proximity to Byzantine mosaics and early Christian reliquaries. Conversely, to track the medieval strain in modern art liberates modern episodes from their position in the traditional lockstep sequence of modernist and postmodernist "movements." Moments from the earlier history of modernism become newly available to contemporary thought and practice in a way more or less corresponding to the ways they surface in the retrospections, reenactments, and reuses that make up so much contemporary art.

Why not start the story of medievalizing modern art earlier? Where are the Nazarenes and the Pre-Raphaelites, William Morris, and John Ruskin? This book concentrates on the twentieth century because medievalism, here, is not programmatically obvious and is only rarely part of an effort to revive a medieval life-world. Whether in Schwitters's cumulative works (see chapter twenty) or in Anni Albers's applied abstractions, in Smithson's *Non-sites* (chapter ten) or in Yves Klein's art of immaterial sensibility, in Louise Bourgeois's memory-theaters or Nancy Holt's observatories, in Sol LeWitt's distributed authorship or in Heiner Friedrich's recourse to the medieval chapel as his model for the Dia Art Foundation's activities (chapter nine), the premodern element in twentieth-century art introduces a break with established practices. When it is there, it is often at the heart of what is most aggressively contemporary about the intervention.

Medieval Modern is thus a convenient but restrictive title. If readers take "Modern" to mean strictly "modernist," then they will wonder why I deal with art after the sixties. If they take "Medieval" to mean only art between the Fall of Rome and, say, Giotto, then they are going to question why Brueghel and Michelangelo come into it. And yet I maintain that it would be a mistake to include, on the one hand, Rothko's admiration for Giotto or Fra Angelico, or Barnett Newman's professed admiration for Byzantine art, and yet exclude, say, Eisenstein's interest in the narrative dynamics of Baroque art, or Rothko's own equally strong admiration for Michelangelo's architecture (see chapter eight), on the grounds that these works "belong" to the later periods. Smithson was an admirer of Byzantine icons and Giotto's contemporary Pietro Cavallini (chapter ten), and he was also fascinated by what he saw as the inhuman, crystalline structures of Mannerist art. When in Rome in 1961, he wrote his future wife Nancy Holt that the "glow from the 17th century candles on the faces of the saints hidden in secret shrines evoke the invisible worlds of dreams within dreams." I propose to see these interests, from Byzantine to Baroque, in their mutual relations, rather than insist that each period must be treated separately because it has some essential validity that must be respected.

What mattered from the point of view of many twentieth-century artists was that both Byzantine icons and Baroque chapels belonged to a world before the existence of a conception of the fine arts, a world where art was overwhelmingly site-specific in conception, which is to say embedded

Opposite
2.1
Nancy Holt, *Annual Ring*, 1980–1, GSA Commission, Saginaw, Michigan, steel, concrete, sunlight, diameter 30 ft (9.1 m), height 14 ft 3 in (4.3 m), interior view. This observatory piece by Holt is named *Annual Ring* because every year at solar noon on the summer solstice at 1:37 pm, when the sun is at its highest point in the sky, the sun shines through the ring at the top of the domed sculpture, casting a circle of light onto a ring in the ground. Commissioned in 1981 by the US government for the Federal Building in Saginaw, Michigan, the sculpture was moved to Saginaw Valley State University when the building was demolished in 1999. The move of just a few kilometers required that the ring be shifted by two inches in order to capture the shadow in its new location. A small opening (six foot in diameter) frames the North Star when viewed from the center of the ring on the ground that marks solar noon on the summer solstice.

in environments whose parts were made at different times and by diff-erent hands—multi-temporal and multi-authorial settings where artists responded directly to institutional and societal imperatives and worked largely within iconographic systems they did not invent. In the case of self-reflexive works like those of Brueghel, which did detach themselves from traditional institutional and iconographic structures, the very process of dislocation informs them at a basic level, making them acutely relevant to certain modern viewers. One can see the differences among the various forms and periods of premodern art and yet also see the ways in which they spoke to twentieth-century art.

The same goes for the modern materials. To speak of a medievalizing strain through the twentieth century does not mean we have to sacrifice historical and individual specificity. Duchamp's practice was remote from the mystically oriented, nature-worshiping, and temperament-heavy art of the German Expressionists, and yet in the same years he established an equally powerful if different relation to what might be called, in his case, art before the ascendancy of classical European painting. We can see the larger connection and still appreciate the important local differences.

Tracing the dialogue with this long Middle Ages makes it hard to stay within established routines for writing histories of art. I have abandoned a chronological presentation (either on the medieval or the modern side) not to advertise grandiose resistance to "chronologocentrism" but because the cross-temporal surfacings I study here simply make it impossible. A good deal of the modern material, of course, offers implicit or explicit theoriza-tion of these gatherings or foldings of chronological time. Walter Benjamin responded to a series of unsettling modern developments by rehabilitating and remobilizing the logic of sixteenth- and seventeenth-century allegori-cal images, signs built out of fragments and open to unending readings, and who extracted from Jewish mystical traditions spanners to throw into the works of the historical method. The Benjamin cult has been rampant for some time, but the fact is that Benjaminian histories of art remain rare. This is not another book about him—he will barely be mentioned again—but it is shaped at a fairly deep level by his style of thought. Readers will not be thrown into "convolutes" in these pages, but they will encounter, again and again, art works that refuse to stay stably in their time and relations of contemporaneity persistently routed through anachronisms.

IF YOU GO FAR ENOUGH BACK, THE WEST IS NOT "EUROPE"

And yet isn't this larger framework still a bit tame? Why remain focused on medieval and early modern art? Why not include ancient materials? Why stay in Europe? We have lived through a century of intensive globalization; why leave out Greco-Roman art, pre-Columbian art, Asian and African art? My answer is first of all pragmatic: the medieval revivals are a real phenomenon of modern art and enough for one book to take on. But there is a more substantive reason. Globalization notwithstanding, the contemporary art world is still structured by museums, biennials, curatorial practices, the business of art galleries, the protocols of art criticism, and so on. It is still dominated by Western art publications. All these institutions are bound up with a primarily Western history. I am proposing that that history is stranger, configured in a different way than the modernist and postmodernist histories have made visible. If we take it back well before the eighteenth century, we find ourselves immersed in a set of cultural practices that precedes the existence of a Eurocentric world view. This prepares us better for what is happening now.

Before turning to the non-Eurocentric Middle Ages, let me make the point about the primariness of the Western medieval field of reference by invoking an emblematic case. The figures in Picasso's *Les Demoiselles d'Avignon* may wear masks from the Etoumbi region and elsewhere, but in overall structure and mode of address the painting is modeled on altarpieces, a point that was clear enough to André Breton, who called the work a "sacred image" and compared it with a Cimabue Madonna (see next chapter). It was, indeed, a polemical return to the overt address of altarpieces, with an array of figures all facing outward, a pictorial structure that flew in the face of the previous two centuries of tidily framed salon painting. The non-Western references are there, but these regressions are collected together by the first, organizing regression on the level of structure and format.

The premedieval ancient world is similarly filtered. Picasso's Bacchanals refer to Greco-Roman mythology, but as metabolized in Renaissance

3.1

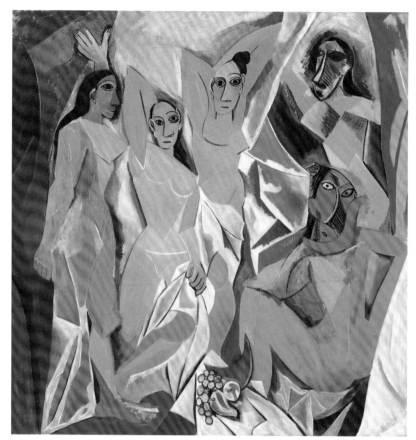

3.1
Pablo Picasso,
*Les Demoiselles
d'Avignon*, 1907,
oil on canvas,
96 × 92 in
(243.9 × 233.7 cm).
André Breton wrote
an impassioned letter
about the painting to
Jacques Doucet in 1924,
concluding it with the
words: "Perhaps you
were hoping I would
talk about it more
directly, but it is so
difficult. And would it
not be lowering it to
submit it to rational
critique, when what we
are dealing with is, for
me, a sacred image?"

painting forms; Titian and Poussin were the real ground he was working
against, and their revival of antiquity was, needless to say, deeply shaped
by the intervening Christian centuries. I simply do not believe that ancient
art was present for the twentieth century the way it was for Raphael in the
Renaissance, and still was for Jacques-Louis David and Antonio Canova
in the late eighteenth and early nineteenth centuries—even in Giorgio De
Chirico, even in neoclassical Picasso. Cy Twombly's antiquity is literary
rather than artistic, I would submit; and his artistic Arcadia is primarily
in dialogue with Poussin. Perhaps a completely revised understanding of
ancient art and its reception—something along the lines laid down by Aby
Warburg, something in the spirit of Bredekamp's *The Lure of Antiquity and*

the Cult of the Machine—will one day reclaim an unsuspected history that puts these materials together for future artists. But in my view it is what has happened in Western art since the decline of Rome that has mattered primarily for twentieth-century and contemporary art.

To return to the Christian Middle Ages is not simply to stay in "the West." It is to encounter a decentralized and also decentered Europe. The "center" for Christian culture lay in what we now call the Middle East, in 3.2 Palestine, and yet after the fourth-century Roman emperor Constantine made Christianity the official religion of Rome, the demographic and institutional weight of Christendom lay in the West, a West dominated by a Roman empire in the phase of its disintegration. Not surprisingly, Constantine was soon enough pulled eastward, relocating his empire to the Bosphorus when he founded Constantinople on the existing city of Byzantium in AD 330. Within a hundred years, Rome had fallen, and Christianity had been split up into an Eastern (Byzantine) world and a Western (Latin) world, with different rites and power structures.

In the famous account of Virgil, Emperor Augustus's select poet, Rome originated in a transplantation of refugees from Troy, the eastern Mediterranean capital. Under the empire, Rome eventually extended (back) eastward to include Palestine and the Near East. Christianity, born under the Roman regime, originated in Palestine and extended westward, first claiming Greece and eventually becoming the official religion of Rome around three hundred years after Christ. It was then spread throughout Europe by fast-moving barbarian tribes that themselves had migrated from Central Asia. Western civilization's eastern roots shaped its history, impelling it always to look eastward. And with Constantine it moved back in that direction.

In the post-Constantine era, the area we now call Europe was governed by a weak pope and a succession of relatively unsuccessful claimants to the mantle of Roman imperial authority, such as Charlemagne and the Holy Roman emperors. After the fall of Rome, the region was most often designated as the Latin West, and it was most emphatically not the center of the world. The Holy Land was far away and difficult to reach, especially 3.3 after it came under Muslim domination in the seventh century. This organizing center was always more fantasy than reality, and as such it exerted a powerful symbolic pull, occasionally impelling real and violent efforts

3.2
The Psalter Map, c. 1265, manuscript on vellum, map diameter 3⅝ in (9 cm). This illumination, made in England in the thirteenth century, is typical of the style of map known as a *mappamundi*, which presents a circular formation with Jerusalem dead center. East, at the top, is presided over by Christ, with Adam and Eve in the walled Eden at the easternmost edge of the world. Below, or West, of Jerusalem one can make out the inscriptions that identify Roma and Graecia. To the right (South) is Africa, bordered by a highly coloured Red Sea.

Opposite
3.3
French illuminated manuscript, fifteenth century. Pilgrims arriving at the Church of the Holy Sepulcher in Jerusalem. After Muslims took control of the region in the seventh century, access to Christian sites was limited and pilgrims were obliged to buy permission to visit the most sacred of shrines.

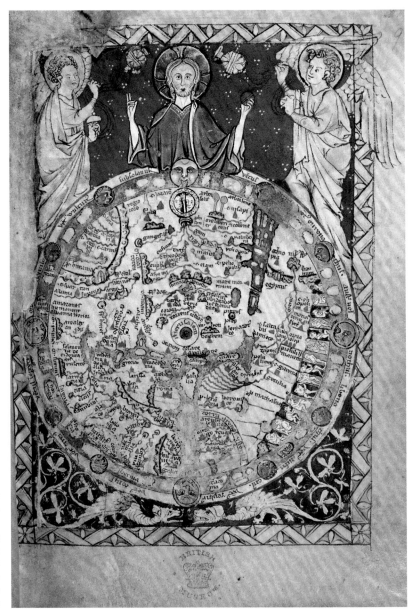

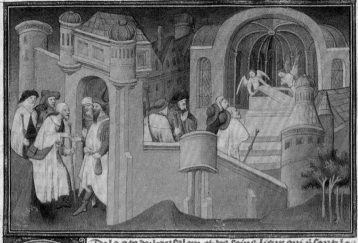

De la cite de iherusalem et des sains lieux qui y sont le
temple nre seigneur et plusieurs autres

ous les lieux dessus dis par la grace de dieu visitez ie seray
en iherlm la sainte cite du benoit roy nreseigneur thesucrist qui
de son precieux sanc la nobliament et richement a noble. Elle est
la maistre cite de la sainte terre de promission. et est assise en
tres bon air et pur et sans riuiere et sans fontaine leaue que ilz ont et de quoy
ilz font leurs necessitez ilz sont venir par conduis artificiement. Et si a pluseurs
cisternes en la ville. leaue qui vient en iherlm vient de deuers ebron. et a present asses
ces conduis par dela la voie qui vient deuers ebron. En ceste sainte cite est le te~
ple de nreseigneur. non pas celui temple qui salemon edifia. car celui est pie~
ca destruis comme tesmoingne la bible. mais vn autre fu referict en ce mei~
mes lieu. tout vont asse, large couuert de plonc il est tout quarre de pierre ron~
de et poliie vn grant aire tout entour. si que nulle maison ny approudr. cest
aire est tout descouuert et paue de blanc marbre. Les sarrazins le tiennent ⁊
moult nettement. car ilz le ont en grant reuerence. Ilz ny euterent fors deschaux
seruent se mettant a genoulx et baisent ce pauement. il ny laissent nul entrer
entre a dieu que si sains lieu comme la sainte maison de dieu ne doit estre
poluie ne contaminee de iuifs ne de arrheriens lesquelz ilz reputent diuers mes~
creans. Certes maintes belles nurucles a dieu fait en ce temple materiel cōe
nous trouuons ou viel et nouuel testament. lesquelles seroient trop longues
a toutes raconter. On dist que en cest lieu offry melchisedech pain et vin sigu~
ant le sainct sacrement de lautel. Cilz lieux si deuotes. a abraan pour sacrifier

of recovery such as the Crusades. The Latin West also had to live with the fact that the true heir of Christian Rome was its double to the east, Constantinople, which filled the geographical and mental area between here and the Holy Land.

A sense of a Christian European center, coinciding with that of the Roman empire, emerged only in the Rome of the Renaissance popes, which started to gather some authority in the fifteenth century as the Byzantine empire went into steep decline and then fell to the Ottoman Turks in 1453. Until then a geographical designation and barely anything more, the words "Europe" and "European" now began to be used in a broader cultural sense. The new idea was articulated most clearly by Pope Pius II at the end of the 1450s, and in doing so he was responding to a new and alarming situation: It was no longer a matter of mounting a crusade against the Infidel over there; the Turks were gathering themselves to invade Europeans where they stood. This gathering definition was in turn deeply affected by two geopolitical events: the discovery of the New World and the Reformation. The new internal binary of Protestant and Catholic and a new positioning between truly Old (Holy Land, as well as parts east of there) and truly New (America) produced the structural conditions necessary for a notion of Europe to emerge in the sixteenth and seventeenth centuries.

Displacement was thus a constitutive feature of the "post-Rome" / "pre-Europe" phase of Western history. Unlike Islam or the Jewish diaspora, Latin Christendom read and sang its sacred texts in translation, a fact that was never forgotten. The art and architecture of the medieval period registers this displacement by persistently referring to other, far-away places, or instantiating other places in the here and now. Roughly ninety percent of Western art produced during the post-Roman period right through the fifteenth century *points* in one way or another to the Holy Land—all those Crucifixions, all those altars standing in for the tomb of Christ, all those reliquaries, all those churches in the shape of a cross, their apses oriented eastward, all those eastern marbles used for construction and minerals used for pigments. It was a culture continually engaged in processes of translation and translocation, continually measuring and closing the distance between here and there, between us and them, between now and then. Western art elaborated an impressive array of techniques to manage these spatio-temporal relations: surrogate pilgrimage (where a proxy location

closer by stands in for the far-away pilgrimage target), dramatic restagings in both visual art and performative art, the imitation of authoritative, "Eastern" architecture and image prototypes, and the intensive elaboration of compensatory devices of pictorial realism, rendering it possible to visualize faraway places and, along the way, raising pointed questions about what, where, and when were being represented. Western medieval art, at bottom an art of displacement, generated particular forms of artistic self-awareness.

All of this is to say that to focus on the premodern period in a contemporary context is not a matter of "staying in Europe." The premodern Western conditions of decenteredness, migration, and exile—and the artistic responses they provoked—speak to the conditions we inhabit now: the state of postcolonial hybridity as described by Homi Bhaba, the expanding condition of extraterritoriality as theorized by Giorgio Agamben, and the non-places of what Marc Augé calls supermodernity, a world marked by the expansion of intermediary zones, physical and virtual, that belong to no nation and no culture.

There is no question, therefore, of denying the persistent recourse to non-Western alternatives throughout twentieth-century art, but only of providing some materials toward a reframing of that unending search for alternatives to modern, Western, bourgeois culture. The new and more open framework proposed here destabilizes the terms "Western art" and "modernism," and thus can only have troubling effects for the ways of thinking that produce terms like "primitivism."

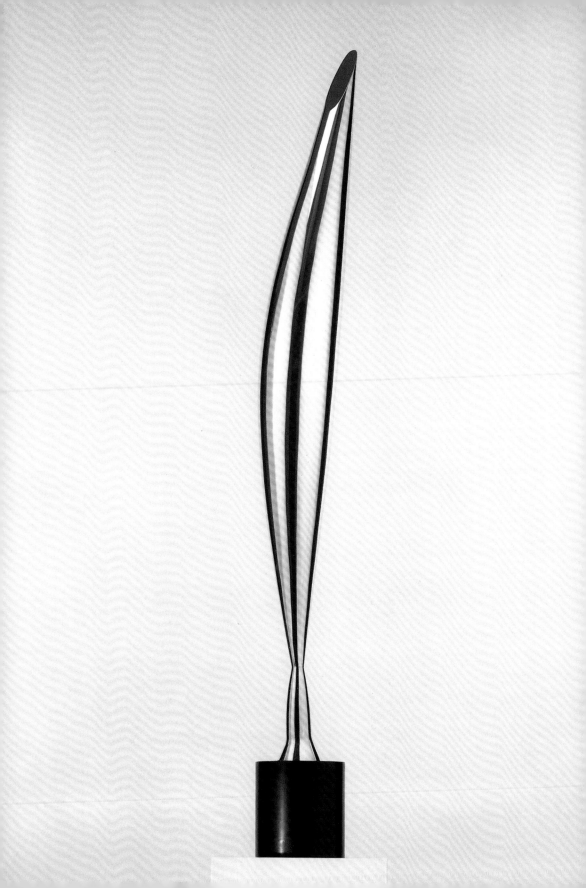

AIRPLANES AND ALTARPIECES

The artistic revolutions of the twentieth century mounted various assaults on the conception of the work of art enshrined in museums, art galleries, and academies, ultimately raising basic questions about the history and constitution of art. When did the "work of art" and the institutions that support it come into being? What political and social structures do they serve? Will the modern era of art—the era of the museum and the art academy—turn out to be a passing historical episode? What forms of art and culture existed before this episode? How did art function when it was made primarily on commission, to serve political and religious structures and institutions? Is "art" the correct term to use?

In the company of Fernand Léger and Constantin Brancusi at the Salon de la Locomotion Aérienne of 1912, Marcel Duchamp pointed to an airplane propeller and said, "Painting is over and done with. Who could do anything better than this propeller? Look, could you do that?" In a twist of fate, when in 1926 Brancusi's *Bird in Space* now in Philadelphia arrived in the United States for an exhibition at the Brummer Gallery in New York, it was misidentified by customs officials as a propeller, prompting a debate over the definition of art, in the form of a courtroom battle: Should the higher customs fees levied on manufactured metal objects be applied to this work? Duchamp's admiration for the new forms of modern technology would be shared by many twentieth-century avant-gardes, from the Futurists to the Bauhaus, to Le Corbusier, to Benjamin, and beyond. Our question is, did this new sensibility, with its concomitant rejection of museum art, also involve a new appreciation of medieval art—also famously an art of craft and technology, an art made to serve practical functions? In the case of the Bauhaus, as we will see, the recuperation of medieval modes of organization and integrated production was a programmatic part of the mission. In Duchamp's case, the association is less obvious. Duchamp never invoked the modalities of medieval art the way Walter Gropius (and, say, Kurt Schwitters) did, and he never, in fact, fell in with the idea of a functional art, but other evidence suggests that there is a medieval dimension to his appreciation for the airplane propeller.

Opposite
4.1
Constantin Brancusi,
Bird in Space, 1924,
polished bronze, with
black-marble base,
height 50⁵⁄₁₆ in
(127.8 cm), circumference
17¹¹⁄₁₆ in (45 cm)

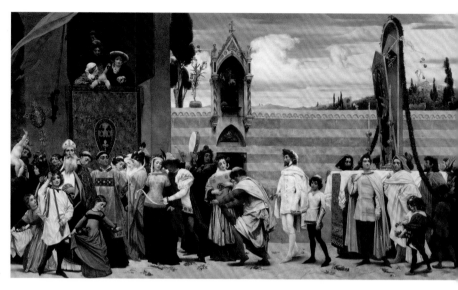

4.2
Frederic Leighton, *Cimabue's Celebrated Madonna is carried in Procession through the Streets of Florence*, 1853–5, oil on canvas, 91¼ × 205 in (231.8 × 520.7 cm). Leighton's painting shows the celebratory procession of Cimabue's panel from his studio to the church of Santa Maria Novella, as recounted by Vasari. Cimabue and his pupil Giotto can be seen walking hand in hand directly in front of the painting. There is no existing documentary basis for the episode, but there is a period account of a similar event involving Duccio's *Maestà*, which was carried through the streets and installed in Siena Cathedral in 1311. The gabled panel here is seen only obliquely, but it is clear Leighton has shown the so-called *Rucellai Madonna* in the Uffizi, which was indeed painted for Santa Maria Novella in Florence. Believed by Vasari to be the work of Cimabue, it retained that attribution until the twentieth century, when the current attribution to Duccio took hold.

In 1913, one year after Duchamp's remark to his artist confrères, Guillaume Apollinaire published his essay *The Cubist Painters*, which concludes with a segment on Duchamp. The final paragraph of the book reads:

Just as a work by Cimabue was paraded through the streets, our century has seen the triumphal procession to the Arts et Métiers of the airplane of Blériot, a work invested with humanity, with millennial aspiration, with necessary art. Perhaps it will be the task of an artist as detached from aesthetic preoccupations and as concerned with energy as Marcel Duchamp, to reconcile art and the people.

Apollinaire is making reference to a story told by the sixteenth-century artist and art historian Giorgio Vasari about a Madonna surrounded by angels, painted three centuries earlier by Cimabue, that was carried by the populace of Florence in procession to the sound of trumpets from the artist's house to the church of Santa Maria Novella. Vasari says Cimabue's panel was larger than any that had been made in that time, causing astonishment among the people, and he gives special praise to the angels flanking the Virgin. In the summer of 1909, Louis Blériot succeeded in flying an airplane of his own design across the English Channel, successfully landing in Dover and causing an instant frenzy in the news media. Shortly thereafter, the plane, much damaged in the landing but repaired and transported back to

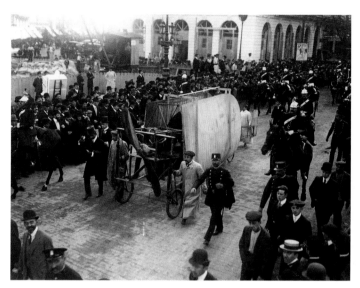

4.3
Louis Blériot's plane
being paraded through
Place de l'Opera,
Paris, on its way to the
Conservatoire Nationale
des Arts et Metiers,
13 October 1909

France, was paraded through the streets and installed in the Conservatoire
Nationale des Arts et Métiers, where it remains to this day.

Cimabue's panel of the *Madonna and Child Surrounded by Angels* in the
Louvre was certainly the Cimabue that Apollinaire knew best. The primary **4.4**
basis of comparison between the airplane and the religious image is clear
from Apollinaire's passage: craft and technology serving society, to sublime
ends, and the celebratory recognition of that achievement by the populace.
Both the Madonna and the airplane were celebrated by the people of their era
as marvels of human ingenuity. As Vasari notes, the Cimabue panel carried
aloft by the people of Florence was not installed on an altar but "placed high
up in between the Rucellai and the Bardi di Vernia chapels." It happens that
the Conservatoire Nationale des Arts et Métiers arose in 1802 on the site of
the deconsecrated church of Saint-Martin-des-Champs, so Blériot's plane,
like the Madonna, was escorted through the streets in order to be installed
high up near the rib vaults of a late medieval church. But the parallel goes
beyond that. The comparison prompts us to see that there is considerable
liftoff occurring in Cimabue's altarpiece. The angels hold up a throne that is
not actually on Earth but suspended. There is no landscape and no sky. There
is just the throne—massive and yet levitating—held aloft by a fluttering
angelic machinery that extends right to the edge of the picture.

37

4·4
Cenni di Pepe, known
as Cimabue, *Madonna
and Child Surrounded
by Angels*, c. 1280,
tempera on wood
panel, 168 × 110¼ in
(427 × 280 cm)

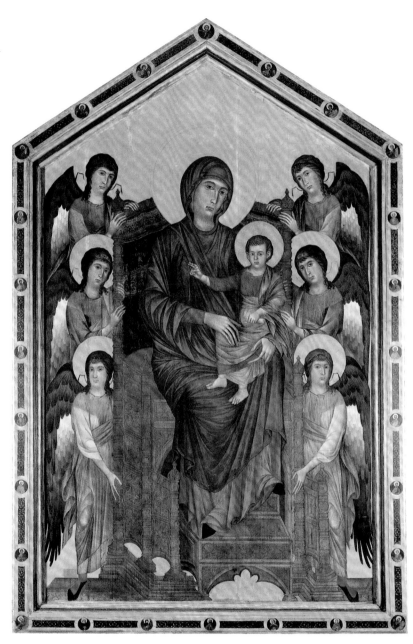

In fact it is not accurate to say that those wings reach the edge of the "picture," or even that the picture has a "frame." The woodworkers who made such pieces of ecclesiastical furnishing were generally paid more than the painter, who was employed as a decorator of the woodwork, although Vasari's story and the kind of account it was based on reveal those priorities undergoing a significant shift. In the fifteenth century, a new system arose whereby the frame, now understood as an architectural form, was constructed separately from the panel, which was now conceptualized as a pictorial field. The panel could thus be painted before, during, or after the construction of the frame. This was the material premise of the easel-picture format that was to become dominant in the early modern era. New terms were coined in artistic contracts to designate this field occupying the area inside the frame, terms such as *piano* (plane) or *vano* (pane, as in window pane), metaphors suggesting the new status of a surface that was entirely given over to painting, projecting a world understood as something seen through an embrasure-like frame. In material terms, this plane or pane was still typically made out of wood (canvas would not become common for paintings until the sixteenth century), but notionally it disappeared as material support and became a pictorial zone. Leon Battista Alberti, an early theoretician of this new idea of the picture, insisted on the distinction between image and frame in 1435, stipulating that gold and gems should be left to the frame, while the picture proper should be occupied only by the invention of the painter, whose value lay not in the inherent worth of the materials used but in the ingenuity of the conception and pictorial realization.

Rather than a picture in a frame, the pictorial work in Cimabue's *Madonna* is integral to the painting's material structure, an artistic conception that was to be revived only in the concrete painting of the twentieth century—in, for example, the work of Robert Ryman and the Supports-Surfaces group in France. That means that the levitation of the angels and of the Madonna's throne does not occur "in" the painting. Rather, the *whole panel* is understood to be a vehicle, something that has alighted or is even now in movement, an effect that would have been enhanced in the celebrated Cimabue panel's original placement up near the vaults of Santa Maria Novella. The liftoff quality of the work in the Louvre makes it an aberration, still, in the context of the great gallery, a display environment with an extraordinary ability to convert even works from the pre-museum

of Icarus (Gabriele d'Annunzio insisted on the connection when he met the aviator at the Brescia air show in September 1909, an event the young Franz Kafka also attended).

Apollinaire connected Cimabue's great work to Blériot's flight and to the work of Marcel Duchamp, the Cimabue of his age, detached from aesthetic considerations and preoccupied with "energy," a force to reconcile art and the people. But the advances in flying were linked to other artistic adventurers as well. The 1908 review by Louis Vauxcelles that coined the term "Cubism" (of an exhibition of works by Georges Braque, the catalogue for which carried a preface by Apollinaire) appeared directly above an article celebrating a triumphant flight by Wilbur Wright at Le Mans. Daniel-Henri Kahnweiler, the painter's dealer, seeing the justness of the juxtaposition, kept the two articles together in his clipping from the paper. Not long thereafter, Picasso, who was fond of going to the airfield of Issy-les-Moulineaux to watch the planes fly in the company of Braque and Robert and Sonia Delaunay, took to calling his pioneering painter copilot (Braque, that is) by the nickname "Wilbourg." In 1912 Picasso produced the collage *Nature morte: nôtre avenir est dans l'air*, drawing a direct connection between the new experiments in art and flight. By the time of Robert Delaunay's 1914 *Hommage à Blériot*, the association of flying and modern art had become a cliché.

Blaise Cendrars, who met Apollinaire in late 1912 or early 1913, was also a lyricist of the industrial/commercial sublime, and his vision of it, too, had a place for Cimabue. His poem "Contrastes," published in 1919, concludes with the lines:

L'aérodrome du ciel est maintenant, embrasé, un tableau de Cimabue
Quand par devant
Les hommes sont
Longs
Noirs
Tristes
Et fument, cheminées d'usine

A *banlieue* of factories and airfields reorganizes perception in a way that is, to use Apollinaire's words, detached from aesthetic considerations. The sky is an airfield, ablaze like the Cimabue panel, which is also both sky and field, a surface rendered unnaturally brilliant by human industry. Under

the new conditions, men merge with their environments in new ways, a poetic metaphor brutally realized by the modern city. "Everything is halo," an earlier line of the poem reads, a spectacular array that is violently poetic and something other than beautiful. The poem makes one aware of the Cimabue Madonna as a painting that makes a steady noise.

In a letter of 1924 written to convince Jacques Doucet to purchase *Les Demoiselles d'Avignon*, André Breton called Picasso's work "the most important event of the early twentieth century," and then proceeded to compare it with the Cimabue Virgin that had been hoisted in triumph through the city of Florence:

This is the painting that we would be carrying through the streets of our capital, as with Cimabue's Virgin in times past, if skepticism had not succeeded in becoming the great specific virtue that our time agrees to live by, in spite of everything. It seems to me impossible to speak of it other than in a mystical manner. The question of beauty arises only much later, and even then it is only fitting that it be broached with prudence. The "Demoiselles d'Avignon" defies analysis, and the laws of its vast composition cannot in any way be formulated.

WORKS BECOME ENVIRONMENTS AND ENVIRONMENTS BECOME WORKS

The contemporary installation artist Ilya Kabakov once proposed a "historical fantasy" whereby the icon, a portal to the heavenly cosmos, settled down into the easel picture focused on the earthly world (Renaissance), which eventually became the image of a fragment of the world (eighteenth and nineteenth centuries), and then a mere thing (twentieth century). World-creation was lost when pictures became mere market objects, but it has now come back with installation art. "In the installation," Kabakov says, "the lost pictorial reality is reconstituted." Here, installation art is not pursued *against* painting, but is understood as one of its phases, a modality that allows what was formerly accomplished by painting to happen again, realizing painting's earlier purpose by other means.

This fantasy complicates the simple idea of an opposition between easel painting and an art of installation and site-specificity, pointing the way to a more complex pattern of commutation between objects and environments, a pattern in fact much more complex than Kabakov's sketch allows. By commutation, I mean a process of interpenetration, displacement, and substitution. Chapels were often conceived as macro-versions of shrines, and shrines were designed as miniature architecture. Containers were contained by larger containers, themselves placed in larger shrines, in turn encompassed by chapels, and so on. These were not just formal games but repeated reminders that controlling ideas such as scale, topographical distance, and organic unity were open to redefinition. What is large to humankind is infinitesimal to God; things at a distance on the plane of physical relations can be contiguous if that plane is folded rather than extended; what appear to be two different things turn out to be phases of the same thing; what looks like the macrocosm to us may be a microcosm at another level.

There is no need, incidentally, to imagine those spaces, those churches, chapels, and treasuries, as zones exclusively for ritual and prayer and acts

of devotion. For citizens, they were also meeting places; for pilgrims, they were galleries of sorts, display spaces for sacred or curious items, or for very practical transactions between potent objects and believers. When pilgrims arrived at a church, they wanted to be shown the best things the church had, and often paid for the privilege. "Best" often meant most sacred or most powerful, but it could also mean most wondrous for reasons of workmanship or rarity—a painting of hoary age, for example, or a whale-bone.

We can insist on everything that distinguishes these spaces from modern museums or we can choose to see the things that are common to both. Acknowledging the similarities does not have to mean indulging in historical telescoping; it may entail, instead, seeing the museums differently. It no longer seems very productive to see museums in the apocalyptic modernist mode, which is to say as cemeteries for art. Museums were not peculiarly modern in displaying "detached" items from faraway places. Premodern displays were full of exotica, especially in the Latin West, a culture fundamentally disposed to be receptive to important relics and images from the eastern Mediterranean. Not just in their recent reincarnations but throughout their history, museums have presented an integrated and dynamic installation practice, interacting with other more commercial forms of display and showcasing. These were different from the earlier practices in various practical details, but perhaps not that different.

To take this view of things through some examples, it was Domenico Fontana's job, in the late 1580s, to coordinate the activity of a number of artists working in various media in the Sistine Chapel of Santa Maria Maggiore in Rome. The walls carry paintings executed by famous paint- 5.1 ers of the day. The tabernacle in the chapel's center, of Fontana's design but made by a team of sculptors individually credited for its different parts, houses a constantly replenished anonymous serial production of eucharistic wafers. Beneath the great new tabernacle was the most impressive part of Fontana's work as curator, if we stay close to the original definition of curator as caretaker or keeper: the cavelike *Presepe*, a thirteenth-century structure housing what was believed to be the original manger from Bethlehem. Originally occupying another chapel along this aisle of the church, it was reinstalled here in the new space with its decorations intact. Fontana devised an elaborate mechanism to move the object, with its already once-transported architectural relic, to its new home. Fontana was

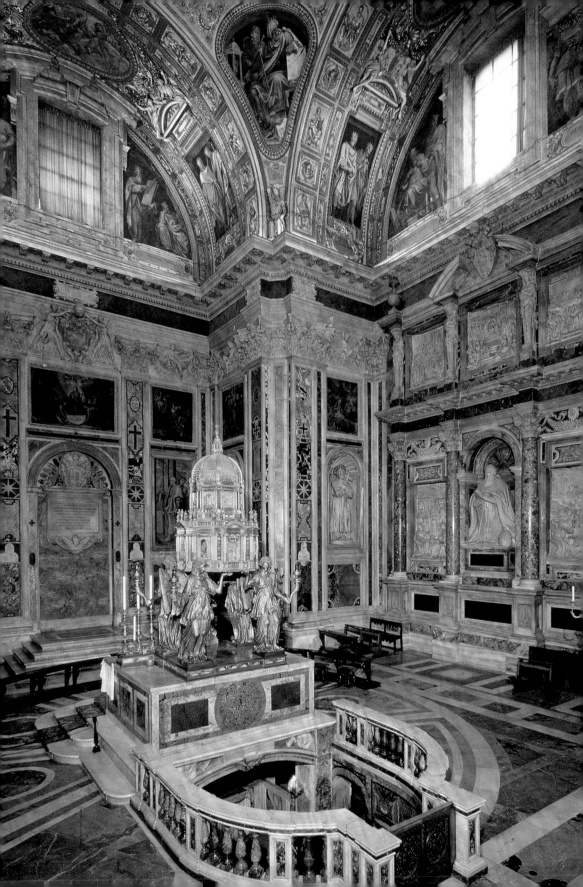

a specialist in the relocation and redisplay of relics of earlier architecture, as several other spectacular installations throughout the Lateran attest.

Is this so different from later examples of reinstallation that bring us closer to the history of the museum? In the middle of the eighteenth century, Horace Walpole built Strawberry Hill, a castle at Twickenham on the outskirts of London, to house his vast collection of objects from antiquity to his time. More than a private museum, it was a Gothic architectural fantasy come true, a composite work designed to contain other works, "my oracle of taste," as he called it. During the period of the French invasion of Italy in the first decades of the nineteenth century, the Venetian priest Guglielmo Wambel scrambled to save the sacred objects in Venice, amassing a collection of close to ten thousand items, including thousands of reliquaries, which shortly after his death in 1844 were installed in a newly built rotunda attached to the church of San Tomà. Was this new construction a chapel or was it a proto-museum of religious art? This was less a clear epochal succession from sacred to secular than a layering of functions. In Paris, the connoisseur Alexandre du Sommerard took over the late-Gothic townhouse of the Abbots of Cluny in 1832 and turned it into a historical museum, known as the Musée de Cluny after it became the responsibility of the French state in 1843. Classes of objects were arrayed in period-specific ensembles: the Salle François I contained Renaissance furniture, and the "chapel" contained liturgical books and reliquaries of various kinds.

Such assemblies confuse the categories. Sommerard's museum and that of Sir John Soane in London, or the collecting practices of Gustave Flaubert's fictional hoarders Bouvard and Pécuchet, might be just as typical of nineteenth-century museum and display practices as the silent mausolea of art despised by the modernists and postmodernists. Nineteenth-century art museums and exhibition spaces were quite multiple in their incarnations and in fairly fluid dialogue with many other modes of exhibition that both preceded and succeeded them. Soane bought the sarcophagus of the Pharaoh Seti I—his prize possession, installed with great ceremony in 1825 in his museum home—at the Egyptian Hall in Piccadilly, a highly various exhibition space that also hosted traveling shows (a few decades later it hosted the spectacles presented by P. T. Barnum). Art exhibitions occurred in the immediate vicinity of show business, well before King Tut arrived at the Metropolitan Museum in 1976.

Opposite
5.1
Sistine Chapel, Santa Maria Maggiore, Rome, showing the entrance to the *Presepe* beneath the chapel altar and tabernacle

5.2

5.3 and 5.4

47

5.2
Edward Edwards,
'The Cabinet at
Strawberry Hill', 1781,
an illustration from
*A Description of
the Villa ... at
Strawberry-Hill* (1784)

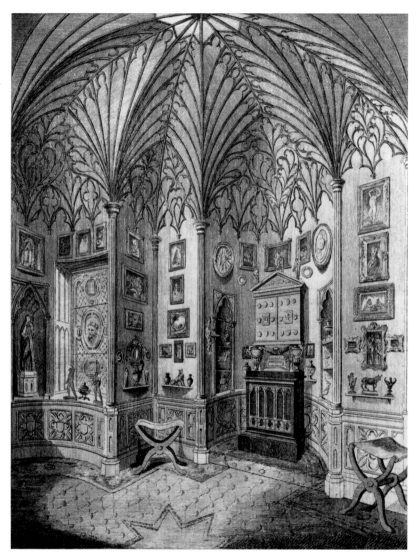

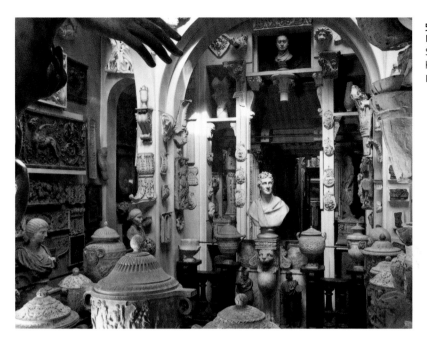

5.3
Interior view of
Sir John Soane's
house, Lincoln's
Inn Fields, London

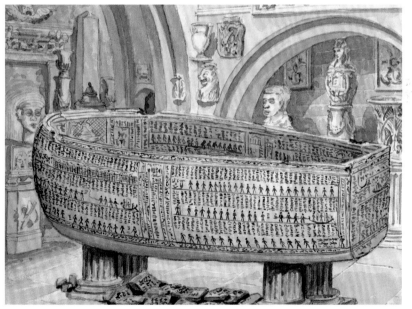

5.4
The sarcophagus
of Seti I in Sir John
Soane's house.
The pharoah's tomb
was discovered in
1817 by Giambattista
Belzoni, an Italian
showman and
explorer who was the
first European to
find Egypt's Valley
of the Kings.

it with the residual performative energy and temporal resonances of those spaces. Originally the underdog among the media, the cheap alternative to marble carving, tapestry, or mosaic, painting in the West entered into these exchanges especially aggressively after 1300, using its special advantages to play games with scale and to stage the other media in relation to one another. By the late fifteenth century, there were those, such as Leonardo da Vinci, who claimed for painting a superintendent position over the other arts. Painting was in an excellent position to absorb earlier multimedia environments and repropose that multiplicity in a dense pictorial structure. Paintings were not detached from their environments so much as they internalized them. A famous early example of the phenomenon is Masaccio's *Trinity* fresco from the late 1420s, a virtual view into the Holy of Holies. Even when, after 1500 especially, paintings were framed off as independent pictures—no altarpiece framework, no framing pilasters encrusted with smaller paintings and/or gemstones, no crowning element featuring more images and elaborate woodwork, but rather one unified field with an independently crafted frame placed around the painting after it was finished—even when it no longer needed to clear room for itself vis-à-vis the other visual arts, it carried the traces of a history of location, relocations, and embeddings.

This is not to deny that the post-Renaissance picture was a radical and novel development. European paintings after 1500 began to attract new forms of attention and new modes of criticism, ultimately bringing into being new institutions, such as the salon, the picture dealer's shop, and the museum. Viewers were invited to set works of art into a complex of intra-artistic references. It became increasingly common for works to be taken up into different and intersecting archival formations of quite abstract sorts, such as the artist's corpus, regional styles or schools, or iconographical categories—a redistribution applied first to painting, then to sculpture and architecture. These new developments in the study of art and its history were then formalized into the discipline of art history in the eighteenth and nineteenth centuries.

These emergent conceptions rebounded retroactively on earlier environments. The extraordinary ascendancy that painting won in the fifteenth and sixteenth centuries eventually provided the ideological conditions for the more literal detachments of later centuries, as dealers and collectors went

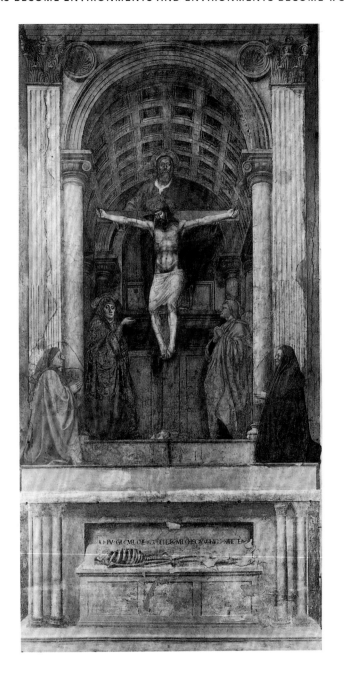

5.5
Masaccio, *Trinity*, 1427, fresco, 252 × 124¹³⁄₁₆ in (640 × 317 cm), Santa Maria Novella, Florence. Masaccio's wall painting depicts a transition from the real space of the church into an otherworldly sanctuary. Farthest in, God the Father stands on the Ark of the Covenant, holding up the crucified Christ, who is accompanied by his companions at his death, Mary and John. As one moves down toward the viewer, things become more secular. On either side of the arch, outside the sanctuary, the donor Domenico di Lenzi and his wife kneel in prayer, at near life size. Roughly two-thirds of the painted surface is understood to be taking place on our side of the depicted entrance. Below the donor figures, an actual altar once projected from the wall; the skeleton was thus understood to be lying in our space, in the vicinity of members of the Lenzi family, who are buried in the floor in front of the fresco. The presence of a real altar with tombs before it means that this ensemble functioned as a consecrated chapel. The novelty was that a good part of it existed in virtual space.

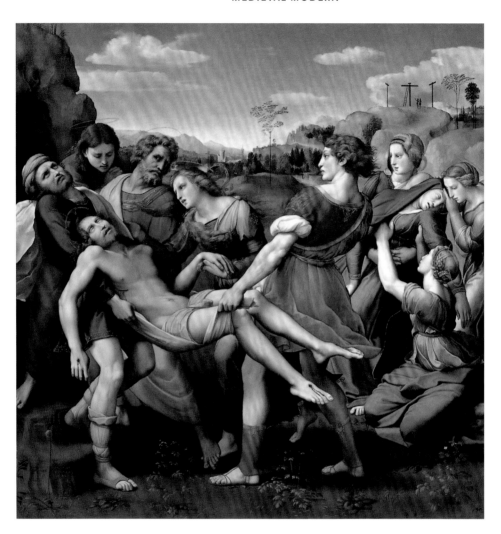

5.6
Raphael di Sanzio,
The Entombment,
1507, oil on panel,
72⅜ × 69¼ in
(184 × 176 cm)

about acquiring "pictures" even from the era before easel painting, which is to say, brutally sawing them out of their altarpiece structures and other encompassing frameworks, thus giving art historians much reconstructive work to do. In 1608, one hundred years after it was painted, Raphael's *Entombment* was taken from its original location in the church of San Francesco al Prato in Perugia and transported to Rome, where it entered the art collection of the extremely powerful Cardinal Scipione Borghese. The

5.7
A reconstruction of the original 1507 altarpiece in San Francesco al Prato. The altarpiece's crowning oil-on-canvas panel showing a blessing God the Father, designed by Raphael but acknowledged as the work of an associate, was left behind in Perugia, where it remains today. After it was taken by Cardinal Scipione Borghese, the main panel was (and still is) displayed alone as "the" picture by Raphael. The three oil-on-poplar predella panels at the bottom depict Hope, Charity, and Faith.

work had been commissioned and made as an altarpiece but now was recognized as an eminent gallery picture *avant la lettre*, an altarpiece whose true home had, as it were, finally come into being. Even before it was appropri-

5.7 ated by the cardinal, the painting had become a tourist magnet in its church, visited by art pilgrims who had read about it in Giorgio Vasari's *Lives of the Artists* and other texts. Thus Scipione Borghese was only making concrete a development that was already under way on the conceptual level, namely to see the church altarpiece as a work belonging to more abstract formations: the oeuvre of the artist, the history of painting, style, etc.

The new discipline of art history, founded on neoclassical premises, was quick to forget the messy prehistory to its own historical logic. Linear chronology and style history blasted away at the temporal confusions in which earlier installations had lived and thrived. Ensembles composed of works in different media and assembled over time were parsed, their artistic elements physically and virtually removed from their physical and institutional settings and "given" to individual artists. The extracted elements, now seen as works in their own right, were resorted into new ordering systems, such as museums, art-historical monographs, and catalogues. Frescoed elements were catalogued as "paintings," sculpted elements were reconstituted as "sculptures," or as "ornament" and classed accordingly. Photographs of these objects imposed boundaries on them consonant with the new classficatory schemas. The story is by now familiar enough.

All this came under critical scrutiny especially after the 1960s, a methodological reorientation strongly tied to questions raised by the art of the period. In the 1950s, a preoccupation with mural painting and artistic environments, as well as the canonization of the vast canvases of the New York school, brought into focus "The Great Age of Fresco" for students of art history. Then, in the wake of Minimalist sculpture, performance art, environment art, process art and land art, which provoked fierce disputes over the limits and definition of art works and over modes of display and institutional "frames," art historians began in a more systematic way to study works of all periods in relation to their physical and institutional settings. It is now the standard first step for any historian of older art to take the work imaginatively out of the museum, to resituate it in an original physical, institutional, and programmatic context, and to relate it to other works and to historically determined rituals of behavior.

The site-specifists have clearly come out on the winning side of the debate. In David Summers' monumental 2003 book *Real Spaces*, site-specificity functions as the governing premise for a synthetic reappraisal of world art. Even the era of the supposedly autonomous easel picture turns out to have been, in recent assessments, a continual series of reflections on the question of its situatedness and substitutability. Assertions about the autonomy and singularity of painting "since the Renaissance" in fact come from the same period that saw the development of modernism, that is, as one element in a modernist debate about the history of painting and the definition of the art object. It is difficult, now, to imagine that the museum picture could have loomed as such a mighty enemy in the eyes of the avant-gardes. The twentieth-century critiques actually turned their precursors into the powerful institutions they needed them to be.

5.8
Carolee Schneemann, *Up to and Including Her Limits*, 1973–6, performance, live video relay, crayon on paper, rope and harness suspended from ceiling, performed at The Kitchen, New York. The artist described the piece as follows: "My entire body becomes the agency of visual traces, vestige of the body's energy in motion."

THE HISTORY OF THE MUSEUM IS THE HISTORY OF MODERN ART

Is there any real opposition between the "autonomous" museum piece and the site-specific work? Were the boundaries of the gallery picture between Caravaggio and Picasso ever very stable? What if the insistence on site-specificity, a recurrent battle cry of twentieth-century art, were part of the same cultural formation as the museological insistence on artistic autonomy? What if the idea of historical context were as much part of a modern conception of art history as the museological categorizations?

As a point of historical fact, the critique of the museum and the defence of the value of site-specificity did originate with the inception of the museum, as is clear from the writings of Quatremère de Quincy, a nobleman and scholar who wrote a series of public letters in late spring and summer of 1796 protesting the expropriation and exportation of Italian works of art to France. These *Letters on the harm that would be caused to the arts and sciences by the displacement of the monuments of art of Italy, by the dismembering of its schools of art, and by the spoliation of its collections, galleries and museums, etc.* provoked a lively debate over the function of the museum and the nature of art in the immediate aftermath of the founding, in 1793, of the Musée Central des Arts, the original incarnation of the Musée du Louvre. In contrast to Hegel's writings on art, which are the stuff of basic art-historical curricula and have informed much of what is written about modern art, these letters have never even been translated into English. Astonishing premonitions of the modernist and postmodernist critiques of the museum were uttered at the inception of the museum's history, and to read them now is to reenvision the history offered by those critiques. Like all prophecies, these letters force the realization that what was believed to be safely in the past is actually only assuming its true relevance now, and what is happening now actually came to pass a long time ago.

Quatremère wrote these *Letters* just as it was becoming clear that the French campaign in Italy, commanded by the ambitious general Napoleon, was going to be accompanied by the systematic removal of exemplary works

of art in all media and from all periods (although medieval works were of distinctly subordinate interest). Art experts and artists were involved in the campaign, consulting on which works to take. To tear works of art out of their original settings, Quatremère argued, was to cut them off from their sources of meaning. "The museum that will be formed elsewhere from these dismemberments," he wrote, "will not have the whole ensemble and the foundation that would give those fragments their true value." In order to understand art, in order for art to have the beneficial effect it is meant to have, one had to experience it within its original "ensemble," what we might now call its context. The ensemble, for Quatremère, was a complex of several layers: first there was the land, the natural environment out of which the work grew; then there was the institutional framework (the temple or church complex, for example) in which the work was made and which it served; and then there was the art-historical context, the other works of art made in that place and time. When a work of art is taken from its originating context, not only is the original ensemble left mangled, but the work itself falls silent in its new museum location. It loses the capacity to mean. It can no longer deliver what it has to deliver.

Quatremère is, nonetheless, caught up in the logic that he is protesting. He laments the dispersion of the works of Raphael, but his solution, to reunite all the works of the Raphael school in Rome, is a very modern one,

6.1
George Cruikshank, *Seizing the Italian Relics*, satirical print of Napoleon I leading the looting of the French army in Italy, published by Thomas Tegg, 3 Cheapside, London, December 1, 1814, hand-colored etching and aquatint, 5½ × 8⅜ in (14.1 × 21.3 cm)

an artificial and anachronistic enterprise. Raphael spent time in Urbino, Perugia, Florence, and also in Rome; as we saw in the last chapter, one of Raphael's works to be seen in Rome during Quatremère's time and still today had in fact been taken from Perugia in the early seventeenth century. Quatremère was proposing nothing other than a blockbuster Raphael exhibition, a familiar enough idea now but one that was unheard of in 1796. Quatremère's proposal was bound up with the incipient museum culture in which he was writing. His notion of the unity and integrity of the original ensembles of ancient Rome is no less abstract or modern than the idea of admiring a work in aesthetic isolation. He was able to see the negative effects of "*déplacement*" because, as he himself said, Rome had already become a "*véritable muséum*"—a museum of itself. Art history had already begun to do its work of creating virtual unities out of fragments. The recently born science of the archeological study of antiquity, led by the eighteenth-century art historian Johann Joachim Winckelmann, had begun to put a systematic picture together. Winckelmann's inestimable contribution was, in Quatremère's words, to "*décomposer l'Antiquité*," that is, "to analyze the times, the peoples, the schools, the styles, and the nuances of style," and then to move from analysis to synthesis, "to make a body out of what had been until then only a mass of débris." Unfortunately, Winckelmann had accomplished only one one-hundredth of what needed to be done, and now, Quatremère laments, the pieces are being dislocated and dispersed in foreign collections before the scientific project could be completed.

Thus the one, bad development (*déplacement*) is not really in contradiction to the other, good development (creating art-historical unities out of the past). They are both part of the same logic, for once Rome starts to be seen as a "*véritable muséum*" it is only a matter of time before the real logic of museology takes over and effects its disintegrating work of *déplacement*. Even the artists participate in the process, helping to select and transport the works, without realizing that they are contributing to the "*déstruction des arts*" and thus to the end of their own art.

Déplacement is destructive, according to Quatremère, not only due to the physical effort of extraction, often materially destructive, but because to make art portable is to introduce it into an economy of speculation. Not that art works had never been bought and sold before, but now they were moving at something like the rate of commodities and acquiring something of their

status. Works of art were being unmoored from their conditions of production and set adrift on the market. The destruction this brings empties out the very cultural-artistic enterprise that drives the interest in art and culture. This ironic and tragic development is only to be expected, Quatremère says, because when social harmony is overturned (writing in the aftermath of the Terror, Quatremère was eluding a death sentence as he wrote these words) then so are the principles of metaphysical harmony. Artists trained under these conditions will not know to make anything else but works for the market, works with no home from the first, dead works served up to a dying artistic culture. As Quatremère sees it, everyone is speculating on art, but it is speculation feeding on itself, because art no longer has integrity or purpose. The future is, inevitably, a market bubble that will soon burst and produce a great recession of art: "I ask of speculators in the political economy, who is being served by your artists who are fed by this foreign commerce in portable works of art? What benefit will you derive from this exclusive privilege of a commerce without an outlet, and of productions without consumers?"

Social disharmony that produces metaphysical destabilization and capitalist speculation that alienates productions from their makers and consumers: Quatremère seems to have the predicament of modernity pretty clearly in focus. He is asking what happens to art when its role in society is dislocated, that question to which modernism would offer a continuous stream of answers. His anti-capitalist critique comes from the right, but it anticipates with astonishing lucidity points later elaborated by the most influential modernist Marxist critics. His exasperated questions preempt, and can be used to reframe, the later responses to those questions, namely that art could continue under these conditions only by a logic of negativity. Clement Greenberg was to offer one response well over a hundred years later: An art stripped of its inherent social connection and in danger of becoming absorbed into the realm of entertainment must bear down with ever increasing intensiveness on its own area of competence, which is to say, the conditions and limitations of its medium (in painting, the flat surface, the shape of the support, the properties of the pigment, etc.). For Theodor Adorno, autonomy was the curse of art under modernity but also its occasion: Constantly defining themselves against unrelenting processes of reification and co-optation, works of art are uniquely capable of posing critical resistance to the "culture industry."

Opposite
6.2
Andy Warhol,
Brillo Boxes, 1969
(version of 1964
original), acrylic
silkscreen on
wood, each box
20 × 20 × 17 in
(50.8 × 50.8 × 43.2 cm)

Since the 1960s, art has openly surfed the waves of the culture industry. An abject capitulation in the eyes of some, for others it is a continuation of the Adornian project by any means necessary, or by the only means left. In any case, these developments come as fairly direct answers to Quatremère's pointed questions. "Do you believe," he asked, "that a nation that acquires a few pieces of beauty, like so many boxes of merchandise, will really be benefited by this importation?" As if translating it into the bluntest terms, Andy Warhol's *Brillo Boxes* of 1964 put Quatremère's question—art or commodity, what's the difference now?—squarely on the table, or rather on the floor. A slower historical route would pass, first of all, through Marx's *Das Kapital*, where, in a famous passage, the uncanny autonomy of commodities alienated from their conditions of production brings them into the sphere of the fetish. It is not difficult from there to point out that rather than merely becoming a commodity, the deracinated work of art, presented as something autonomous of its social and even historical circumstances, is rather the *prototype* of the commodity-fetish. Under these conditions, the only reasonable task for a work of art is to investigate and expose its status as a commodity-prototype. Quatremère's account of military men ravaging Italy's fertile cultural soil makes it clear enough that the element of gender has never been far from these questions of art and the political economy. Many decades later, Manet's *Olympia* flatly suggested a correlation between the work of art and the woman for sale, a correlation brought home with post-Adornian rigor in Andrea Fraser's 2003 work in which a night with her was sold to a collector for $20,000, a performance that neatly collapsed distinctions between the art work, the offering of the artist's body, and the commercial transaction.

Quatremère depicts the new market in art fetishes as a grotesquely updated relic cult. Pieces by Raphael are frantically collected and displayed in galleries and museums, he writes, "more or less as in former times when every church wanted a piece of the true cross." But, Quatremère continues, the modern art cult is only a perverse adaptation of the former relic cult, which respected a synecdochic logic, a piece of the sacred body or object carrying the virtue of the whole. This logic is misplaced in the art sphere, because a whole artistic school cannot be expressed by each detached bit of the school; one learns the secret of a school of painting not from its masterpieces, Quatremère says, but only from seeing the whole array of

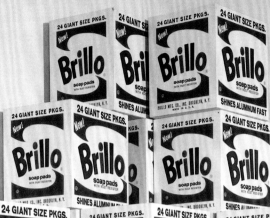

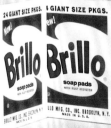
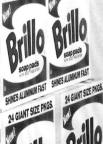
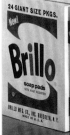
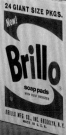

6.3
Damien Hirst,
For the Love of God,
2007, platinum,
diamonds, and
human teeth,
6¾ × 5 × 7½ in
(17.1 × 12.7 × 19.1 cm)

Opposite
6.4
Reliquary bust of
Saint Yrieix,
c. 1200–40, silver
and gilded silver with
rock crystal, gems,
and glass. The skull
of Saint Yrieix, the
sixth-century founder
of a monastery south
of Limoges that still
bears his name, was
once contained in this
reliquary.

openly acknowledged that without the compensatory beauty of the reliquary the relic would be repulsive in its ugliness. Rather than accruing to the object by magical sympathy, a post-hoc validation that this piece of detritus is instinct with otherworldly power, the diamonds and platinum in *For the Love of God* are manifestly there to produce value where there is none. Or rather, they are there to jump-start a spiraling accrual of super-added, metaphysical value, symbolized by its selling for that magic multiple of ten with all the zeroes after it. But this comparison is not just a neat demonstration of the emptying out of spiritual value. The anti-reliquary rebounds on the medieval reliquaries, bringing a long-standing critique back to life. Sixteenth-century Protestants were not the first to be horrified by the spectacle of people worshiping parts of dead bodies encrusted in jewels. In a treatise on relics written in the early twelfth century, Guibert of Nogent wrote: "These things are clearly done by those who, according to the Apostle [1 Tim. 6:5], 'suppose gain to be godliness' and turn those very things which should serve for the salvation of their souls into the excrement of bags of money." The revulsion he expresses cropped up periodically all the way through the Christian relic cult, and it turns out that the same questions come up repeatedly in the midst of the art cult: Why all the expense, why all the competition? Are these things authentic, and how do we know? Who authorizes them? What do we do when we are faced with more than one of the same thing, all claiming to be authentic? And even if the one you revere is authentic, isn't there something compulsive and blind in this worship? Given the amount of fraud and greed at work, how is it possible to be entirely free of uncertainty when participating in any part of the system? And if you are uncertain in your devotion, then what is the point of spending all that money? Is there any way for the basic impulse to covet, collect, and revere these things, which is based in something profound and in any case will never go away, not to devolve into this indictment of ourselves?

PAINTING AS SECOND-ORDER OBSERVATION

In Ilya Kabakov's compressed history of art, discussed briefly in chapter five, art was rendered inert when it devolved into a market object, but it was revived through installation. Installation was not so much counter to painting as a way of returning art to the function served by icons, which was to act as a portal to the universe. Whether or not this is accurate as history, it suggests a principle of interactivity—paintings model worlds, and environments take over the function of images—that does speak to dynamic patterns of medieval figuration. Sacred display environments were highly mutable spaces, and were themselves subject to a recursive pattern: they often enshrined display cases that held miniature reiterations of holy places (paintings, sculptures, micro-architecture) or actual samples of holy things (relics and bodies). The chapels were often themselves presented as models, three-dimensional representations of other chapels or environments located in more sacred places, which is to say that they were presented as great sculptural works that contained other works. In such spaces, the container and the contained undergo constant redefinition in part through mutual "reentry." This is a term developed by the sociologist Niklas Luhmann to describe the process whereby a distinction between inside and outside, defining what belongs to a system and what does not, is itself internalized in a system, as when the boundary between art and non-art becomes a matter for art in the readymade. In the fourteenth and fifteenth centuries, interactive ritual spaces entered into the space of image-making with increasing intensiveness.

Gentile da Fabriano's painting *The Crippled and the Sick Cured at the Tomb of Saint Nicholas* in Washington is an astonishing example of what happens 7.1 when painting takes on the task of representing other media: altarpieces, frescoes, mosaics, tomb sculpture, the church interior itself, as well as the human performances that unfold within these surroundings. Such visualizations both presupposed and facilitated a capacity to see the spaces themselves as aesthetic wholes—as spatial, multimedia art works. It is possible that the very concept of site-specificity did not precede such visualizations but was one of their effects. This small panel was one part of a larger structure, originally belonging to an altarpiece predella, the steplike register at the bottom

7.1
Gentile da Fabriano,
*The Crippled and
the Sick Cured at
the Tomb of Saint
Nicholas*, 1425,
tempera on panel,
14⅜ × 14⅛ in
(36.4 × 35.9 cm)

7.1
Gentile da Fabriano,
*The Crippled and
the Sick Cured at
the Tomb of Saint
Nicholas*, 1425,
tempera on panel,
14⅜ × 14⅛ in
(36.4 × 35.9 cm)

of the structure, usually consisting of several small panels. This panel was one of five predella panels dedicated to stories from the life of Saint Nicholas, and it occupied the final position at the extreme right. The altarpiece was commissioned in 1425 by the Quaratesi family for the high altar of the church of San Niccolò sopr'Arno in Florence; but it was taken apart, probably between 1824 and 1832, and its pieces were dispersed: the central panel of the Madonna and Child is now at Hampton Court, the four tall panels of saints remained in Florence and are now at the Uffizi, and all the predella panels went to the Vatican except for this one, now in Washington, D.C.

Our panel shows pilgrims approaching the tomb of Saint Nicholas, which, according to legend, exuded oil that had a miraculous healing

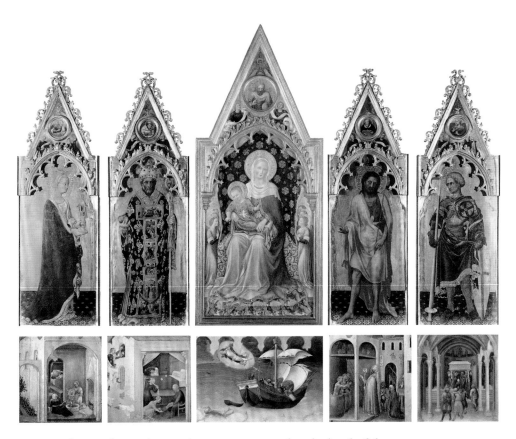

power. The saint's raised sarcophagus is positioned at the head of the nave and is shown within a church space decorated with several interesting works of religious art. On the wall near the apse to the left we see a gold-ground image of the Madonna, and on the other side we see a frescoed Crucifixion. A good example of this rectangular *Maestà* type is the Madonna and child of around 1270 by Coppo di Marcovaldo, a type still easily visible in Florence in Gentile's time. On these side altars we can just glimpse slivers of fairly elaborate polyptych altarpieces of a recognizably fourteenth-century type.

In the main apse there is an image program in yet a third medium, mosaic. A Christ sits in majesty in a mandorla above, flanked by the Virgin and Nicholas with the symbols of the evangelists at their feet; in a register below

7.2
A reconstruction of the altarpiece in San Niccolò sopr'Arno, Florence, by Gentile da Fabriano, c. 1425.

7.4

7.3
Detail of Gentile
da Fabriano's *The
Crippled and the Sick
Cured at the Tomb of
Saint Nicholas*, 1425,
showing the painting
of the Madonna
in the depicted
church's left apse.
The Madonna
panel represented
by Gentile is of a
sort made a little
over a century
earlier than his own
painting. The figures'
drapery carries
gold striations, a
convention that fell
away from Italian
painting after 1300.

are five scenes from the life of Saint Nicholas, the very same ones represented on the five-piece predella to which our panel belonged. The scene corresponding to this one can be clearly made out at the extreme right of the represented apse, in the same position that this panel occupied within its own predella sequence. Looking at the framing of this register of the mosaic, five archways framed by finials, we find that it, too, offers a kind of imagined prototype for the polyptych framework of the whole of Gentile's altarpiece. Beyond offering a résumé of earlier church decoration, this little painting presents us with a prototype for itself—at one level for the predella and at another for the whole altarpiece. This prototype is in a medium, mosaic, which by the fifteenth century had assumed symbolic value as a venerable modality of art.

7.4
Coppo di Marcovaldo,
*Madonna and Child
(Madonna del Bordone)*,
1261, tempera on panel,
88⅝ × 49¼ in
(225 × 125 cm)

Given all the information being offered, the viewer is invited to ask precise questions, primary among them: What place is being shown? The obvious answer is the Basilica di San Nicola at Bari in southern Italy, which holds the body of the saint to this day. In fact, the *Crucifixion* fresco depicted on the right side of our painting, which shows Gentile imitating typical work of the fourteenth century, is not very different from a fresco of the same subject and of roughly that date in the church in Bari—also, as it happens, in the right apse. But there is a catch. The Bari church was built only in a second moment, after the body had been taken from its original site in the town of Myra, a Greek city on the southern coast of Asia Minor (present-day Turkey), where Nicholas had been bishop, and where a shrine containing the saint's body existed from the time of his death in the fourth

7.6

7.5
The church of Saint Nicholas in Myra, in present-day Turkey, bears a remote, possibly fortuitous resemblance to the church depicted by Gentile. We see freestanding columns in the chancel area that once sustained a structure—probably a baldachin like the one built at Bari, but nonetheless a structure that could be imagined to correspond to the raised tomb seen in Gentile's picture.

century. As the area came under Seljuq Turk domination, Latin travelers claiming to be acting as protectors of the saint's remains against the enemies of the faith took the body away to Italy in 1087. The saint's oil-exuding body was already a pilgrimage site during its time at Myra, famous enough to attract the acquisitive Latin visitors. The church at Bari was newly constructed to house the body, which continued to perform miracles of healing in its new location. Not just the body but in some sense the shrine had been transported to Italy; after all, it was always part of the legend that the healing oil was somehow secreted out of the saint's sarcophagus, and thus it was necessary to transfer some part of the housing and not just the body itself. The tomb was thus the architectural germ from which the new, Italian church sprang. The idea of moving some significant material sample of holy sites from east to west, thus scrambling the data of topography itself, was a common one, realized in various ways in medieval architecture.

The earlier church of Saint Nicholas in Myra, now in ruins, also shows similarities to the church painted by Gentile. The possibility of a more distant Myra reference prompts another look at those works of religious art represented by Gentile. On the gold-ground panel on the left, for example,

kind of activity: they approach, they touch, they pray, they give thanks, they depart. One could emphasize the implicit prescriptions here: This is a church environment and there are protocols governing this behavior, even if it is not formally prescribed in ritual. One could take this into a deep sociological account: The later pilgrims before us are engaged in acts of imitation, in some way modeling their behavior on earlier behavior, perhaps even taking their cues from things like the mosaic depiction in the apse. Of course, one could decide that what really matters here is the fact that within a fairly delimited framework the pilgrims show a great deal of variation in their behavior. And then one could simply wave all this away, attributing any resemblance to the artistic mediation; all that we see here is, after all, the handiwork of one artist.

The main point is that the painting before us is more than a rendition of the scene in the mosaic apse. It offers a kind of document of routines of imitation occurring in the world, including the world of art-making. Art works model themselves on earlier art works, and pilgrims model themselves on earlier pilgrims. This painting shows us these processes at work and even interactions between the two processes. The painting thus offers what Niklas Luhmann would call "a second order observation." It is a fairly abstract commentary on how behavior and beliefs take shape in communities. For this to occur, there has to be a means, call it an author function, by which the maker of such a commentary can take up position as an observer of the observation. It is a quasi-anthropological painting.

There is no way to know which slice of this history of transfers and imitations is being put on view here. This could be a moment of the Myra history, in which case we see the original church decorated with a mosaic program that already records a cult history at the site, a sanctuary that is now receiving increasing pilgrim traffic before our eyes. Or it could be a slice of Bari time. In that case, the mosaic would be offering scenes that had possibly occurred in earlier and distant Myra, but now presented in a church in Italy where the cult continues. One assumes, in that case, that not just the body but also its immediate packaging, the sarcophagus, was relocated to its new location. We would have the sarcophagus in its new location overlapping a scene of the same sarcophagus in its old location. Or, the painting could be floating between two sites, somehow showing us the Myra space now filled by the new Italian pilgrims. Nothing prevents a painting from engaging in such

impossibilities. And not only painting. Liturgical drama of the period regularly produced just such mergings: The part of the church transformed into a setting for a biblical story or a saintly miracle melds, at some point in the nave, back into the "local" church space. It is ultimately impossible to know which of the three possible spatio-temporal scenarios this painting shows. In any case, the painting puts on display those processes by which commemoration, imitation, and transfer occur across time and space.

What Gentile's contemporary viewers would have known is that the scene belongs to a past time, even if it was unclear how far in the past it was. It is clear from the somewhat antiquated dress of the figures (antiquated for Gentile) that Gentile is not representing pilgrims from his own time. The scene unfolds on the far side of a certain temporal threshold, a threshold beyond which different times mingle. The logic of the entire scene is designed to celebrate an earlier time of direct contact, when pilgrims approached a freely accessible cult object. The various images put on view here—altarpieces, frescoes, mosaics—cannot hold a candle to that source of power that is more present than any image: the saint's body, exuding oil through an aperture in the sarcophagus. The pilgrims approach a shrine that is free of obstruction, an experience that was in fact fairly foreign to worshipers of Gentile da Fabriano's day, when ordinary lay people were kept far from the chancel area, and would typically listen to mass from outside a massive choir enclosure that allowed limited if any visual access to the high altar. This fact of daily life in fifteenth-century Europe is now difficult to appreciate, as most of these barriers and enclosures were torn down during the church reforms of the sixteenth and seventeenth centuries. We see a rendering of one such screen, the one in the Venetian church of Sant'Antonio di Castello, in Vittore Carpaccio's *Vision of Prior Ottobon* of c. 1515. The structure cutting across the nave is so massive that it carries altars and chapels within it. (Like Gentile, Carpaccio takes the opportunity to visualize a bit of the history of art here, depicting an antiquated Romanesque-style wooden Madonna sculpture in one of these choir-screen chapels, as well as a résumé of the history of the altarpiece along the nave.) As it happens, the church of San Niccolò sopr'Arno in Florence, where Gentile's altarpiece stood, had a fairly substantial screen, large enough to house altars and chapels. One of its altars carried an *Annunciation* altarpiece by Masolino (now also, as it happens, in the National Gallery of Art in Washington, D.C.). The screen was removed

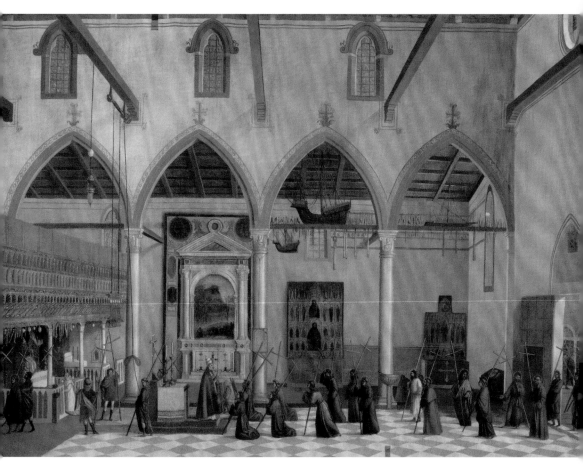

in the middle of the sixteenth century by Vasari, who undertook similar clearing campaigns in several Florentine churches. Gentile's painting projects an environment located at some point in the past, before such structures were a normal fact of church interiors.

This difference between now and then, inscribed into the picture, would have been obvious to a viewer of Gentile da Fabriano's time but is easy for later viewers to miss. The painting offered its contemporary viewers a world where art and cult cohere, a world that belongs by pictorial definition to a time separated from the time of this painting, the one we are looking at, which has lost the gold ground and (thus) developed the pictorial

7.9
Vittore Carpaccio,
*Vision of Prior
Ottobon*, c. 1515,
oil on canvas,
48⅜ × 69⅞ in
(123 × 177.5 cm)

means to make this elaborate depiction of a cult environment available to its viewers, in the process turning its viewers into second-order observers. It is as if the new potential for virtual access offered by the new mode of painting compensates for what has been lost in terms of physical access. But, paradoxically, Gentile's intricate panel, with its subtle reentries, would not have been visible to most of the parishioners of its church. It offered a scene of earlier cult practices where the underprivileged have free access to the miracle-working body of the saint, but now under conditions where only the privileged would have had access to the painting.

This pictorial projection no longer belongs to the same order of object as the gold-ground altarpiece, wall fresco, and mosaic it depicts, just as a photograph belongs to a different order than the salon painting that it would soon dethrone (or so it was believed in the nineteenth century). Of course, it is possible, and illuminating, to see a line of development from painting to photography, to emphasize all the ways in which one informed the other. The line here, from the apse mosaic or the altarpiece to the painting that depicts it, is arguably even stronger. After all, this panel once belonged to the predella of an altarpiece. They are all religious paintings, made for a church. And yet it is also clear that a gulf separates the one from the others and that the gulf is itself a sub-theme of this retrospective picture. The picture's ability to "reenter" that difference into its thematics is part of what makes the difference.

This is the moment that saw the appearance of cabinet pictures not very different from this predella panel. (A few years later, Mantegna made his *Agony in the Garden* now in London, an independent picture but very close in scale and format to the picture of the same subject now in the city of Tours, which was once a predella panel.) Cabinet pictures, made for domestic settings or for scholars' studies, were commissioned by individuals who delighted in the capacity of painting to customize such public environments and stories to individual viewers, and thus make them available for reflection and commentary of a new kind. It is not difficult to imagine a viewership for this picture that was able to discern a historical puzzle here and take pleasure in teasing out the various temporal clues it offers, warming to a discussion of the customs and beliefs of common pilgrims, and welcoming an opportunity to pronounce on the relative merits of artistic techniques, and thus the artistic achievements, of past and present.

Paintings like this brought to a new level a development already at work in the design and outfitting of chapels and churches themselves: a perception of these environments as integral wholes, as multi-part, temporally open works of art. Of course, some sense of integrity was usually built into chapels from their foundation, but this was above all a programmatic integrity. Chapels and churches were meant to honor the patron saint or theological mystery to which they were dedicated. In the later Middle Ages, they increasingly registered elements that were designed to commemorate and to serve the spiritual interests of a donor and the donor's family. These so-called private chapels were, among other things, concerted essays in the integrated design of multimedia ensembles, the role of a quasi author being taken up by the family representative to whom it fell to commission new works and reorganize the existing elements in the chapel. It was a subtle but significant shift from this kind of integrity to one of perception, an ability to see these spaces as experiential ensembles. Gentile's picture imagines a whole church space as if it were a kind of dynamic, multi-articulated work of art, a composite made up of mosaics, frescoes, panel paintings, and the non-figurative but body-containing central tomb. Between the dead but still pulsing body and all the figurations, the pilgrims function as the motors of a work whose true media are space and time.

Enabled by prior developments in the configuration of sacred environments, works like Gentile's in turn accelerated and facilitated the ability to see real environments in these terms. Another way to put this is to say that there was no single historical succession from lived "medieval" environments to distanced "Renaissance" pictorial visualization. The idea that there once had been spaces characterized by integrated, kinaesthetic experiences came into conceptual focus as an effect of the pictorial visualizations.

THE DEBATE OVER IDOLATRY PERSISTS

Things did not simply settle down with the ascendancy of easel painting in the sixteenth century. The re-three-dimensionalization of pictorial ideas became a theme of Baroque art, a reassertion of sacred site-specificity in the era that saw the institutionalization of picture galleries and an art market that traded in mobile works. Even earlier, however, the alternation between painting and sculpture had been rife. In the 1420s and 1430s, painting achieved a new status as a result of the works of Robert Campin, Jan van Eyck, Gentile da Fabriano, and Masaccio, among others. Already in the 1440s, Donatello was retranslating pictorial conceptions into sculpture, and his inventions (in particular his altar at the church of Sant'Antonio in Padua) were soon translated back into painting by Mantegna and others. From the 1480s, Leonardo da Vinci was formulating powerful arguments for the superiority of painting, and producing work that was to exert an incalculable influence on the presiding geniuses of the next generation, in particular Giorgione and Raphael. By 1500, the sculptors knew that no one with any understanding of artistic matters would any longer reflexively regard painting as the cheap alternative to work in wood, stone, and metal. In the first two decades of the sixteenth century, sculpture, especially in Italy, staged a revanche in the form of an aggressive, highly conscious revival of antique statuary in the round, in bronze and marble.

One of the most signal "post-pictorial reactions" was Michelangelo's Medici Chapel of 1519–34, also known as the New Sacristy. Like its predecessor and counterpart on the other side of the church, the earlier sacristy by Brunelleschi of the 1420s, it is composed of a large square space and a smaller but proportional chancel in which the altar is placed. In the earlier chapel, however, the altar faces into the chancel and away from the larger space of the chapel. Any small assembly that gathered here would be looking at the priest's back as he celebrated mass. In Michelangelo's chapel this relation is exactly reversed. The altar in the chancel is turned 180 degrees and the priest celebrates mass looking into the chapel. With all the doors closed, the space was a sacred capsule, sealed away from the outside world. It was intended to be inhabited by the officiant, who celebrated mass there three times a day

8.1
Michelangelo, Medici
Chapel (also known
as the New Sacristy),
San Lorenzo, Florence,
1519–34

8.2
Filippo Brunelleschi,
Old Sacristy, San
Lorenzo, Florence,
1420s

8.3
Ground plan of
Michelangelo's Medici
Chapel, San Lorenzo,
Florence

8.5 and 8.6 in the presence of the Medici tombs. There is no room for a congregation here and no purpose for one in a chamber dedicated exclusively to masses for the dead buried there. The entire chapel, in other words, unfolds on the "sacred" side of the altar, as if the uninhabitable spatial illusion of painted altarpieces (which often did depict churchlike environments) were now again projected into three dimensions. There are many examples of painted architecture one could point to but the best, because it is the foundational 5.5 one and a work Michelangelo knew well, is Masaccio's *Trinity*, illustrated in chapter five, a work so architectural in conception that Masaccio recruited the collaboration of the architect Brunelleschi in designing it. (In fact, Masaccio's fresco was retranslated into three dimensions already in 1451 by a pupil of Brunelleschi, in the Cardini Chapel in the church of San Francesco in Pescia.) In any case, the result of the peculiar conception of Michelangelo's Medici Chapel is a space that behaves unlike normal space, unlike, even, traditional chapel spaces—in part because this chapel is at least at one level a spatialization of a pictorial conception.

There is a larger architectural framework formed by the dark pietra serena members. This framework is in a relatively traditional architectural language, but embedded in it is another kind of architecture, a more sculptural version that is in fact carved out of statue-quality Carrara marble. This

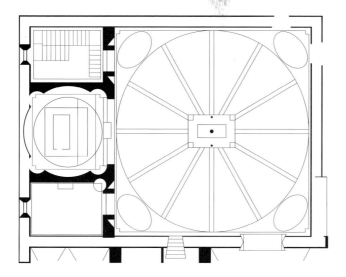

8.4
Ground plan of
Brunelleschi's Old
Sacristy San Lorenzo,
Florence

internal architecture speaks a much more unconventional language and in general behaves in a more "plastic" way. It protrudes between the pietra serena membering, projecting out of the wall into the chapel space. It is almost as if we are seeing the short end of unfathomably deep tomb monuments, pushing into the chapel. The effect would have been even stronger if the double tomb on the wall across from the altar had been completed. The side tombs, originally designed to spill even further into the chapel space, are also incomplete: river gods were planned, which would have lain on the very floor of the chapel. It is a highly dynamic conception, as if in the absence of human occupants the architecture and sculpture take on new life. If one looks at the two side walls, with the more nearly completed tombs, it is impossible to establish where the plane of the wall stands. There is no neutral wall surface "against" which the tombs and the decoration have been placed. Even the floor of the chapel is not a simple "floor." It is not level with the rest of the church. One steps *down* into the chapel through the doors. The door frames surround the opening on all four sides, including the bottom. This emphasizes the effect of hermetic enclosure, of having entered a capsule where the normal spatial rules do not apply.

As I have described it, the entire chapel unfolds on the sacred side of the altar like a three-dimensionalized altarpiece. I do not mean this in a literal

Following pages
left
8.5
Michelangelo,
Tomb of Giuliano
de' Medici, 1524–34.
Marble, height
of central figure
5 ft 11 in (181 cm).
New Sacristy, San
Lorenzo, Florence

right
8.6
Michelangelo,
Tomb of Lorenzo
de' Medici, 1521–34.
Marble, height
of central figure
5 ft 10 in (178 cm).
New Sacristy, San
Lorenzo, Florence

87

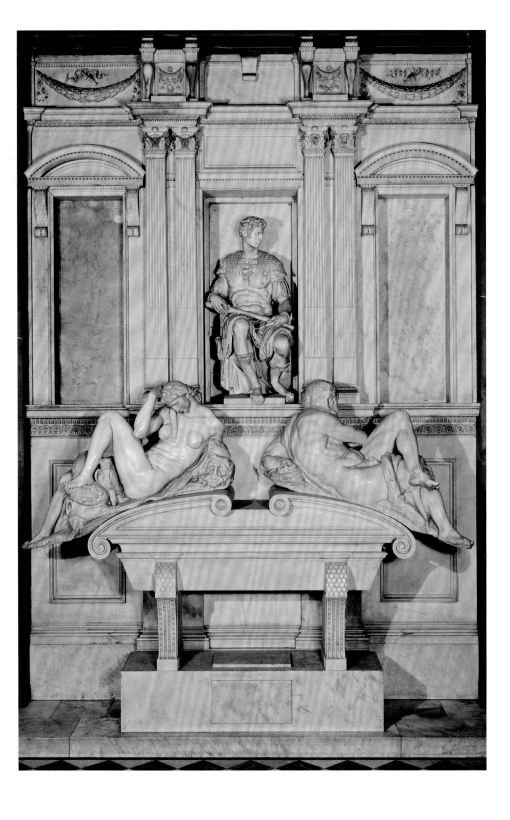

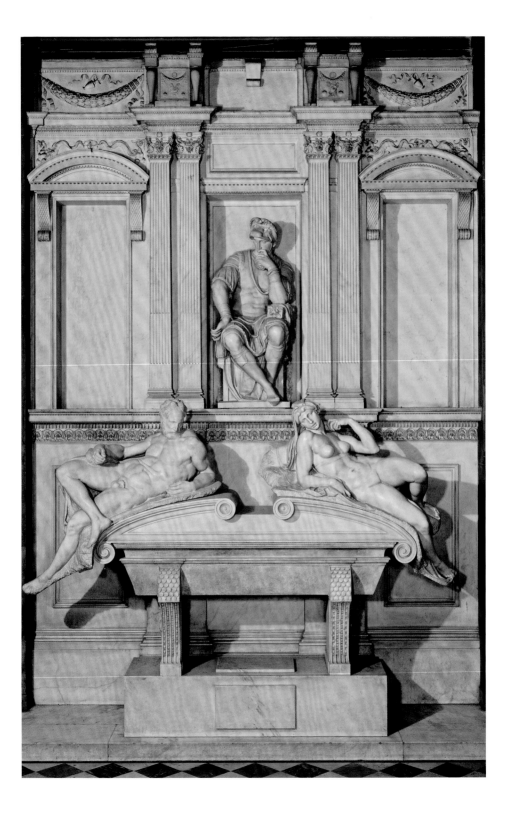

sense, only in the sense that the space of the chapel is not understood as real space but as transfigured space, something like the space of painting, a "figural" space in which all the elements work together and depend on each other. Even the architectural members participate in the figurative work. The river gods were to rest directly on the chapel floor because even the floor is not neutral ground. All the elements of the space have been taken up into the work. The effect is not very far from that of certain installations of the 1960s, later called Minimalist. At Dan Flavin's 1964 Green Gallery show, the first exhibition of his that consisted exclusively of works made out of fluorescent light bulbs, the pieces were individually titled but the installation was newly important, even constitutive. The pieces conspicuously raised the question of the definition and limits of the work of art, not just because of the authorship-dispersing readymade element but because of the very use of light, light passing through glass, "a buoyant and insistent gaseous image," in Flavin's words, "which, through brilliance, betrayed its physical presence into approximate invisibility." Out of respect for this aspect of the work (it was a show of singular works with individual titles, and yet it was also clearly an installation, with a sort of processional pathway), the curators of the Flavin retrospective of 2004, organized by the Dia Art Foundation and the National Gallery of Art in Washington, D.C., chose to remain true to the original physical circumstances of the installation, scrupulously reconstructing the Green Gallery show in its original dimensions and layout. When Robert Morris's inarticulate beams hit the gallery floor in his L-beam installation of 1965, they activated the space. The work makes claims on the viewer's space, including and incorporating the viewer into its workings. The viewer is placed in the strange position at once of being in the world, inhabiting "normal" space, and yet finding him- or herself involved in a work of art.

On one level this comparison is obviously ludicrous. One space involves a complex figural program, while in the others we have an obvious adaptation or even outright repetition of simple shapes. The L-blocks are the same form in different positions, and surface interest and internal intricacy have been all but obliterated. In the chapel, architecture is integral to the conception, yet in the gallery all that is required is that the blocks be installed in a suitably sized space. (As Donald Judd said about an earlier 1964 Morris installation at the Green Gallery: "The occupancy of space, the access to or denial of it, is very

9.6
The rotunda of the
church of the Holy
Sepulcher, Bologna,
Italy, twelfth century,
one of a number of
existing Romanesque
copies of the original
Holy Sepulcher in
Jerusalem

9.6
The rotunda of the
church of the Holy
Sepulcher, Bologna,
Italy, twelfth century,
one of a number of
existing Romanesque
copies of the original
Holy Sepulcher in
Jerusalem

as it is in Jerusalem. As Richard Krautheimer showed in a classic study, identity was established not formally but structurally, or even notationally—through numerical and typological correlation, for example, or through the sheer act of dedicatory naming.

If in the early period the holy sites were largely unmarked and thus difficult to recognize, after Constantine they were increasingly denatured through art, and so in another sense became difficult to recognize, a situation familiar enough today. Encountering first the church and the chapel, it is often difficult to imagine the original site—the desolate hill on which the cross stood, the cave in which Christ was buried, even assuming they are correctly identified—before there was commemorative architecture built on it. One cannot gain access to the historical facts of the time of Christ except through a web of reconfigurations that recruit the real sites and events of Christian history into an elaborate theological and ecclesiological framework.

9.7
The Holy Sepulcher in Bologna was just one element in a sprawling complex of buildings dedicated to Santo Stefano that was designed as a topographical replica of the holy sites of Jerusalem. Buildings in the complex re-created the site of the Crucifixion, linked to the Holy Sepulcher by a courtyard, as it was in Jerusalem at that time, as well as the Mount of Olives and the Church of the Ascension; there was also a Valley of Josephat, a Pool of Siloam, and a Field of Aceldama.

But these grand buildings are not mere institutional overlay; the logic of their construction and maintenance is that they come as the fulfillment of the meaning of those sites. The very fact that these sites have accrued these extraordinary buildings and celebratory image programs comes as visible proof, for Christians, that they had in fact never been ordinary sites and events, that the event that occurred there had never been a mere historical episode. The historical register is, it turns out, always caught up in a supra-historical framework, a divine plan that gives it meaning, and the buildings

9.8
Calvary Chapel,
church of the Holy
Sepulcher, Jerusalem

commemorating (and covering) the site give that meaning concrete form. Christ's crucifixion occurred, according to legend, on the exact site where Adam, the first man, was buried; topographical superimposition concretizes the eschatological succession by which Christ redeems Adam's sin. The Calvary portion of the Holy Sepulcher complex in Jerusalem "reveals" this relation with the clarity of an archeological exhibit: We see a two-tier chapel arrangement, the Calvary Chapel directly above the Adam Chapel. We see the rock that connects them. We see Adam's tomb cut out of the same rock that held the cross.

To return to Rome, or rather Jerusalem in Rome, by the later Middle Ages, the fourth-century Jerusalem Chapel was well below the level of

9.9
Adam Chapel,
church of the Holy
Sepulcher, Jerusalem,
which lies directly
beneath the Calvary
Chapel and houses
the tomb of Adam

the contemporary church, only reinforcing the effect of its encapsulating an "elsewhere." The ramp leading down to it descends and the walls along it are not regular but undulate and widen as one approaches the chapel. Entering the passage, one leaves behind the regular, measurable space of the church, a space of symmetries and regular intervals, and enters a different space, a malleable space that reveals itself as one makes one's way through it. It is an excellent illustration of the difference between "striated" and "smooth" space as described by Gilles Deleuze and Félix Guattari. Smooth space is a haptic rather than optical experience, a space of experienced variation through continuity, tracked at close range, in contrast to the visually modeled and plotted distances of striated space. The church space is made available to the eyes as an integrated visual experience, while this undulating corridor, darkening as it descends, is a space of emergences and singularities, or what Deleuze and Guattari would call intensities and events. The coordinates of the Roman reality outside and above ground fall away as one is drawn down the passage into the "substitution chamber," where the soil of Calvary and the wood of the cross and other relics provided material traction on the sites and events of Jerusalem and the history of Christ's torture and murder. Let us explore a little further the question of the transported earth in the Jerusalem Chapel. It is an unusual relic in that it is "formless," with no delimitations except the physical boundaries of the new site in which it has been installed. It is a literal application of the logic of transplantation that governs the entire chapel. Though this chapel is in many ways unusual, it is unusual only in the rigor and intensiveness with which it diagrams and applies this logic.

Every Christian church was an image of the heavenly Jerusalem, and at the same time usually a less orderly, irregular envelope encompassing a long history of efforts to shape sacred space. Space inside the church was designed and expected to function differently from the world outside its perimeter. It is an associative space, or rather a conglomeration of associative spaces, designed to produce reconfigurations of temporal and spatial logic, an effect that achieved special intensity in chapels that held site-specific power or that were endowed with special relics. These hotspots sometimes coincided with the church's officially administered high altar, but often they did not, a cause of periodic annoyance to church authorities who preached that the most important time- and space-collapsing event of all was the rite

of the mass, a daily "application" of the eschatological significance of the sacrificial passion of Christ conducted according to sanctioned ritual forms. After 1517, waves of reformers throughout Europe purged churches of the riot of images and cult objects that had come to fill them; especially after the **9.11** Council of Trent concluded in 1563, the Catholic Church also engaged in clean-up campaigns, reordering churches and refocusing them on the high altar. All were efforts to neutralize the irregular, multiple, pulsing space of the pre-Reformation church. Existing churches give us very little actual sense of that pre-Reformation world; only visualizations such as those of Carpaccio and Gentile da Fabriano (see chapter seven) can help us to imagine it, but of course even they are fictions designed to their own purposes.

9.11
A hand-colored copy,
made in 1605 by
Heinrich Thomann,
of an illustration from
Heinrich Bullinger's
Reformationschronik
of 1564, showing the
destruction of Church
idols by iconoclasts in
Zurich in 1524

The Jerusalem Chapel is a very good example of the sort of intensified spatio-temporal configuration that could be found in pre-Reformation sacred environments, although it, too, has been cleaned up quite a bit. Due to its especially powerful ongoing mirroring relationship with the church of the Holy Sepulcher in Jerusalem, it laid out the logic of "reinstallation" with exceptional clarity. The fact that it was originally a space of exhibition was an important aspect of its function; in this sense, it can be seen as a proto-formation of modern galleries and museums. Visitors, pilgrims, went to it primarily to see very important relics: the pieces of the cross, the thorns, the nails, after 1492 the Titulus of the Cross with the designation "Jesus of Nazareth King of the Jews" in the three languages of Hebrew, Greek, and Latin. These objects were truly on show. But of course it was more than an exhibition space. What kind of space was it?

As we have seen, it was a space constituted as different in kind from ordinary, quotidian space, different, even, from the rest of the church space. It was a capsule that was "off the grid," or at least in an oblique relationship to the topographical grid. In this chapel, one gazed upon the cross while treading on the soil of Calvary, which was a relic like the other relics housed here but also a different order of relic—a sub-relic. The soil is not an object, nor even properly speaking a piece of an object. There is no whole, like a body or the cross, of which it is a part. It is rather a portion of a non-whole,

9.12
Engraving of the relics
from the Passion held
at the church of Santa
Croce in Gerusalemme,
Rome, including the
Titulus of the Cross
(*top*), a nail and three
fragments of the True
Cross, two thorns from
the crown worn by
Jesus, and the bone
of an index finger said
to be the one Saint
Thomas placed in the
wounds of the Risen
Christ (*bottom from left
to right*)

a sample of material in a "preorganized" state, an extension of infinitesimal matter here enclosed within an artificially bounded square room. It is pure matter before it has been organized into separate bodies, mud before it becomes material for the building, clay before it has achieved form. It is material in the "atomic" state, a state in which everything is still connected

to everything. In its self-similarity, it is in the purest synecdoche condition, all parts that are indistinct from the rest that makes up the whole.

One must ask, why were the object-relics—the thorns, the wood, etc.—not sufficient? Why was it felt necessary to capture and install "earth from Calvary" as one of the relics here? This is a structural-logical question, separate from any questions one might have about whether this earth actually comes from Calvary, or was in fact brought to Rome by Helena. At a pragmatic level, it is here primarily as the formless vehicle for a precious (and formless) holy substance, the blood that issued from Christ's body, infusing the earth on Mount Calvary. The relic of Christ's blood was especially important because of the general absence of earthly relics of Christ's body, which according to doctrine had been resurrected whole and in the flesh on Easter Sunday. The only relic of Christ's body (with the possible exception of his umbilical cord, or his foreskin removed at the Circumcision) was the blood that flowed copiously in his Passion. The evangelists and above all Saint Paul celebrated the blood as the source of redemption. Fifteenth-century theologians argued that this blood remained united to the Word, and therefore enjoyed the potential to prompt miracles.

The only way to capture the blood that had soaked the area at the foot of the cross was to take a generous sample of that earth. The soil is a contact relic, therefore, but it is also a container—an atomized container adapted to its fluid contents. The earth at the foot of the cross was literally consecrated by Christ's blood. It is a contact relic that is unusually intimately bound up with the source relic, a container impregnated by what it contains. Of course, any believer knew that not just this patch of earth but the whole Earth had been consecrated, redeemed by Christ's sacrifice. The fact that this sample of earth is part of an unbounded extension, the fact that one can only guess which parts were soaked with blood and which parts remained as before, the fact that one must impose boundaries on it artificially—we will take this many square cubits of dirt, transport it by ship, and then lay it into the chapel in Rome—all these facts only confirm this larger point. It is a piece of displaced territory, removed to a new location in order to claim at one and the same time that geographical sites are distant and they are not; that topography matters and it does not.

With the relics removed to another part of the church the effect of the chapel is now all but lost. It had already been weakened in the seventeenth

9.13
Lippo Memmi,
Crucifixion, c. 1330–40
tempera on wood panel,
gold ground, 37 × 17¼
in (94 × 44 cm). The
soldier Longinus has
opened Christ's side,
which spouts a torrent
of blood. The blood
instantly converts the
torturer, who puts
his finger to his eyes,
indicating new vision.
The blood also travels
down the cross,
irrigating the earth and
christening the skull of
Adam at the cross's
foot. The sin of Adam
has been washed in
the blood of Christ,
completing one stage
in the cycle of
redemption.

Opposite
9.14
Antique statue of a
female figure adapted
in the eighteenth
century as Saint Helena
carrying the True Cross,
church of Santa Croce
in Gerusalemme,
Rome. The mosaic
work above is of the
early sixteenth century,
and is usually attributed
to Baldassare Peruzzi.
It replaces a mosaic
program of the fifth
century.

and eighteenth centuries by the decorations added to the chapel. In the early seventeenth century, the chapel received three paintings by Rubens that narrated history, as it were, from a distance. Two side panels represented the *Raising of the Cross* and the *Crowning with Thorns* and an altar panel showed Helena carrying the True Cross. Produced amidst the reinvigorated saint cult of Counter-Reformation Rome, these paintings (now in the town of Grasse in Provence) moved the focus of the chapel away from a "shiftable" Calvary and toward a commemoration of the chapel's patron saint, Helena. The chapel was now less a spatio-temporal conundrum than an ancient Roman foundation whose founder is honored among the ranks of saints. After that, in the eighteenth century, as if to concretize the historicizing logic, Rubens's altarpiece was replaced by an ancient Roman statue of a female figure adapted as a portrait of Helena. In this adaptation, the chapel was reinterpreted "archeologically" as an ancient Roman site, according to then-reigning neoclassical principles. The focus was now on the antiquity of the chapel itself and its roots in Rome; the element of spatio-temporal transport to Jerusalem was subordinated. The removal of the relics from the chapel to a newly erected chapel in 1930 was only the final step in the dissolving of the "substitution-chamber" function of the space. The idea of geographical and chronological instability was, nonetheless, reactivated in other spheres of twentieth-century artistic practice, as we shall now see.

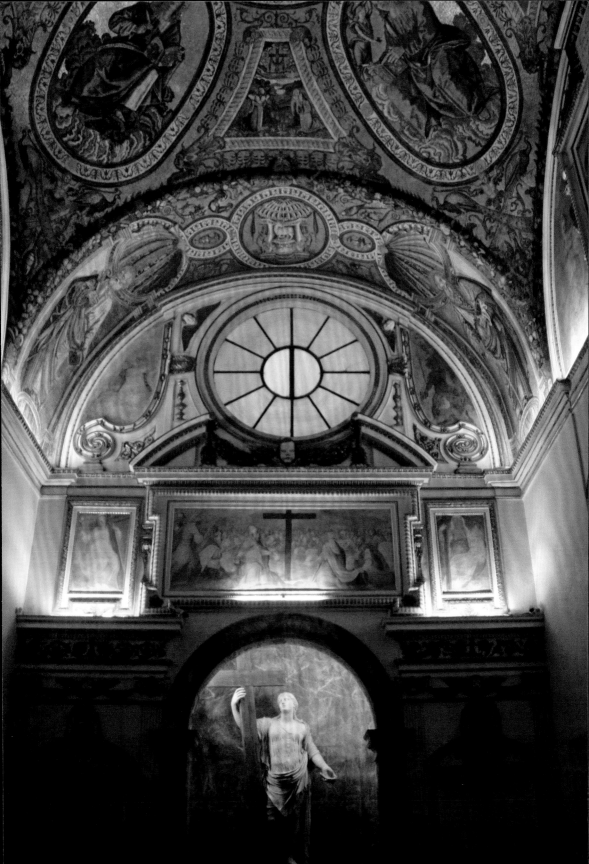

NON-SITE-SPECIFICITY

On June 14, 1968, Robert Smithson, together with the artists Nancy Holt and Michael Heizer, took a trip to Franklin, New Jersey, to collect mineral deposits and bring them back to New York City, where Smithson would display them in bins in the now-famous "Earthworks" show at the Dwan Gallery in October 1968. The installation (now reinstalled in the Chicago Museum of Contemporary Art) involves bins occupying the space of the gallery and, on the walls, visual documentation of the site in the form of aerial photographs. In other "*Non-sites*" Smithson exhibited maps pinpointing the exact locations from which the minerals were drawn.

"If one visits the site," Smithson wrote, "he will see nothing resembling a 'pure object.'" It is matter that has been scattered, as he puts it, in heaps, lava flows, ash pits, etc. by unknown agents. It is a pure example of non-art: undifferentiated, random, self-similar. The delimited *Non-site*, putting the samples into bins, brings the entropic site into artificial focus, and yet neither one stands independent of the other: the *Non-site* is determined but displaced, whereas the so-called real site is undifferentiated but now designated and determined by the portion of earth that it has lost to the *Non-site*. As Smithson put it in an unpublished note from 1968, "both sides are present and absent at the same time." The *Non-site* bin is "a three dimensional logical picture that is abstract, yet it represents an actual site in N.J. (The Pine Barrens Plains)." "Logical pictures" can be of either two or three dimensions:

By drawing a diagram, a ground plan of a house, a street plan to the location of a site, or a topographical map, one draws a "logical two dimensional picture." A "logical picture" differs from a natural or realistic picture in that it rarely looks like the thing it stands for. It is a two dimensional analogy or metaphor—A is Z.

Acute readers will note a Wittgensteinian flavor in these formulations. In the *Tractatus Logico-Philosophicus*, we learn that propositions are logical pictures of reality. Every picture is a logical picture in that it has something in common with what it pictures in order to be capable of representing it at all. This common property is "logical form." Pictures have the same logical form as what they represent, even if they differ from what they represent in many ways. Smithson owned G. E. M. Anscombe's *Introduction*

In this container the stones are displaced, but their real connection to their sites is proclaimed by a system of inscriptions and pictures. We thus have one site existing in two different locations. Smithson described this effect of topographical destabilization in terms of metaphor:

Between the *actual site* in the Pine Barrens and *The Non-Site* itself exists a space of metaphoric significance. It could be that "travel" in this space is a vast metaphor.... Let us say that one goes on a fictitious trip, if one decides to go to the site of the *Non-Site*. The "trip" becomes invented, devised, artificial; therefore, one might call it a non-trip to a site from a Non-site.

He really meant it when he said it was metaphorical. This comes through in a questionnaire that he filled out on the occasion of a showing of one of his *Non-sites* in the summer of 1968 at the Milwaukee Art Center. It was a large group show called "Options," which the director, Tracy Atkinson, had originally intended to call "Participatory Art." The poster for the exhibition and the cover of the catalogue, which contain phrases such as "Pull me," "Play me," "Squeeze me," broadcast a new art that actively involved the viewer. Because the interactivity was considered new and possibly a source of controversy, the Art Center distributed a questionnaire that asked each artist two questions designed to ensure the artists' compliance with the implications of the show. The first (rather awkwardly phrased) question asks, "Does your work relate to a participatory physical contact with the spectator, rather than a purely visual one?" Smithson's pithy reply was: "No." In fact, he was not inviting a physical engagement on the part of the viewer. He was not interested in an actualized bodily performance in the space of the art gallery. Visitors were not meant to pick up the stones from the bins. The viewer here is really a viewer who inspects the bins and then studies the maps to understand the relationship between these samples and the place where the samples come from, which as it happens is quite far removed from Milwaukee. In other words, the event, if there is one, does not happen in an immediate and "fulfilled" relation to the work in the exhibition. Instead, the bin filled with rocks and its pictographic framework are understood as relays, sending the gallery visitor to another place. Participation occurs "elsewhere."

Smithson then had to respond carefully to the next question, which is also framed in the terms of the prevailing discourse of participatory art. "Do you willingly, and to what extent, provide various options in arrangement

and usage of the work by the spectator?" His mocking but also serious answer was:

There is a distance between the site and the Non-Site. This distance is established by where the Non-site is installed. If a spectator in Milwaukee wants to "participate", he will have to travel to the original site in New Jersey. (A map is provided for such an occasion.) The "option" is what could be called "anti-travel."

Clearly the questionnaire was not well suited to Smithson's work. The with-it participatory rhetoric notwithstanding, the exhibition organizers at the Milwaukee Art Center were still working within a quite traditional conception of the work of art as something that takes place in the gallery. The "Options" show still imagined that the work of art was something here and now—it was just a bit more interactive. But works made according to that conception are just a degree or two more interactive than a Rembrandt portrait, which after all also demands the participation of its viewer.

In the *Non-sites*, the work of art is instead an occasion for displacement— a displacement of the art work, which is both here and elsewhere, and a displacement of the viewer, who is here but confronted with an elsewhere, and with the fact that implied travel (or fictitious travel or, as Smithson also called it, anti-travel) to that other place is built into the work. Smithson was asking viewers to confront the urgent question posed by the comic troupe The Firesign Theatre in the title of their 1969 record (owned by Smithson): *How can you be in two places at once when you're not anywhere at all?* For Smithson, the art gallery was quintessentially "not anywhere at all." And rather than try to make it a somewhere, a place where art happens, he exploited the strangely extraterritorial status of the gallery space as an occasion. In the *Non-site*, the gallery space becomes a place for thinking about displacement. The art work happens in the anti-travel between a "here" that is present but somehow unreal, displaced, and a "there" that exists in undifferentiated form but is now constituted as a target by the samples and indications offered in this strange, displaced "here."

In an interview with Tony Robbin conducted in 1968, he explained the logic as follows:

I'm interested in expanding the limits beyond the interior of a room so that one can experi- ence a greater scale in terms of a work of art.... As I say our usual idea of looking at art as an object in a room without any kind of other references seems to be a product of reductive

10.3
A late-nineteenth-
century photograph of
the Camposanto, Pisa

formalism, which just gives you one object. My method operates more in a dualistic frame of reference that gives rise to an infinite number of possibilities. It sort of bifurcates, so that the work of art doesn't exist merely as one object.... The site and the *Non-site* become like interactive reflections.

This expansion and multiplication, these "interactive reflections," resonate strongly with medieval modalities for thinking about art as both site-specific and not, as both of its time and not. The Jerusalem Chapel in Rome, discussed in the previous chapter, is a *Non-site*, a logical picture of Jerusalem containing samples from that place. In many ways this chapel is unusual and special, but its modalities conform to a larger logical pattern that applies to much of the "Christian diaspora" of the Middle Ages. In the twelfth century, Archbishop Ubaldo Lanfranchi brought several shiploads of earth from the site of the Crucifixion to Pisa. The newly laid-in soil was used as a cemetery for illustrious Pisan citizens up to 1779 and was decorated with frescoes in the fourteenth and fifteenth centuries. It was called the Camposanto, the Holy Field, because it is in fact a piece of Jerusalem in Pisa, a *Non-site*. A *Non-site* is split, and here, as in Smithson's works, pictures pointed you to the "other" location: behind the altar were scenes from Christ's life, a *Crucifixion*,

10.4
The Psalter Hours, a French illuminated manuscript, 1455–60, ink, paint, and gold on parchment, 6 × 4⅜ in (15.2 × 11 cm). This page shows some of the reliquaries in Sainte Chapelle in Paris, labeled with inscriptions that identify them as containing the holy blood, a chain from the flagellation, the Virgin's milk, the Holy Sponge, the Crown of Thorns, wood from the True Cross, Moses's rod, and the reliquary head of Saint John the Baptist.

Resurrection, Doubting Thomas, and *Ascension,* designed to be viewed when facing eastward, toward the land where these events occurred. Another well-known case is the town of Borgo San Sepolcro in Italy, which grew, according to legend, from the germ of stones from the Holy Sepulcher transported there by two pilgrims in the tenth century. The Sainte Chapelle was

built in Paris in the thirteenth century to house Holy Land relics acquired during the Crusades, relics of the True Cross, the Crown of Thorns, the Holy Lance, the Holy Sponge, Holy Sepulcher, and various relics of the Virgin Mary. Aspects of its internal architecture (no longer extant) quoted features of the throne of Solomon in Jerusalem as it was described in the Bible. The relics did not come directly from Jerusalem but from the palace chapel of the Byzantine emperor of Constantinople dedicated to the Virgin of the Pharos. Thus the Sainte Chapelle was a second-degree *Non-site*, a new Pharos chapel, reconstituting what was already a relay station for Holy Land relics.

It is sometimes said that in the Smithson *Non-sites*, the original site or the exact location of the site from which these bits of rubble were excavated were in themselves not important—that they were chosen at random and acquired meaning only once they were put into dialectical relation with the art installation. But that is not exactly true. As has often been pointed out, the New Jersey places mattered to Smithson, a native of that state. Moreover, the Franklin minerals have special properties that endear them to geology enthusiasts, such as the fact that they assume bright fluorescent colors under black light. But the relevance of site goes beyond the places that were important to Smithson's biography.

A New Year's poster and greeting card commissioned by the Jewish Museum in 1969 brings us full circle, as it reveals Smithson applying the logic of the *Non-site* to the Holy Land itself. Ultimately, the Jewish Museum used an image of Smithson's *Mirror Trail*, but a quite different 10.5 initial idea was earlier approved by Vera List, the funder of the annual poster, and produced. We see Hebrew letters spelled out in red earth on 10.6 a chalky ground. As the inscription below states, the letters spell the date (5)730, which in Hebrew chronology translates to 1969, and explains that the figures are formed using earth from Hebron (nineteen miles south of Jerusalem) and that this earth has been placed on Mount Moriah, that is, the Temple Mount, a site sacred to the Jewish, Christian, and Muslim faiths. 10.7 Contestations over both sites and bloody violence continued through the year 1969. After being approved and actually going into production, the poster idea was scuttled. It is clear that Smithson was the one who pulled it, though it remains unknown why.

The thinking that went into the work is clearly illuminated by a memo-randum of March 13, 1969 from the Jewish Museum director, Karl Katz,

10.5
Robert Smithson,
poster for the Jewish
Museum, New York,
final version with
Smithson's *Mirror
Trail*, Paterson Quarry,
Paterson, New Jersey,
1969, poster from
126 chromogenic-
development slide,
20½ × 20 in
(52.1 × 50.8 cm)

to List and the curatorial staff recording a conversation with Smithson, in
which "the following idea of his was discussed":

A piece of interesting land on the site of Mt. Moriah (the navel of the world—the site where
tradition has it God created Man) will be the ground for one set of numbers 5730 and the
Hebrew equivalent letters. The numbers and letters will be made of the red earth selected

10.6
Robert Smithson, initial
idea for the Jewish
Museum poster, with
red clay from Hebron
placed at Mount
Moriah, 1969, poster
from 126 chromogenic-
development slide,
20½ × 20 in
(52.1 × 50.8 cm)

5730-RED CLAY FROM HEBRON PLACED AT MT. MORIAH

from near Hebron (where tradition has it God found the earth to make Man). These numbers
and letters on the ground will be photographed from above and the photo will be reproduced
as a poster, reduced as the greeting card and postcard for the new Jewish year. The text will be
simple and on the face of the poster. The text by Smithson will elucidate the image.

It is a typical Smithson gesture to return to the geological reality that lies
at the basis of the legendary tradition. The figure 5730 marks the number
of revolutions of the sun (in a heliocentric system) that had occurred since
the moment of the creation. The Babylonian Talmud (Tractate Yoma 54b)
states that it was from the Foundation Rock of Mount Moriah that the
world was created; earth taken from Hebron was then used to create the
first human at the site of the creation of the Earth itself. The displacement
of earth captured in the poster was merely a recapitulation of the original

10.7
The foundation stone of the Dome of the Rock, Temple Mount, Jerusalem, seen in an undated photograph taken between 1900 and 1920, glass, stereograph, dry plate, 5 × 7 in (12.7 × 17.8 cm). Erected in 691 CE on the site of the former Jewish temple, the Dome of the Rock remains one of the most important Muslim holy sites. In the wake of the Six Day War of 1967, both Hebron and the Temple Mount were newly under the control of Israeli authorities, causing bloody conflict that grew especially violent during the year 1969.

displacement that occurred at the creation of man. That intervention was not only the first work of art but also the first *Non-site*. (The name Adam in Hebrew means "earth," and most etymologies also see a connection between the Latin *homo*, man, and *humus*, earth.) To recapitulate the gesture now, 5,730 years later, marks out a span of time and also reveals that human time is of no relevance at all. From a geological perspective, this earth from Hebron is not only from the same place but is in fact *the same* as the original earth used 5,730 years ago to make man. It is matter pretty much as it was before humans existed and as it will continue to be after humans cease to

exist, pre- and posthumous earth. Thus, this *Non-site* is also a *Non-time*, folding this bit of earth from elsewhere back into the Earth's navel and black hole and thus in part reversing the unfolding of the Earth's creation.

Smithson's piece is a sort of parallel, on a geological scale, to Michel Foucault's chronology of the invention and disappearance of the category of the human in the concluding sentences of *Les Mots et les choses* of 1966: "As the archaeology of our thought easily shows, man is an invention of recent date. And one perhaps nearing its end." If the organization of knowledge that brought man into being were to disappear, "then one can certainly wager that man would be erased, like a face drawn in sand at the edge of the sea." The figure drawn in sand in Smithson's poster is a fragile bit of human time-keeping made possible, here and now, because "the navel of the world" has just been reclaimed in the latest of the wars that humans have carried out in the name of scripture-based land claims. But just as those human strivings and conflicts will all eventually pass away from the Earth, entropy will ensure that this "Earthword" (so the documents surrounding the poster title the piece) will blow away. It will return to its former condition as mere unfigured earth, though now some distance from where it was taken, a redistribution that only accelerates the entropic return from distributed order back to the dedifferentiated sameness toward which all matter is tending. The fragile time-sculpture survives thanks to the photo that has captured it and that will now be used to convey this less-than-cheery New Year's greeting to the various patrons of New York's Jewish Museum—or it would have, if Smithson had not pulled the poster after it had gone into production, replacing it with something closer to home, a New Jersey *Mirror Trail*. And yet a number of prints of the rejected poster were made, providing suitable conditions, now, for an almost-forgotten abortive project to say what it has to say to those unintended recipients who take special pleasure in reading dead letters.

This work, based in scriptural and postscriptural sources, is as close as Smithson got to producing a *Non-site* of the sort familiar from traditional religious art. Was it too close to being religious art in its own right? "Bob decided against the poster after it was printed, and after he had reluctantly and doubtfully proceeded with it"—that is the summary offered by his wife Nancy Holt. It is true that in his other *Non-sites*, Smithson stops short of providing anything like a Mount Moriah, "the navel of the world." The

10.8
Robert Smithson,
*Pointless Vanishing
Point*, 1968, fiberglass,
40 × 40 × 96 in (101.6 ×
101.6 × 243.8 cm)

structural model for the *Non-sites* may well have been the topographical reliquary of the holy site, but in the absence of a consecrated holy site those earlier forms of religious art function as nothing more than a logical model. The converging bins of the Franklin *Non-site* look like fragments of a perspectival recession, with the emphasis very much on the fragment idea. In his 1968 essay "A sedimentation of the mind: earth projects," Smithson

The "inorganic" structure of art can do just fine without any help from life's "luxuriant creativity" and "unrestrained anarchy." Just look at Stoer and Jamnitzer!

Lack of organic unity was not too far, in Smithson's thinking, from the alienation effect, or "a-effect," of Bertolt Brecht, and the connection came through Brueghel, an artist Smithson classed among the Mannerists. Brecht elaborated the principle of the alienation effect (*Verfremdungseffekt*), in his writings on theater, where he taught that bourgeois theater, or what he sometimes called Aristotelian theater, was based on the idea that the story should be presented in such a way as to encourage the empathy of the beholder, who becomes absorbed in the fiction, experiencing it and becoming emotionally invested in it. The alienation effect of Brecht's "epic theater" was meant to disrupt that involvement, which is a form of false consciousness, insisting instead on the artifice by which the production is made available to the spectator. Rather than fall into an empathetic relation to the character of Galileo, the dramaturgy should always make the viewer aware that it is Charles Laughton playing Galileo. That kind of viewer may then be more able to see the constructedness of the wider social relations normally taken for granted under the effects of capitalist mystification. Brecht found early applications of the *Verfremdungseffekt* in the work of Brueghel, where, unlike what we find in traditional salon painting with its tidily framed narratives, there are unresolved contradictions and the simultaneous presence of unintegrated modes. Smithson gave Brecht's brief notes on Brueghel some heavy underlining in his copy of *Brecht on Theater*.

In an essay of 1967 not published in his lifetime, entitled "From Ivan the Terrible to Roger Corman, or paradoxes of conduct in Mannerism as reflected in the cinema," Smithson quotes Brecht on Brueghel's *Tower of Babel*, a monument to miscommunication and imperfect execution and thus a primary theater of the alienation effect. He writes that Brecht did not merely recognize Brueghel as a precursor but actually "derived" his conception of the alienation effect from the old master's paintings; Smithson thus claims a "pictorial origin of the a-effect." Visual art, and particularly Mannerist art, becomes the true birthplace of an art of irony and detachment. What is true of Brueghel, Smithson points out, is true of many Mannerist pictures. "[E]verything turns away from the center of interest. This turning away from what is thought to be 'important' is at the bottom of the a-effect."

11.5

11.5
Pieter Breughel the
Elder, *The Tower of
Babel*, 1563, oil on
panel, 44⅞ × 61 in
(114 × 155 cm)

He then refers to an "excellent example of the a-effect" in a painting in the
Prado alternately identified as an *Allegory* or as a *Beheading of the Baptist*
where "a bare-breasted woman holding the head of John the Baptist on a
plate is seen looking indifferently away from the gruesome object."

Among Smithson's books is a volume entitled *Europäische Allegorie* that is
devoted to explicating a painting in the Prado, *The Beheading of Saint John the
Baptist*, attributed to Bartholomäus Stroebel, which must be the painting he
is discussing in the Ivan the Terrible/Mannerism essay. The book interprets
this vast picture (almost ten meters wide!) as an allegory of the religious wars
of Europe. The figures arrayed throughout the painting are dressed in courtly
garb of the early to mid-seventeenth century, highly elaborate costumes that
turn the bodies into artificial, virtually geometrical shapes encrusted in
metal (gold, silver) and minerals (gems, diamonds). The book illustrates a
detail of Salome in an elaborate dress that leaves the breasts exposed, turning
her head and—an exquisite violation of narrative closure—sliding her eyes
toward the viewer. In Smithson's description, "the prominence of the (face)
and (breast) admit the chaos of poisonous brocades and jewels and somehow
suggests the 'woman series' of Willem de Kooning."

11.7

11.8

The language Smithson adopted in the later sixties—entropy, geometry, the crystalline, the inhuman, the inorganic, the fragmentary—is very cool, a stark contrast to the heated rhetoric of his 1961 letters describing "Ikons infused with the feelings of the Aztec human sacrifice; the visions of the Spanish mystics; and the Martyrdoms of the Early Church." It seems clear enough that after 1964 he left the mysticism of his youth behind. But did he simply abjure religion for geology, geometry, and entropy? Overtly religious language certainly disappeared from his writing, but his brand of anti-humanism was largely motivated and formed by theological, not to say mystical, habits of thought all the way through. This puts him at odds with a contemporary such as Judd, whose own anti-humanism came via Pragmatism.

In a letter to his gallerist George Lester of May 1961, Smithson says that the art "faithful" have worshiped the figures of Renaissance art ("these playboys of Galilee") for the last four hundred years and that modern art is no more than a kind of chaotic winding down of the humanist regime. "[T]he modern Isms are the result of the Failure of the 'humanism' of the Renaissance." Modern artists from Picasso to Pollock, still working in the horizon of humanism without believing in it anymore, are making an art of despair, which is nothing other than an art possessed by demons. "The deadly effect of despair breaks down or distorts, ie, Picasso, all vision, confounding divine and worldly into a horrible mire. Jackson Pollock, for example, died of modern demonic-possession. All the Psychoanalysis in the World couldn't save him. Action Painting is the Art of Despair." In an interview ten years later the demon-talk is gone but the point is largely the same.

11.6
Bartholomäus Stroebel, *The Beheading of Saint John the Baptist*, 1630–3, oil on panel, 110¼ × 374⅞ in (280 × 952 cm). Robert Smithson owned a book devoted to this painting, with many illustrations of its details.

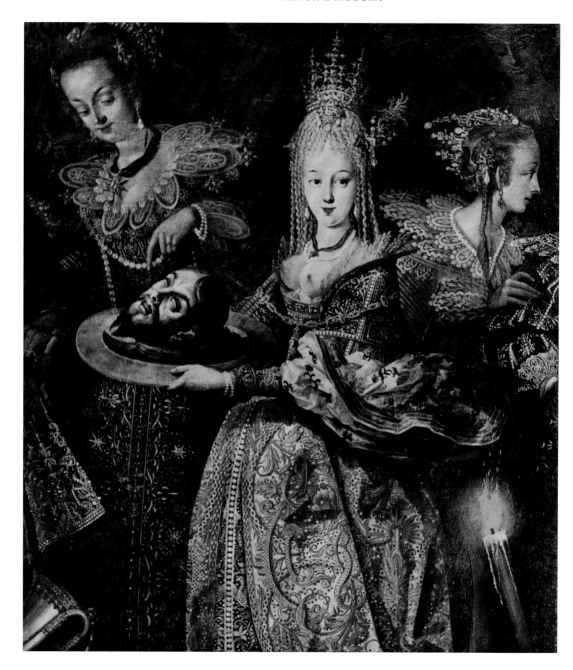

Opposite
11.7
Detail of Stroebel's
*The Beheading of Saint
John the Baptist,* taken
from the book on
the painting, which
Smithson owned.

11.8
Willem de Kooning,
Woman and Bicycle,
1952–3, oil on
canvas, 76½ × 49 in
(194.3 × 124.5 cm). An
Abstract Expressionist
strays from AbEx
orthodoxy toward
Mannerism: as
Smithson puts it,
"Actually, de Kooning
speaks like a Mannerist,
not an Expressionist,
when he says 'art
doesn't make me pure'
or 'I'm not a pastoral
character,' and paints
like one—'I put the
mouth more or less in
the place where it was
supposed to be.'"

He now presents his early work as a rejection of the anthropomorphism that "had constantly been lurking in Pollock and de Kooning. I always felt that a problem. I always felt that it was somehow seething underneath all those masses of paint."

Here is another example of how "hot" early Smithson "cools" later. In spring 1961 he wrote, "Against backgrounds of dead-space and no-time, I painted ikons bleeding from every stroke.... My Man of Sorrow is paralyzed in a Divine agony, unable to explode into some cheap Ism. This creates an almost unbearable tension. I am a Modern artist dying of Modernism." This was not merely reactionary anti-modernism but in fact already a fairly well-articulated postmodernism. Subtracting the obvious Christian talk, it is not too far from this to his later preoccupations with an art not of its time, and with other, Postminimalist approaches to "dead-space" and "no-time." A letter from September 1961, after his Rome exhibition of July, includes a drawing of a female figure in a landscape—literally in it, embedded deep underground. The letter surrounding the drawing, describing his most recent paintings, reads:

Nature cannot touch these figures, because the figures are not real. The figure in this sketch is where it is not. The lovely terror beneath beauty. Animals, plants, + minerals unlike animals, plants, + minerals. Far from the boring eyes of nature. Transformations within transforma-tions. Colors without color. ect. ect. [sic] ... the way up is the way down! The above figure knows no model. The eye of nature is the black hole posing as the sun, which means in English "O" = zero.

The Matisse-like nude embedded in a Dubuffet-like underground with a black-hole sun above may not look much like Smithson's later work (with the exception of all those spirals!), and yet the main themes of the later Smithson are here. Gestures unmoored from action later became Brechtian alienation effects. Figures in a world without nature were later called Mannerist. The figure that "is where it is not" would return as the *Non-site*, and the "lovely terror beneath beauty" became the entropic "material abyss of raw matter." "Transformations within transformations" would later be found in crystalline structures below the threshold of the visible, and the later *Cinema Cavern* was certainly designed to be "far from the boring eyes of nature."

Just now I said the underground nude in Smithson's drawing was Matisse-like, but that is simply a routine stylistic observation. A figure submerged

this approach almost as a method, inspired by Borges: "That kind of taking of a discarded system and using it, you know, as a kind of armature. I guess this has always been my kind of world view."

 This is Smithson in cool mode, speaking as if one "discarded system" was as good as any other, all equally serviceable as "armatures." But if there was a primary alternative to the ascendancy of humanism since the Renaissance (and thus the dominance of "expression," "creativity," "empathy," and "anthropomorphism" in art), it was Christian cosmology, a vast relic of a system though it may be. The basic problem is all too familiar and was the core concern of the German art historian Hans Sedlmayr's *Verlust der Mitte* of 1948; the English translation, *Art in Crisis: The Lost Center*, appeared in 1957 and not surprisingly Smithson owned it. His copy of the book has no underlining in it, and it is easy to see why he might not have taken to it. Throughout, Sedlmayr argues that modern art has exploded the human boundaries of traditional art; it is an art of the extrahuman, the inhuman, the subhuman, even the prehuman, all of which he sees as symptomatic of a "disturbance" in the human relation to God, to the self, to other humans, to nature, to time, and to the spiritual world. The only way to save art, Sedlmayr argues, is to bring it back within a human compass and a conception of humanity in touch with divine spirit. Smithson may have read the book and disliked it or he may not have read it at all. Either way, it is clear that there was not much he could do with it.

 However, another book, with a similar title and closely related concerns, was quite important to him, and that is Nathan A. Scott's *The Broken Center: Studies in the Theological Horizon of Modern Literature* of 1966. The book made something of a splash in its day. The Chicago Divinity School professor's views were controversial enough to merit a profile in the December 22, 1967 issue of *Time* magazine, which marveled at a book that could put modern literature in a religious context. "Behind [*The Sound and the Fury*]'s secular façade, he argues, lies a poetic expression of what theology calls kairos—the divine gift of time span in which man exists on earth." (Smithson's copy, which carries underlinings all the way through, was printed in 1968, he thus read it not in his mystically inclined youth but right in the midst of the later work with the *Non-sites* and earth art.) According to Scott, we live in a desacralized world, in the sense that we are unable to see in the world "any animating power of *presence* amid and within the familiar

Opposite
11.11
Parmigianino, *Madonna of the Rose*, 1528–30, oil on panel, 42¹⁵⁄₁₆ × 34⅞ in (109 × 88.5 cm). In an essay on Mannerism, Smithson quotes from Sydney Freedberg's *Parmigianino: His Works in Painting* (1950) and specifically invokes this painting. Freedberg writes (p. 81): "The ideality of Francesco's pictorial world has been refined in the *Madonna della Rosa* a step farther in the direction of abstraction; that sphere parallel to reality within which Parmigianino constructs his painting has here withdrawn one stage more beyond the objective world."

12.1
Yousuf Karsh, *Marshall McLuhan at the Royal Ontario Museum*, 1967

homogenization, standardization, and rationalization. For all of them James Joyce was a hero and a guide.

They share a further, decisive feature. Like Joyce, all three had extensive training in medieval traditions of knowledge and premodern art and aesthetics. Steinberg worked for several years toward a dissertation on Romanesque architecture before abandoning it, finally submitting a thesis in 1960 that offered a highly exegetical reading of Borromini's San Carlo alle Quattro Fontane. Eco submitted his thesis on the development of medieval aesthetics in 1959. McLuhan, the eldest of the three, had been a student of scholastic theology, completing in 1943 a dissertation on the mechanics of the *trivium* (grammar, dialectic, and rhetoric) in the Elizabethan writer Thomas Nashe. Their training equipped them to respond with extraordinary agility and acuity to the contemporary developments. In McLuhan's *The Gutenberg Galaxy*, the medieval connection was an explicit part of the argument: an understanding of the pre-typographic era was a necessary counterpart to the electronic revolution, since we were undergoing, in his view, a return to the medieval integration of the senses after centuries of subjection to the visual systems of ordering (and their correlates, nationalism, individualism,

historicism, rationalism, logocentrism, etc.) imposed by typography. In Eco and Steinberg, by contrast, premodern aesthetics remained an implicit, if enabling, field of reference in their treatments of the contemporary material. One has only to read Eco and Steinberg at an oblique angle to find the connection there. That will be the task of the following two chapters.

A 1967 photograph of McLuhan by the renowned photographic portraitist Yousuf Karsh shows the scholar at a desk with a bank of telephones arrayed on the wall behind him. Before him, the book is opened to a page showing a mosaic from the church of Hagia Sophia, the principal church of the Byzantine empire, portraying the emperor John II Komnenos with his wife Irene besides the Virgin and Child, and their son Alexius to one side. The detail visible here is the head of Alexius. McLuhan's range of references was vast; this could easily have been a book on another subject. But everything in this photo is deliberate, as deliberate as in a mosaic. In another Karsh portrait of McLuhan taken in his University of Toronto office, we see a book opened on a stand before a candelabrum, as if on an altar, and showing more photographs of mosaics from Hagia Sophia, the 12.2 complementary section of the very same mosaic with the parts portraying John II and Irene flanking Christ. It is possible that this is the very same book, opened to a different page.

Why such emphatic references to the mosaic art? For McLuhan, mosaic was more than a technique; it was a primary modality of medieval culture and a model for understanding communication in the present age. Early on in *The Gutenberg Galaxy* he describes his patchwork mode of presentation—a series of short sections, some of them made up largely of quotations from various sources, meant to be read as discrete units and not necessarily in sequential order—as a "mosaic or field approach." The inspiration came in part from the modernist writers he revered—Proust, Pound, and above all Joyce, whom he calls a "modern master of medieval tactile mosaic."

In adopting the mosaic approach, he was resisting what he took to be the protocols of typographic culture. The advent of typography in the fifteenth century, according to McLuhan, introduced a new organization of experience, a rewiring of the human faculties, as words were dislocated from their oral context and came to be understood and manipulated as logical visual arrays, a development that he consistently related to the development of modern European conceptions of time and history, logic and reason,

12.2
Yousuf Karsh, *Marshall
McLuhan in his office*,
1967

authorship and art, and their political correlates, individualism and national-
ism. Post-Renaissance perspectival painting, which presents a plotted world
where figures exist in defined dimensions of space and time and where the
visual array is organized by a singular posited viewpoint, was a clear cor-
relate to the nearly simultaneous development of typography. In mosaic
work, by contrast, figure and ground are not distinguished a priori but are in
a relation of "dynamic simultaneity" with their surround. Figures and phe-
nomena represented by the mosaic belong to a continuous and yet not planar
field. An in-situ shot of the Hagia Sophia mosaic shows that the figures are
not merely arrayed laterally but wrap around the walls. Alexius faces both his
progenitors and the viewer; space is understood not as something inside the
picture but rather as the animated area before and between the walls, a space
that includes the viewer. More than an optical witness, the "viewer" enters
into a relation of cohabitation with the image. In his 1968 book *Through the
Vanishing Point*, coauthored with the artist Harley Parker, McLuhan glossed
William Butler Yeats's poem "Sailing to Byzantium" as kind of prophecy
of what the century was to bring, namely a reorientalization of experience

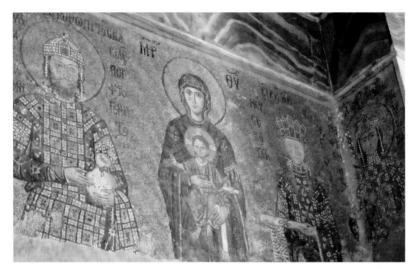

12.3
Mosaic showing
John II Komnenos and
Empress Irene flanking
the Virgin and Child,
with their son Alexius
on the wall to the
right, Hagia Sophia,
Istanbul, 1118

and a reintegration of the senses: "'Sailing to Byzantium' in the twentieth century has been a purging of the visual images of the Western day. The splendor of the Eastern resonance has been restored to the arts of the Western world in poetic rhythms and symbolic forms."

As with viewers, so with authors. The typographic era introduced a modern notion of authorship and its administrative/legal correlates, such as copyright, a notion foreign to scribal manuscript culture, where copying and transmission and distributed authorship were the order of the day. "Authorship before print," McLuhan writes in *The Gutenberg Galaxy*, "was to a large degree the building of a mosaic." Behind McLuhan's formulations is a fairly elaborate but never quite articulated understanding of the conditions of mosaic production, which would go something as follows. In mosaics, the artist uses chunks of readymade material and patches them into a composition that is understood as an application of a program—a program typically not of the artist's invention. Once it is in place the mosaic lives a very long life, not only because its materials—glass and stone—are more durable than pigment on canvas or panel, but because it is by nature structurally amenable to ongoing restoration. Tesserae can be—and almost always were—replaced over time without compromising the transmission of the image's program. Many "ancient" or "medieval" mosaics are in fact the ongoing work of succeeding generations.

159

For McLuhan, the mosaic mode of being and apprehension was again relevant in the new age of the electronic media, which were exploding the clear boundaries of a mechanically understood world, putting things once again into multiple relation across space and time. Television—multi-channeled and multi-authored, light beamed through glass into the space of the spectator, an image produced by a repetitive scanning of the front area of a cathode-ray tube by electronic beams in a fixed pattern—was a mosaic medium par excellence and was gaining preeminence over film, whose sequential continuity and material print-form (the frames) still subscribed to the linear logic of the printing press. In the portrait photograph of McLuhan there is not one but a multiplicity of telephones arrayed on diverging walls behind the scholar, insisting on the idea that in the electronic age communication does not merely speed up but beams out in all directions, creating presence and "simultaneous happening" where there had been distance.

Simultaneous happening is the very modality of mosaic. Mosaics engaged an integrated medieval "sensory ratio" where the visual was not disconnected from the other senses and if anything was subordinated to the "audile" and "tactile" modes. McLuhan most often describes relations of multiplicity (whether in mosaic or in the electronic age) as a form of "resonance." "The two-dimensional mosaic," he wrote, again in *The Gutenberg Galaxy*, "is, in fact, a multidimensional world of interstructural resonance"—in contradistinction to modern perspective, which was "an abstract illusion built on the intense separation of the visual from the other senses." The photograph of McLuhan with the telephones reveals the meta-resonance, so to speak, between mosaics and telephonic communication, which reintroduced the "audile" dimension that had been subordinated under the typographic era.

Photography is a child of perspective, but here, in this photograph, it is as if the medium of photography is warping under new pressures, becoming more mosaiclike. One may well wonder what could possibly have been the setting for this photo, with this bank of telephones swimming toward and away from his head, and that shell almost like a nimbus behind him. As it happens, McLuhan is sitting in an art installation of sorts, one in fact shaped by his ideas. The person responsible for its design was Harley Parker, who had studied at Black Mountain College under the former Bauhaus artist and teacher Josef Albers. From 1957 to 1967 he was the head of design and

installation at Toronto's Royal Ontario Museum, as well as a close collaborator of McLuhan's. Parker's culminating work at the museum was the new Hall of Fossil Invertebrates, which offered an integrated exhibit about the development of life in the prehistoric seas. This is the strange space in which McLuhan sits, explaining the presence of the shell among the phones. These phones were an innovative precursor to the now familiar acoustiguide, offering visitors information about the exhibit all around them. The use to which they were put explains why these phones have no dialing feature.

Thus, we are in a museum if not quite an art installation, although it was close to being one for all its innovations. In a 1967 article on his rationale for the exhibit, published in the magazine *Curator*, Parker called it a "break-through in museum design," based on the principle that "space is very seldom purely visual." Parker asserts that "acoustics, kinetics, the olfactory, in fact, proprioception itself can govern our perceptions of space. The space of a medieval cathedral, for example, is governed as much by the sound of our tapping heels as it is by the visual, which is, at any rate, in medieval cathedrals in very low definition." The new galleries were a direct application of McLuhan's ideas to the realm of the museum. "We are back in acoustic space we are back in acoustic space" repeats a spiraling purple 12.4 banner in McLuhan's 1969 *Counterblast*, which was designed by Parker. And yet the talk about medieval space as acoustic and tactile is in fact as much from Parker's teacher Albers as from McLuhan. The Museum of Modern Art in New York is in possession of a student's notebooks—those of Harry Seidler—from Albers's design course of the summer of 1946, the very same course attended by Parker. From these notes we gather that Albers presented design not as the making of visual forms but as a means of activating perception by creating effects of movement, arousing sensations of tactility and enlisting the viewer's participation. A primary path to dynamic design, according to Albers, is to activate senses other than the visual. The notes read: "Sound has no boundaries—has no space although it fills space.... Noise in a direction heard by ear nearest to it.... Focusing [is an] important factor in reading space." And also: "Substitute eyes by tactile experience. Babies touch, chew things—only slowly replaced by visual sensations. HAPTICS (optics, acoustics)—we are concerned with sense of touch." On another page, the student wrote, "Renaissance afraid of texture. Gothic much more care of matière."

PHOTOGRAPHY was the mechanization of the perspective painting and of the arrested eye; it broke the barriers of the nationalist, vernacular space created by printing. Printing upset the balance of oral and written speech; photography upset the balance of ear and eye.

TELEPHONE, PHONOGRAPH and RADIO are the mechanization of post-literate acoustic space. Radio returns us to the dark of the mind, to the invasions from Mars and Orson Welles; it mechanizes the well of loneliness that is acoustic space: the human heart-throb put on a PA system provides a well of loneliness in which anyone can drown.

By surpassing writing, we have regained our sensorial WHOLENESS, not on a national or cultural plane, but on a cosmic plane. We have evoked a super-civilized sub-primitive man.

NOBODY yet knows the languages inherent in the new technological culture; we are all technological idiots in terms of the new situation. Our most impressive words and thoughts betray us by referring to the previously existent, not to the present.

Movies and TV complete the cycle of mechanization of the human sensorium. With the omnipresent ear and moving eye, we have abolished the dynamics of Western civilization.

WE ARE BACK IN ACOUSTIC SPACE WE ARE BACK IN ACOUSTIC SPACE

WE ARE BACK IN ACOUSTIC SPACE

We begin again to structure the primordial feelings and emotions from which 3000 years of literacy divorced us. We begin again to live a myth.

12.4
Double-page spread from McLuhan's *Counterblast* (1969), designed by Harley Parker

These were basic Bauhaus lessons, and in the 1960s Parker layered McLuhan's medievalism over the Bauhaus medievalism he had learned from Albers. The exhibit at the Royal Ontario Museum, Parker explains, was intended to maximize the participation of the visitors in multi-sensorial ways, rather than replicating book-page design in two-dimensional visual displays in the way that was standard in museums. "The walls undulate; the ceilings reflect water patterns and the spectator can touch the various fossils and weathered-in-water rock forms." And there is also a sonic dimension, both of an ambient sort (the sound of breakers, the cry of sea birds) and through the telephones. Among educational institutions, Parker affirms, museums "could be the first to use electronic communication techniques properly." The exhibition designer "must be aware of the changing sensory orientation of the public as this can be deduced from advertising, clothing,

transportation, even Go Go girls and the psychedelic event." The article imagines a museum that "will involve the young people as completely as television." Parker (Albers + McLuhan) = Hall of the Fossil Invertebrates.

Parker's article carries photographs of the interior of the exhibition, among them one of the very same curving corridor with the telephones that we see in the McLuhan portrait, a sort of counterpart to the ambulatories 12.5 of medieval cathedrals. There are other period accounts of this exhibit and 12.6 of this curving space in particular. The extremely well-connected English poet Eric Mottram, on a tour of literary North America in 1965–6, recalled spending a long afternoon on March 22, 1966 with McLuhan in his office. "Then we visited Harley Parker's exhibit at the Museum—designed to alert youngsters to a full sense experience of under-sea and sea-shore, through light controls, ozone smells, and a sea-shell implanted ramp, climbing which triggered off a photo-electric cell and a huge film of a wave breaking just above your head." Developed in 1904, the photoelectric cell produces an electric current upon exposure to light, without the need for an energy source. Interruptions of the light signal could also be put to effect to trigger motor actions, as happens when an approaching body causes a door to open (an invention first sold and distributed by the American company Horton Automatics in 1960). Applying this recent invention to new ends, the film of a wave breaking overhead here was triggered as the visitor came onto what Mottram called the "sea-shell implanted ramp." It is little surprise that McLuhan should have had himself portrayed at just this juncture of the exhibit, where the interaction of a body with light produces an immaterial, quasi-magical transmission of information and activity.

The portrait is a dense paradox. As McLuhan pointed out, photography was a "mechanization of the perspective painting and of the arrested eye." It was the medium of the point of view, a final expression of the Gutenberg era. And yet here he is, presented in a photographic author portrait, an artifact of typographic culture if ever there was one. The author is shown consulting a book, the Gutenberg format par excellence. And in the book we see a photograph of Alexius presented as a "detail," an illustration in isolation from the text on the facing page, which explains and identifies the image, putting it in historical context. The detail gives us no sense of the way that this head is connected to the other elements of the mosaic, no sense, for example, that this mosaic wraps around a corner. It seems that the prophet of the electronic

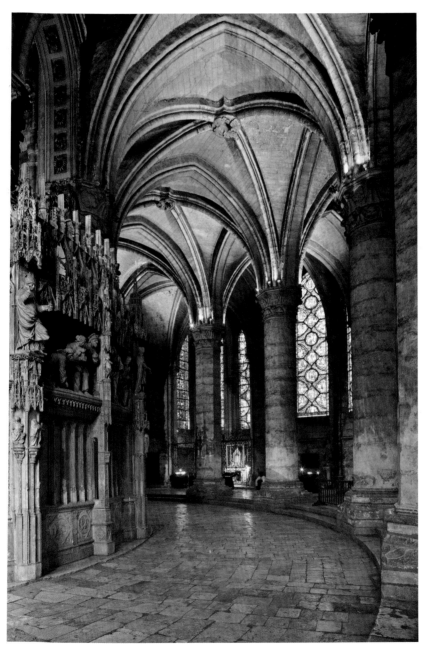

Opposite
12.5
The new Hall of Fossil
Invertebrates at the
Royal Ontario Museum,
as illustrated in Parker's
article in *Curator* in
1967

12.6
The ambulatory and
southeast section of
the chancel screen of
Chartres Cathedral,
France, built in the first
half of the thirteenth
century, with later
sculptural additions

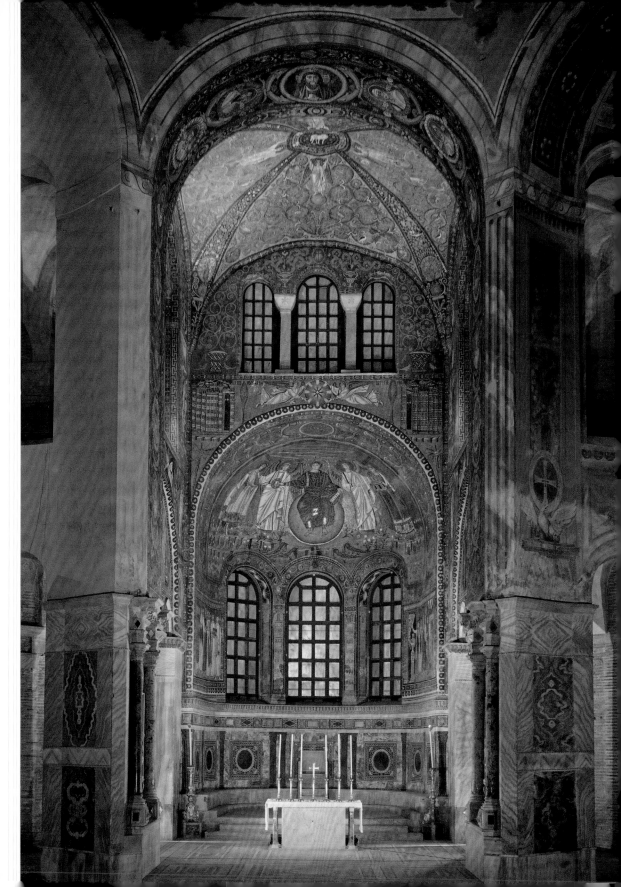

space between the mosaic-covered walls? That kind of analysis might well have led to a rethinking in the context of twentieth-century experiments with open works and viewer participation. It would begin to explain why the Theodora mosaic was the first illustration in Wassily Kandinsky's *On the Spiritual in Art* of 1912, where it stood as a counterexample to the narrowness and inertia of museum pictures.

From Battisti's view, a more sustained analysis of the way medieval works—and especially works of medieval devotional art—functioned would have served to expand and complicate Eco's theory. In fact, Battisti had himself just done a great deal to make the "background noise" of premodern works of art once again audible in his sprawling and revolutionary *L'antirinascimento*, also of 1962, a study of the "dark" side of sixteenth-century art, that is, of the Renaissance preoccupations with magic, the occult, witchcraft, grotesques, monsters, and automata. *L'antirinascimento* is in a sense the counterimage of Eco's book, a study of Renaissance art under the defamiliarizing optic provided by a sustained engagement with modern art. (The year 1962 also saw the publication of Battisti's Italian translation of Robert Rosenblum's *Cubism and Twentieth-Century Art*.)

Despite his declared adherence to a conception of a medieval art in the service of an ordered medieval theological universe, Eco introduces medieval examples that do correspond to the experimentalism of the contemporary works, such as the early thirteenth-century *Poetria Nova* of Geoffroy of Vinsauf, which teaches how the order of stories can be reversed and jumbled, starting with any one point and developing and concatenating the various parts through appropriate rhetorical devices. Eco cites the literary historian Edmond Faral, who says of the medieval writers of *romans* that "they knew which effects could be drawn from the symmetry of scenes forming a diptych or a triptych, of a story adeptly suspended, of the interlacing of narrations pursued simultaneously." For Eco this is nothing less than the germ of a new poetics of the novel that is closer to the contemporary novel than to the well-devised plots of the nineteenth century writers or of Aristotelian drama. "We are thus faced with the question whether the medieval rhetors were ahead of their time or if in fact the roots of certain contemporary poetics (reaching even to the poetics that sustain a novel such as [Robbe-Grillet's] *Dans le labyrinthe*) should be sought in the Middle Ages—and precisely due to the Joycean connection." But Eco

does not make the connection to visual art, despite Faral's invocation of diptychs and triptychs and the interlacing narrations of medieval iconographic programs. The reference to the open structures of reading proposed by medieval narrative image cycles was not a mere gesture on Faral's part. Historians of art both before and after Eco have emphasized the multiple and divergent pathways for reading images in book illustration, stained glass, tapestry, and painting cycles.

On the modern side, the embrace of chance and indeterminacy in the contemporary works turns out to be connected to the search for a new kind of integration. The works of contemporary artists may be open and radically indeterminate, but they are still works, which is to say they are still engaged in the process of producing a constellation of meaning, even if that meaning is now understood in a broader, world- and viewer-involving sense. These ambitions go well beyond those of the traditional closed work, such as the salon picture, and in this sense they have more to do with the world-encompassing, cosmological ambitions of medieval art. The poetics of the open work allow readers, listeners, and viewers to "draw multiple perspectives on the universe-work." They throw the classical division between self and world into question, according to Eco, modeling instead the experience of a life-world in the sense elaborated by the philosopher Edmund Husserl. During the formative phase of the book Eco was exposed to the work of John Cage, who spent a number of months in Italy in 1958 and 1959, appearing regularly on the popular television game show (much loved by Eco) called *Lascia o Raddoppia*. Eco pays special attention to *Fontana Mix*, a piece that Cage conceived and performed repeatedly in Italy. Cage assigned differently colored ribbons to several tapes carrying recordings of concrete world-noises and electronic sounds. He then let the colored bands fall in a tangled configuration, and then, drawing a line through the chaos, fixed the points where they intersect, thus establishing the sequence of the "compositon." In Eco's words, "he selected and mounted the parts of the tape that corresponded to the points selected by chance, obtaining a sonoric sequence guided by the logic of the imponderable." Eco connects this "open" procedure to the Zen philosophy that Cage embraced and propagated, but in the end affirms that really Cage did not need Zen because he had modern physics. We now know, Eco says, that chaos dominates the subatomic sphere, and that uncertainty is the

13.4
John Cage, *Fontana Mix*, 1981, silkscreen on paper, with transparent plastic overlays, image 19½ × 27½ in (49.5 × 69.9 cm), paper 22½ × 30 in (57.2 × 76.2 cm). In *Fontana Mix*, first created in 1958 and subsequently performed several times, the composition is opened to the world by incorporating "found" sound, but also in the structural sense that the notation itself is accomplished intermedially, through a detour into a visual art. A piece of paper with six differently colored bands of different thickness is overlaid by one of several transparencies, each of which has a random array of dots. Then this superimposition is overlaid by a grid. Points from the random array are connected by a straight line, producing the score, including the sequence and the tempo. Images of this "score program" look like abstract compositions, but they are more than that: they are the two-dimensional resolution of a spatial activity, which will then provide the program for "respatialization" in performance.

essential criterion for understanding the world. We know we cannot say that at instant X the electron A will be at place B, but only that at instance X there is a certain probability that electron A will be at point B. We know that every description we make of atomic phenomena is complementary, that is, that a given description can be contradicted by another without one being true and the other false.

The Zen philosophy embraced by Cage and others has, in Eco's view, found a welcome audience in the West because the Western world has already been fundamentally unsettled by these findings in physics. Zen invites us to take pleasure in the mutable rather than simply admit it as a cold methodological criterion. Fine, says Eco, but in the West we still will not give up on methodology; we will not give up on redefining the mutable along the lines of probability and statistics, because we still believe in order and science, even if we have learned to understand these criteria in a new, more "plastic" sense. The open work, open to the world and to chance, is bound up with this larger process of redefinition. That is to give it quite a grand purpose, but it is only by setting the work into this kind of cosmological-historical frame—the frame that a medievalist would apply—that Eco was able to see that there was a cultural movement here at all, that there was a something called "the open work" and that this phenomenon needed to be theorized.

ENVIRONMENTS, FLATBEDS, AND OTHER FORMS OF RECEIVERSHIP

The title of Cage's *Fontana Mix* was apparently no more than a reference to Cage's landlady, "a certain signora Fontana," but in Italy in the 1950s the name was also an unavoidable reference to Lucio Fontana, whose "spatial" interventions in abstraction, the cut canvases of the *Concetti Spaziali*, but also his neon zigzags installed in the Palazzo dell'Arte in Milan in 1951, bear some formal resemblance to the tangle of the *Fontana Mix* super-impositions, as Romy Golan has observed. The image of the spaghetti-like welter of bands was itself the result of a spatial intervention, or rather of the intervention of space. The bands had fallen through the air into this configuration; control over the composition had literally slipped out of the artist's hands. This, together with the fact that this assemblage was overlaid by transparencies, implies that the construction was less a pictorial composition than a horizontal receiving surface, in stark contrast to traditional painting, which was composed by a thinking and "designing" artist and submitted to the visual judgment of an upright viewer. Aleatory "air" between hand and art work and a horizontality built into the conception and the working process—these are two primary ways in which Cage was directing the example of Jackson Pollock to new ends. It is Pollock rerouted, as it were, through Duchamp's *Three Standard Stoppages*.

A month before the conception of *Fontana Mix*, Cage's student Allan Kaprow published an article in the October 1958 issue of *Artnews* that outlined with the greatest clarity the implications of Pollock's example for a future artistic practice. Kaprow had written an essay on Pollock for a 1950 Columbia University seminar given by the historian of medieval and modern art Meyer Schapiro, and in many ways it was the basis for the one eventually published in *Artnews*. The 1958 rewriting unfolded under the direct influence of John Cage, whose course Kaprow was then following at the New School for Social Research in New York. The *Artnews* essay acknowledges that many of the innovations associated with Pollock are by now "clichés of college art departments," but proposes that there was more to

be learned from the artist, starting with the fact that he also "destroyed painting." What Pollock had done was to replace pictorial order with immersion in the work, something "perhaps bordering on ritual itself, which happens to use paint as one of its materials." That means that the person standing in front of the work is no longer a mere viewer but "something of an acrobat," constantly shuttling between an immersive experience and a more passive experience, submitting to the marks as marks. This instability is indeed far from the idea of a "'complete' painting," which would be a well-behaved easel painting. "The artist, the spectator and the outer world are too interchangeably involved here" for the painting to be understood as "complete."

Kaprow concentrates on the scale of the Pollocks: the paintings are so large, so mural-like, that they become environments into which we are "sucked in." In contrast to large Renaissance pictures that proposed a continuity between real space and a picture space designed as an extension of the viewer's familiar experience, this environment offers us no space. Rather, it "tends to fill our world out with itself." A photograph included in the original article, probably taken by Kaprow himself, shows spectators standing in front of the just-finished *Autumn Rhythm* at the 1950 inauguration of the new American galleries at the Metropolitan Museum in New York. As if to illustrate his point, the image shows the spectators as somewhat undifferentiated silhouettes, partly encompassed by the painting. But photographs can go only so far in showing effects of immersion, so Kaprow (I assume) intervened in the photographic print. From the upper left corner of the picture dark fronds encroach on the scene, partly trespassing the borders of Pollock's canvas and overshadowing the spectators.

The key claim to which the essay builds is that Pollock's dissolution of the pictorial tradition "may well be a return to the point where art was more actively involved in ritual, magic, and life than we have known it in our recent past." But what is this "return"? To what moment or period is it a return? Kaprow never names it, but the contrast with the Renaissance picture makes it fairly clear that medieval art is the unstated but structurally implied reference here—and it was hardly an incidental reference for him, given that in the same spring term of 1950 that he took Schapiro's course on modern art he also took a course on Romanesque sculpture with the same professor. Kaprow's class notes have survived, making it clear that the theme he drew out of the course is the idea,

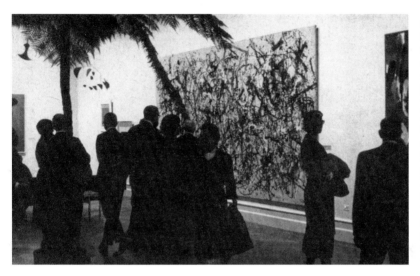

14.2
Photograph of the opening of the new American galleries at the Metropolitan Museum of Art, probably taken by Allan Kaprow at that time, while he was preparing an essay on Pollock for a 1950 seminar on modern art given by Meyer Schapiro at Columbia University. The photo was used to illustrate a more developed version of the essay, published as "The legacy of Jackson Pollock" in the October 1958 issue of *Artnews*. It was probably at the time of publication that the dark frondlike forms were painted onto the photograph by Kaprow in order to suggest the immersive experience produced by Pollock's work.

familiar enough from Schapiro's writings, that Romanesque art registers the secular world together with its social conflicts, thus complicating both art works and religious experience. The notes are peppered with lines such as "Flavor of Reality (domesticisms) which distinguish it [the Romanesque] from Byzantine." One page reads "Rom(anesque) reworks old themes in contemporary terms. Importance of postures. Individuality of gestures toward reality and function." Summarizing Schapiro's 1943 article on "The image of the disappearing Christ: the ascension in English art around the year 1000" (or perhaps Schapiro's own account of it in the class), Kaprow notes: "Eng[lish] Rom[anesque] shows not only Realism, but element of Participation. Ascension of Christ. Desire to show how a thing was done."

In his article on the new iconography of the ascending Christ in English Romanesque art, Schapiro concentrates on the dramatic invention of a phenomenon of disappearance—the partial image of the departing Christ at the top of the scene—with its corollary emphasis on the fact that the event is being seen. He illustrates a page from the Bury St Edmunds Psalter where we see Christ's legs (and only Christ's legs) at the top edge of the 14.3 page. The legs of Christ are shown in profile, as if to emphasize that he is climbing. Schapiro points out how the apostles leap up, twist their bodies, and raise their arms, a multiplicity of reactive gestures remarkable for their

14.3
A page from the Bury St Edmunds Psalter, mid-eleventh century. Illustrated in Meyer Schapiro's essay on "The image of the disappearing Christ," the page shows Psalm 67 and the Ascension with only Christ's legs visible at the top edge. A frame-breaking image, the new conception emphasized dynamic activity and contingency of observation, which for Schapiro were hallmarks of English art around the year 1000, elements of "a real emancipation of art, a widening of its scope and possibilities."

time. This sense for the concrete and the active is a hallmark of English art of this period and it constitutes, in Schapiro's words, "a real emancipation of art, a widening of its scope and possibilities."

I propose that something of the nature of the frame-breaking radicality of the Romanesque as presented by Schapiro informed Kaprow's strategic thinking about the post-Pollock situation. In the wake of Pollock, Kaprow says, artists have a stark choice: Rather than continue in Pollock's line and do work less good than his, producing only "near paintings," Kaprow proposed abandoning painting altogether in favor of a new engagement with the world, or what he called life into art:

Objects of every sort are materials for the new art: paint, chairs, food, electric and neon lights, smoke, water, old socks, a dog, movies, a thousand other things that will be discovered by the present generation of artists.... [T]hese, I am certain, will be the alchemies of the 1960s.

Kaprow had already been at work since 1957 on his environmental interventions, which he called "action collages." In his efforts to introduce sound into his environments he had sought out the instruction of Cage, and with Cage's encouragement developed the concept of the happening in the spring of 1958, just as Cage set off for his European tour (where he would develop *Fontana Mix*, among other works). The medieval element in Kaprow's envisioned future "alchemies of the 1960s" was not so straightforward as an emphasis on physical spatio-temporal experience. Ideas about the actual perambulation of space and viewer-participation in a phenomenological sense were not a prominent theme of the course on Romanesque art, or of Schapiro's writing generally. The important point was to understand how a field of art-making takes in a new order of information from the contemporary world and as a consequence is altered in its basic structure, becoming an art of contingencies and irregularities. These changes did not mean the end of religious art then, any more than they would spell the end of art now, but in both cases a new commerce between art and life would mean art would have to change radically.

The first months of 1958 were also the moment of Jasper Johns. His *Target with Four Faces* appeared on the cover of the January issue of *Artnews*, just 14.4 weeks ahead of his first solo show at Leo Castelli Gallery, which opened to great clamor and acclaim. Leo Steinberg's essays on Johns and contemporary art of 1962, which were based on lectures given at the Museum of Modern

14.4
Jasper Johns, *Target with Four Faces*, 1955, encaustic on newspaper and cloth over canvas surmounted by four tinted-plaster faces in wood box with hinged front, overall, with box open, 33⅝ × 26 × 3 in (85.3 × 66 × 7.6 cm); canvas 26 × 26 in (66 × 66 cm); box (closed) 3¾ × 26 × 3½ in (9.5 × 66 × 8.8 cm)

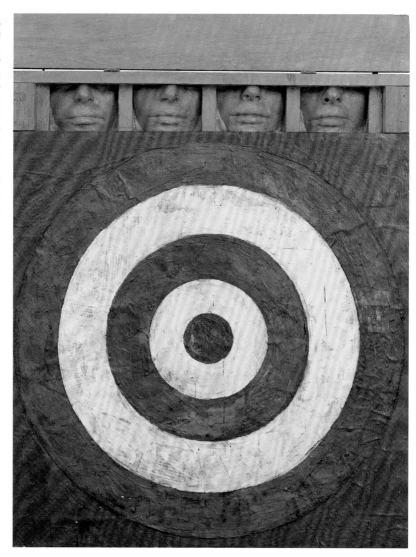

Art in 1960, recognized in Johns a similar break, a break that retroactively staged Abstract Expressionism as the grand tradition's last act. "The pictures of de Kooning and Kline, it seemed to me, were suddenly tossed into one pot with Rembrandt and Giotto." From the post-Johns point of view, even Kline and de Kooning could be seen as old masters, still in the business of pictorial "transfiguration," making paint and canvas stand for more than themselves. Johns, instead, offers only iterations of things that already exist as flat images—flags and targets, for example. He presents object-images. When he wants to present three-dimensional realities he presents them as such, in deadened, "imaged" form—plaster casts, for example, replicas of something he did not make or model. "There is no more metamorphosis, no more magic of the medium." What interested Steinberg in Johns was the emptying out of a "humanist" presence in painting. The paintings do not express a subject position; in fact, they adopt a "totally non-human point of view," even when they present body parts—or rather because they present them as parts, and as parts of casts, replicas of standard mannequin-like bodies. "Only objects are left—man-made signs which, in the absence of men, have become objects." This was not exactly Kaprow's dissolution of painting into its environment, but it was a structurally related move, an opening of painting to the imprint of the environment, and thus a recasting of painting as something other than "painting."

It is hard now to see things in the mournful cast of Steinberg's *Harper's Magazine* essay, for the simple reason that today Johns looks overwhelmingly like a great painter, part of the grand tradition after all. There is plenty "magic of the medium" here, it turns out. There is also a break with tradition, certainly, but then there are breaks all the way through modernism. It is hard now not to see the break prospectively, as a liberating new direction for art-making, a reorientation that led to an explosion of Pop art, interactive art, Postexpressionist art, installation art, etc. It is almost impossible to see the "desolation" and "dereliction" that Steinberg saw around 1960. And yet at that time many people were unhappy about the Johns phenomenon, and Steinberg offers an amusing roundup of the bewildered, dismissive, and puzzled early responses that the young artist provoked. For someone who was deeply attentive both to contemporary art and to Giotto and Rembrandt, the clarity of the loss, and the reasons for mourning it, were especially powerful.

When Steinberg asks Johns if his works were "about human absence," the artist replies that if they were then he had failed, because that would imply that "he had been there," whereas he wants his pictures to be objects alone. He likes the typographical forms of numerals and letters because they already exist. Does he choose one font over another? No, he just takes the font in which the stencils come. Does he like this font? Yes. Does he use it because he likes it best or because the stencils come that way? That's a false dichotomy from this artist's point of view: he likes them best *because* they come that way. His works are without content, Steinberg remarks, if content implies "the artist in attendance pumping it in." Content is instead "self-generated," and that means it is free of the coloring of artistic expression. This holds even for human figures, which are treated in the same way. "[T]he values that would make a face seem more articulate than a target are not being held anymore." As a result, Steinberg points out, Johns' subjects overwhelmingly imply passiveness and uneventful duration: the drawer that will not be opened, the shade that will not be lifted, the empty coat hanger, the canvas turned face to the wall. In that sense, they only reiterate a basic change in the status of the picture. Rather than a window, it is now a passive, "receptor surface": "a surface observed during impregnation, observed as it receives a message or imprint from real space." Which means that it is liable to become more than painting, and accordingly the picture surface begins to accrue real three-dimensional objects and casts—what Steinberg calls "object-repeats." The result is a break with the tradition of the picture as something designed exclusively for optical experience. Instead, Johns elaborates a conception of "visible tangibility," and that means that "any painting can be rehearsed with either its visual or its tangible modality played up or played down. A Johns painting may be flattened into a drawing, or relieved in sculpmetal or bronze."

In a lecture of 1968, published in full form as the title essay of *Other Criteria*, Steinberg was to develop this new conception of the picture in a fuller account of what he now saw as a fundamental change in art-making introduced in the 1950s. In Rauschenberg, Johns, and Dubuffet, Steinberg saw new preconditions at work that no longer obeyed the laws of the "picture" as it had been institutionalized in a centuries-old tradition of European painting. What he saw was a new conception of the work as a surface for operational processes, the work conceived (although not

necessarily worked or displayed) as a horizontal plane, a field carrying asso-
ciations to maps, or newspapers, or charts, or flags, or floors, or beds rather
than to the idea of an upright face-to-face with a visual picture of the world.
The formulation of the principle—what Steinberg called the flatbed picture
plane—was to open the door to a rereading of modernism as a whole, a
project carried out in the 1970s and 1980s Rosalind Krauss, Yve-Alain Bois
and other writers associated with the journal *October*.

Steinberg's essay attacks formalist criticism on two fronts, from the pre-
modern side and from what he calls the "post-Modern" side. He defends the
old masters against the Greenbergian view that they are concerned only with
realism and thus with a naive or, worse, disingenuous denial of the picture
surface. Steinberg shows, against this view, that self-referentiality, complex
relations between representation and picture surface and even collage aes-
thetics were all present in the work of the "old masters." The important
frontier now was no longer the one to be drawn between old masters and
modernists, but the one that separates the whole tradition of "pictures" from
a new form of post-picture. On the one hand, we have "a conception of the
picture as representing a world, some sort of worldspace which reads on
the picture plane in correspondence with the erect human posture." On the
other, after 1950, there were a series of "opaque flatbed horizontals" that "no
longer simulate visual fields," introducing a tilt of the picture plane from ver-
tical to horizontal. This upending of the picture expresses "the most radical
shift in the subject matter of art, the shift from nature to culture." The shift
was anticipated by Duchamp's upended readymades and his anti-pictures
(*The Large Glass* and *Tu m'* offer less an "analogue of a world perceived from
an upright position" than "a matrix of information conveniently placed
in a vertical position") and was developed in Warhol's images of images,
which "let the world in again," though now not in the terms of a perceived
worldspace but rather as a mediated cultural field. Troubling the boundary
between art and non-art, this "post-Modernist" painting leaves the criteria
of the connoisseurs behind as it "departs into strange territories," making the
course of art "once again non-linear and unpredictable."

The discreet "once again" (akin to the "again" in "let the world in again")
points to a missing "before." It indicates the operative but uninvoked term
in this schema, namely the period of art—or rather non-art—before the old
masters. Implicitly but continually, the essay prompts the question: How

did art function before its job was to offer pictures of worldscapes for erect viewer-subjects? Could it be that it has something structurally to do with these post-vertical and post-optical experiments? It seems clear that what made the logic of the flatbed obvious to Steinberg, well before anyone else, was an already sustained exposure to premodern modes of art-making and art-installation—icons that accrue ex-votos, for example, or the worked and discontinuous surfaces of altarpieces—and the ways in which these "prepictorial" image surfaces engage settings and viewers, or rather users.

As Steinberg emphasized in 1962, the object-status of Johns' works invited an approach that was more direct, less contemplative: "The posture of aiming at a Johns target is no less sane than was genuflection before an icon." Michele Giambono's *Man of Sorrows* in the Metropolitan Museum is something more than a picture of a dead body. It is a tooled, gilded, and decorated object that is at once sculpture and painting. The body is dead, inside the tomb, and yet upright, a horizontal body presented formally, which is to say vertically and frontally, to the viewer-worshiper, who is invited to treat the image as a body. Refusing to remain in the past, the body presses into the present, insisting that this sacrifice has occurred *for* the one who confronts this body in the here and now. The blood that poured out of the wounds during the Crucifixion remains on this presented body, maintaining the dripping pattern formed when the figure's arms were raised on the cross. But now it is half-congealed, rising from the surface of the panel, palpable and not merely visible to the devotee.

In larger ensembles, such as Giovanni di Tano Fei's *Coronation of the Virgin and Saints* polyptych, in the Metropolitan Museum since 1950, the figurations are organized in registers designed to be read in different combinations, producing what Steinberg in his later work would call a "multiplex" of meanings and associations. As in Johns, these surfaces combine abstract passages, figuration, emblematic signs, and relief elements; more importantly, the meaning of the ensemble results in important ways from the fact that these various elements set semiotic limits on each other. Ensembles such as these are both unified and not, both continuous and discontinuous. These associations within the altarpiece are in turn developed in dialogue with other figurations and real objects inhabiting contiguous space—the frescoes in the chapel, for example, or the tomb on the chapel floor, or relic-objects, and above all the altar itself. None of

14.6

14.5
Michele Giambono, *Man of Sorrows*, c. 1430, tempera and gold on wood, overall, with engaged frame, 21⅝ × 15¼ in (54.9 × 38.7 cm); painted surface 18½ × 12¼ in (47 × 31.1 cm). This painting has been in the Metropolitan Museum's collection since 1906. Leo Steinberg received his Ph.D. from the neighboring Institute of Fine Arts in 1960.

14.6
Giovanni di Tano
Fei, *Coronation of the
Virgin and Saints*, 1394,
tempera on wood,
gold ground, overall,
with shaped top and
engaged frame,
78⅜ × 76 in
(199.1 × 193 cm).
This work has been in
the collection of the
Metropolitan Museum
since 1950.

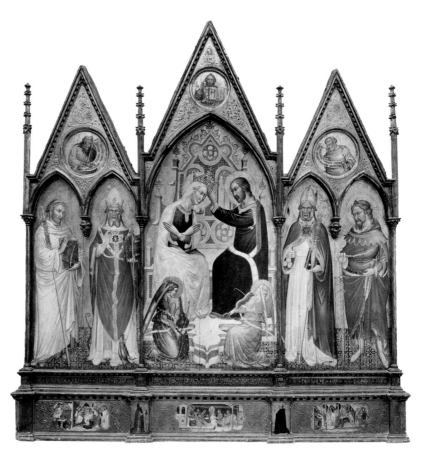

these objects and forms of figuration can be thought of as bounded "works."
Instead, they acquire meaning in their location, in association with each
other, and through the activation of the space by use, or rather through a
multiplicity of uses in no way limited to "official" ritual performances.

These comparisons are not to suggest that the insights went only in one
direction—that Steinberg applied lessons learned from premodern art
to the unsettling developments in contemporary art. His thinking about
Johns also affected his approaches to the earlier material. In June 1959, in the
midst of his grapplings with Johns, Steinberg published in *Art Bulletin* an
14.7 article on the paintings of Caravaggio in the Cerasi Chapel in Santa Maria
del Popolo in Rome. The article is notable for its analysis of the paintings

in their environment and in their relation to viewers. From remarks made in various places, we gather that Steinberg's fateful encounters with Johns and with the Cerasi Chapel occurred in the same year, 1957. It is fruitful to compare what he has to say about the two artists. The paintings in the Cerasi Chapel, Steinberg showed, are site-specific and in active relation to their surroundings. They are bound programmatically to the lunette frescoes above them, and the light in them is not represented as coming from the real windows, in the traditional manner, but from the Holy Dove painted in the vault. "[T]he Caravaggio paintings acknowledge their architectural context. Though painted on canvas, they are not easel pictures." The paintings are also keyed into their setting by being planned with a mobile viewer-worshiper in mind. Marked by dramatic foreshortenings, the paintings were designed not for a viewer positioned directly in front of them, the way they might be approached in a museum or a book. Instead, a viewer is posited who stands at the altar chancel, at an oblique angle to the paintings set well within the chapel. The paintings "no longer conceive of the beholder as a fixed witness; what they presuppose is a being in motion who is never perfectly placed." The viewer is in active relation to the paintings: We are implicated by what we see, almost as if what is shown was, "in some measure, our own doing." "[T]he terrible actuality of these paintings no longer resides in them alone, but invests our relation to them, which is never ideal, geometric, and neat, but in disorderly flux." 14.8

The reading is full of potential applications not worked out in the short article. One would now want to see a more sustained reading of the paintings developed in this framework, beginning with the fact that both paintings take as their theme the violent upending of normative viewer-positions. Paul is thrown off his horse by a fulmination, and in being blinded is made to see. Peter willfully has himself crucified upside down, a gesture interpreted in the Apocryphal Acts of Peter as an ironic cosmological undoing, an image of error that in fact overturns the primordial error, the Fall of Adam and Eve, which had thrown the world awry at the beginning.

We are inside a disorienting feedback loop. The kernel of Steinberg's ideas about the novelty of Johns—that this was the end of a tradition of easel painting, that this work posed resistance to the tradition of commanding, vertical viewership, that it put to work a principle of art work in receivership against an age-old conception of masterful artistic agency—all this

Opposite
14.7
Cerasi Chapel,
Santa Maria del
Popolo, Rome, with
Caravaggio's
paintings on either
side of the altar

14.8
Caravaggio,
*The Conversion of
Saint Paul*, 1600–1,
oil on canvas, 90½ ×
70 in (229.9 × 177.8
cm), Cerasi Chapel,
Santa Maria del Popolo,
Rome

15.1
Ad Reinhardt, cartoon from the "How to Look" series in *PM* magazine, 1946, with a timeline of life before and after the era of "Pictures"

Even before easel painting had become stabilized as a category, the way was paved by prints, which offered a new plane for the circulation and reception of images. In the decades around 1500, prints revolutionized the world of art, or rather catalyzed the advent of a world of art by reproducing site-specific works of art in portable format. Decontextualized, the images

were set in motion, making them available simultaneously to a multiplicity of viewerships. Already in the 1470s and 1480s Andrea Mantegna made engravings understood as publications of pictorial inventions—inventions, not necessarily actual works, putative paintings several of which had never even been realized as paintings and never would be. Those engravings reached Dürer, who took the next step of fusing the art practice and the distribution mechanism: the prints *were* the work. He became the first world-renowned artistic celebrity since antiquity by making each holder of one of his prints the possessor of an original Dürer. Concurrently, Marcantonio Raimondi became the semi-official print publisher of the inventions of Raphael (some of which had been realized as paintings and some of which had not), thus creating conceptual room for the idea that works of art of different media, scale, and location could be placed on a consistent visual plane and assembled under the rubric of an artistic "corpus." Thus even before "gallery pictures" existed, the category was prepared conceptually by prints, which presented notionally site-specific works together with "non-sited" conceptions for which there was as yet no venue within the existing categories of painting. All were now presented as independent "pictures" that could be collected and displayed. The inventory of one of the great collections of prints of the sixteenth century, that of Ferdinand Columbus (Christopher's son), has a title on its binding that reads "Pinturas." Virtual museums existed long before actual ones did.

The displacements of works of art from churches to cabinets that occurred during the Reformation constitute one sensitive moment in the definition of the modern picture. Another is that of Caravaggio, around 1600, when the first proper picture galleries were being formed. Still another is that around 1800, when the foundation of the first modern museums produced a new round of acquisition and thus displacement of art works. By 1900, or even earlier, with Courbet and Manet, the format was coming in for some radical internal dismantling. Viewed in this way, this history no longer seems particularly stable and is anything but monolithic. What emerges from even this abbreviated sequence is a history of fairly continual redefinition, involving a recurrent intersection of painting and its environment. Paintings are displaced, practices change, and any moment of self-definition soon prompts another moment of self-questioning and reframing. It is hard, now, to assent to Ad Reinhardt's description of the era of "Pictures": "We saw that an artist

who makes 'pictures' and purveys subject-matter is a peddler of phoney spaces (buckeye) and optical illusions." Academic painting of the eighteenth and nineteenth centuries is coming into view as the hothouse flower that it is, a dense theater of repressions. This is a history to unsettle the modernist schema of the avant-gardes at war with "the" gallery picture.

Antoine Watteau's *Enseigne de Gersaint* of 1720 takes a playful and critical view of the emergent world of the picture dealer and the connoisseur. It shows older pictures, painted for a variety of purposes, being marketed and sold in an age of unprecedented artistic and social mobility. But rather than presenting the gallery pictures as autonomous objects, this work stages pictures as actors in a complex social ballet. In the summer of that year, Watteau returned to Paris from London, suffering from an illness that would kill him, and painted this final picture, a gift for his friend, the picture dealer Edme-François Gersaint. This is how Gersaint described the episode twenty-four years later:

On his return from Paris in 1721 [Gersaint's memory was faulty], when my business was still in its early stages, Watteau came and asked me if I would receive him and allow him, in order to keep his fingers supple—those were his very words—if I would allow him, as I was saying, to paint a sign to be exhibited outside the shop. I was not in favor of the idea because I would have preferred him to work on something more substantial; but seeing that it would give him pleasure, I consented. The success of this picture is well known; it was done from life; the attitudes were so varied and so graceful, the composition was so natural, and the groups so well thought out that it attracted the attention of passersby: even highly skilled painters came several times to admire it. It was done in eight days, and even then he only worked in the mornings; his delicate health, or, to be more accurate, his weakness, prevented him from working on it longer. This was the only work in which he ever took the slightest pride; he told me this quite frankly.

The painting began its life as a signboard designed to be placed above the entryway to Gersaint's shop on the Pont Nôtre-Dame, but it soon became a gallery picture. A painting by Hubert Robert documenting the destruction of the shops on the bridge in 1786 shows clearly what the portals of these shops looked like. In the era before houses and shops had addresses, signboards were the primary means by which establishments advertised their identity and location. Like many examples of the period, this one shows a (not particularly factual) rendition of the interior of the shop. Originally the painting was arched in shape in order to fit the area above the doorway, but

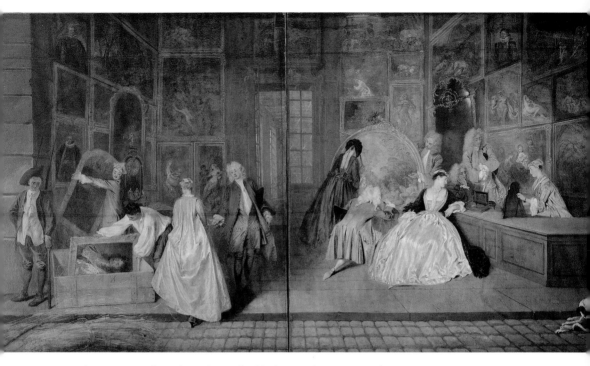

it was later cropped on the sides and added to at the top in such a way as to turn it into a proper rectangular picture.

On a print made after it in 1732 we read that the painting spent only fifteen days outside the shop, which was long enough to attract buzzing attention. It was soon literally and figuratively pulled inside and treated like a work of high art—that is, like the other paintings in the shop. But the view "from the outside" is basic to this painting, and not only its staging and composition. It presents a view onto a new world of art-making and art-dealing. It is a commentary on a new system of art, offered from a position just outside the system.

The painting stood outside in both a physical and structural sense: physically because it literally hung outside the shop, and structurally because it was painted as a signboard, a menial and extremely common form of painting in seventeeth- and eighteenth-century Paris. The later seventeenth century had seen a new, higher conception of painting mark itself off precisely from this crass form of commercial painting. Before the

15.2
Jean-Antoine Watteau,
L'Enseigne de Gersaint,
1720, oil on canvas,
64 × 121 in
(163 × 308 cm)

201

founding of the Royal Academy of Painting and Sculpture in 1648, all painters in France, whether house painters, sign painters, decorators, or painters with high artistic ambitions belonged equally to the *maitrise des peintres, sculpteurs, doreurs et vitriers*, which was part of the *communauté des ouvriers*. (The exceptions were the court artists, who enjoyed special protection and privileges.) The success of the Royal Academy brought about an ever clearer division between art as a learned, elevated pursuit and art as a form of manual labor practiced by members of the *maitrise*, which remained associated with the Academy of Saint Luke and the *communauté des ouvriers*. Watteau reputedly began his career as a sign painter and then rose from these humble origins to prominence as one of the great painters of his time. At the end of his life, he offered a kind of summa of his career, and a commentary on his art, by returning to sign painting, now in the mode of irony. This was the most commercial of painting categories—made in large numbers by hack painters as advertisements for commercial enterprises—but Watteau's signboard was prompted by no commission and was offered as a gift.

The name of the shop was Au Grand Monarque, and thus the portrait of Louis XIV shown being crated (based on a well-known state portrait by Hyacinthe Rigaud) is more than a picture for sale; it is in some sense the emblem of the shop. Like a good signboard, this one offers the image that matches the store's name. And yet this is not a typical signboard, and the emblem-image is shown tipped on its side and about to be hauled away. Louis XIV had in fact died shortly before, in 1715, and thus the playful allusions to an entombment are also topical. Signboards are designed to be read emblematically and so even the upending of the emblem is a figure, a sort of meta-emblem. The shop, which took up quarters on the Pont Notre-Dame in 1718, did not merely coincide with the passing of an historical era; it was in a deeper sense itself a symptom of the passing of an era. The shop may have been called Au Grand Monarque but it owed its very existence to the fact that the great patrons of art were no longer king and state but a new breed of collectors, dealers, and connoisseurs. The arbiters of taste were no longer the officials of the Royal Academy but wealthy men like Antoine Crozat, Pierre-Jean Mariette, and the Comte de Caylus. Nobility was no longer a designation of estate but a matter of class: it was possible to acquire elevated status through cultural capital, like the ability to appreciate art. Paintings were now made for a different kind of viewer and purchaser, and

old paintings made under the earlier system of patronage were brought into circulation and treated in a new way as commodities. Louis XIV's portrait had earlier served as an emblem and even quasi-magical surrogate of royal majesty; now it was a painting for sale, to be appreciated as an example of the painting of Rigaud. Now it was admired and acquiring value as an artifact of an era in the history of France and in the history of art. And it is being readied for dispatch to its purchaser.

In the left-hand panel a man reaches his hand to a woman who is just stepping into the shop from the street. She turns her head to observe one of the shop assistants placing the portrait of Louis the XIV into the crate. Behind the assistant crating the painting another assistant carries a large mirror, presumably also just sold. At the left margin, outside the shop is a young figure leaning on a staff; I disagree with those who say the figure was added during one of the painting's restorations. He may be the one who will cart the crate to its destination. On the right-hand panel another couple attentively examines an oval picture, a mythological scene with nude female figures, presented to them by an assistant to the dealer or perhaps by the dealer himself. To their right, two figures gaze at themselves in a mirror presented to them by a female figure sitting behind the counter, a figure who has been identified as Gersaint's wife, Marie-Louise Sirois. Every bit of the shop's walls is covered with paintings and mirrors. On the bottom right, lying on the cobblestones outside the shop, a dog licks himself.

Signboards are always emphatically surface as well as picture, and this one, picturelike as it is, is a careful orchestration of two-dimensional contingencies. One can read them starting from the left. The shoe of the youth standing on the platform reaches just to its edge. His left hand touches the corner of the crate. His left elbow meets the corner of the mirror. The right hand of the boy in the white shirt who is lowering the painting into the crate is at the exact juncture where the mirror meets the painting. The gentleman reaches out his hand to the lady entering the store but on the surface of the painting his hand touches her elbow and his foot touches the bottom of her robe. The seated woman's hand just touches the edge of her dress. Her nose reaches the edge of the wig of the man next to her. There are more such moments, but it is tedious to go on. Let one stand as the emblematic contingency for all: the seated lady's elegantly pointed shoe pokes out from underneath her dress, meeting the exact conjunction between one of the

the first painter despite the fact that he never wielded a brush: "For what else is painting but the embrace of all that lies on the surface of the water in the fountain?" Narcissus' ability to appreciate the beauty of the one that he sees in the water is predicated on his blindness to the surface of the water itself. He sees through the water, forgetting the fact that the water is a medium. If he did recognize it as a medium—and in Ovid's rendition of the story Narcissus does make this realization—then he would have to acknowledge that the image he is seeing is none other than his own.

This alternative—does one look at the image as a representation or does one attend to the surface, the object?—is the painting's organizing theme. At the left, for example, we see the portrait of the king undergoing a change in state. Whereas earlier the effigy of the king was a quasi-magical surrogate of his body, standing in for him in halls of state and in an array of institutions under royal protection, here the portrait has become an artifact, a framed painting, a work for sale. On the right side, a couple admires an oval paint-ing of female nudes in a landscape. The standing woman has her face pressed up close to the canvas, but even that is not close enough and she has raised her lorgnette to her eyes. She is at the level of the trees, presumably examin-ing the signature-like brushwork making up the leaves. In the art-critical language of the time, she is admiring the "*franchise du pinceau*" and the "*coups de maistre*" visible on the painting's surface. She is assessing the painting in the mode of the connoisseur—as a work whose value lies in the distinctive features of paint-handling that make it the product of a given artist, and of a given school. The man kneels, his hand resting on his cane, and also brings his face up close to the canvas, at the level of the nude figures, a posture that puts extreme comical pressure on the question: Is he looking at bodies or brushwork, scene or surface?

Finally, at the right, another couple, together with an attendant, gaze upon the mirror presented to them. Logically, they are assessing it as an object, a potential purchase. And yet, part of what one assesses in a mirror is its par-ticular reflective properties, and this couple is taking their time in doing so. They sit at some distance from the mirror, look at it, at themselves, con-templatively, almost meditatively. Even the standing attendant behind the counter has fallen into a similar, absorbed, state. They began presumably by assessing the mirror as an object, but have fallen into a state of absorbed atten-tion as they take in what the mirror gives back. And the mirror shows them

each something different, something of particular interest to each, which is an image of themselves in their world, a highly malleable world of movable paintings. They are trying out the mirror, and trying themselves out in the mirror, against a background that is nothing if not a shifting scenery of possible sets.

This double act of perception—of mirror-surface and mirror-image— suggests that something more than financial investments go into the new form of appreciation and acquisition. When the old hereditary class distinctions fall away, art and culture come to play a new role as a means of self-ennoblement. Which is to say, the new would-be connoisseurs are not only admiring paintings, but are rehearsing a new identity. Even if they are nobles, they are assuming an unfamiliar modern role in entering a shop where paintings are bought and sold, a sphere where skills—skills of discernment in arenas of artifice—and not merely privilege are demanded. They constitute themselves anew in their appreciation, and they find in the paintings estranged prefigurations of their own activity. In the mirror image, the distinction between their world and the pictorial worlds, between their bodies and the figural bodies, becomes blurred. They see something like what we see when we look at this signboard—themselves as characters in something like a painting.

The figures inhabiting the shop have a double status: they are the real people wandering among paintings, and yet their attitudes are familiar ones, recognizable variations on the poses of figures in Watteau's own previous paintings. The couple entering the shop with almost balletic cadence recall especially the couples in Watteau's painting of *The Embarkation from the Isle of Cythera*, a painting that exists in two versions. Traditionally 15.5 thought to represent the embarkation *to* the island of love, presided over by Venus, it is now generally accepted that Watteau has depicted instead the departure *from* the isle. The couple closest to the statue of Venus are farthest from the ship and (still) in the warmest embrace, oblivious to any thought of departure. Between them and the coast, we see the stages of disenchantment as the couples slowly and somewhat reluctantly disengage themselves from the beautiful but imaginary precinct of love. The painting dramatizes a return from fiction to reality, a slow waking from a dream world. Viewed self-reflexively, the painting thematizes the end of what could be called the era of mythical-sacred art. What is implicit in the *Embarkation*—a farewell

to a certain world of pictorial fantasy—is made explicit in the *Enseigne*, Watteau's pictorial testament. It is the job of signs to make things clear, and this one does. The middle couple in the *Embarkation* closely resembles the couple entering the shop in the *Enseigne*. The female figure in the *Embarkation* casts one final look at the statue of Venus before leaving the isle behind. The couple entering Gersaint's shop is also passing from one world to another, but here the threshold is very clearly defined. The woman, with one foot still on the street, passes into the new world of commercial art and looks over her shoulder one last time at the quasi-sacred royal portrait being dispatched to its purchaser.

To put it schematically, Watteau's *Enseigne* is the early counterpart to Jasper Johns' *Flag*. As has often been said, *Flag* is both a painting and a flag; the *Targets* are both paintings and targets. Watteau, equally clear-eyed at another point in the history, commented on what looked like the inception of a tradition, and a whole system of art, by adopting the "subaltern" position of the sign painter. The *Enseigne* stood provisionally outside the system and thus could comment on the relationship between inside and outside and on the new boundary being drawn between inside and outside. It is not merely a belated example of site-specific art superseded by the autonomous

easel picture, but a strategic return to a site-specific mode, which it forces in new directions in order to make it reflect on the new relationships *produced* by the newly mobile pictures. Watteau's is no ordinary sign, just as Johns' are no ordinary signs. From its position over the doorway, Watteau's signboard indicated that the principal feature of the new conception of painting is precisely its transportability, its non-site-specificity. The shop is an installation but emphatically a temporary one; these pictures are there to be *moved*. A portrait of Louis XIV is being crated up. A mirror is being taken down. A painting is on an easel for inspection. And eventually the *Enseigne*, too, was moved, first into the shop, whence it was sold into the homes of French collectors, and then to a princely collection, where it remains to this day— that is, when it is not shipped off to a traveling exhibition.

The point is not that Watteau stands at the threshold of art whereas Johns brings it to an end. The preceding chapters aimed to show that even these momentous gestures are part of a larger pattern, focusing attention on the relationship between outside and inside, resetting the boundaries of the art work in part by converting the prevailing art system into the content of a new kind of work of art.

15.6
Jasper Johns, *Flag*, 1954–5 (dated on reverse 1954), encaustic, oil, and collage on fabric mounted on plywood, three panels, 42¼ × 60⅝ in (107.3 × 153.8 cm)

LIMITS OF THE DIAPHANE

As Leo Steinberg clearly saw, the radical element in Jasper Johns' work was not merely the choice of subjects, or the fact that there were subjects, but the basic move from picture to surface, what he called the flatbed picture plane, which signaled a shift away from personal expression and toward a new receptivity to the phenomena of contemporary culture. (More recently, Joshua Shannon has introduced a twist to this idea, arguing that the found objects and references in the art of Rauschenberg and Johns were not exactly contemporary but already then slightly antiquated, a subtle *décalage* that introduces an element of resistance against the advent of a new era of free-flowing "information.") Environments, Pop art, performance art, chance-based work, Minimalism, Arte Povera, and, later, video art, land art and process art, each of these developments in one way or another "let the world in again," in Steinberg's phrase. Another way of describing this shift from the vertical to the horizontal was as a shift from the optical or iconic to the indexical, a distinction theorized by the nineteenth-century American philosopher Charles Sanders Peirce and then taken up by Rosalind Krauss to address developments in the art of the 1960s and 1970s and, through them, in modern art as a whole. In Peirce's schema, the iconic operates by means of resemblance, whereas the index is produced by its referent; it is connected to it not by resemblance but by a physical relation. Peirce's third mode, the symbol, or what he sometimes called the "name," is based on an arbitrary, conventional relationship between sign and referent; words are the most obvious example of this category of sign. A footprint is an index of a person and smoke is an index of fire, whereas icons present images of their objects—an image of fire or a portrait of a person. Certain kinds of sign, such as photographs, partake of both modes.

The work that Steinberg identified as a basic challenge to his generation's artistic presuppositions was deeply committed to indexical procedures, as Johns' various casts and Rauschenberg's *Combines* suggest. John Cage's *4'33"*, a receptacle of incidental sound, is a monument to the index as an alternative to traditional authorship. Kaprow's environments were understood originally as "action collages" taking in elements of their surroundings. Pop art favored photographic reproductions, indexes of the world, insisting

on their status as images to be mechanically reproduced. Performance art and body art turned the artist's body into a medium: Bruce Nauman's *Self-Portrait as a Fountain* gives us the literal version of the artist as source, **16.1** spouting water from his mouth, and Ana Mendieta offers a darker version of the idea in *Sweating Blood*. Alvin Lucier's *I am Sitting in a Room*, a mono- **16.2** logue recorded and fed back again and again into the same room equipped with a recording device, annihilates intelligible communication and gives us "the natural resonant frequencies of the room articulated by speech." Video, meanwhile, reconceived the image as signal, a feed connecting the space of the gallery to an active flow of information—a quality it held even when it was not in fact a simultaneous feed.

Krauss showed how consistently twentieth-century artists wielded indexical procedures against modalities of resemblance, and generally against a visual-optical understanding of the artistic object. From Johns' hero Marcel Duchamp's jibes against "retinal" art on down the line, Krauss showed, twentieth-century polemics against traditional forms of paint-ing have tended to reinforce the opposition between icon and index. As she pointed out, Duchamp produced a kind of meta-statement on the issue in his *Tu m'* of 1918, which stages no fewer than three forms of indexical sign. A billboard of indexicality, the work is a blatant counter to the perceived overwhelming predominance of "iconic" modes in previous art. It was not just an effort to correct the balance, but an announcement that, semioti-cally speaking, this is the form the opposition would have to take. Overkill is part of its point. In Krauss's wake, Georges Didi-Huberman has waged a tireless campaign to recuperate the modality of the imprint, the image pro-duced by physical contact, against the post-Renaissance dominance of the representational visual image. When Duchamp turned to the readymade, a subset of the index known as the *sample*, or when Schwitters dipped Moholy-Nagy's socks in plaster in order to absorb them, now both image and object, into the cumulative work that was to become the *Merzbau*, or when Johns introduced casts of body-parts into his works, they were turning consciously away from what was universally seen as a dominant tradition of painting.

Once again, the twentieth-century rebellion was reacting against a con-ception of vision, an Enlightenment theory, that was not very old. It was, as it were, a near-sighted critique. Perhaps the indexical rebellions of

16.1
Bruce Nauman,
Self-Portrait as a
Fountain, 1966–7,
from "Eleven Color
Photographs," 1970,
chromogenic print,
20¹⁄₁₆ × 23¹⁵⁄₁₆ in
(51 × 60.8 cm)

16.2
Ana Mendieta,
Sweating Blood,
1973, film still, Super-8
colour, silent film
transferred to DVD

twentieth-century art presupposed too firm a belief in the existence of a purely "optical" traditional painting. Pre-Enlightenment visuality, and thus premodern painting, distinguished much less clearly between the optical and the indexical. On a purely theoretical level, Peirce himself grasped this possibility, acknowledging that his semiotic distinctions were schematic and could never be hard and fast: "But it would be difficult if not impossible, to instance an absolutely pure index, or to find any sign absolutely devoid of the indexical quality." If one takes the longer view, exploring, for example, theories of visual communication that dominated thinking about the subject from antiquity until the Enlightenment, then Peirce's caveats turn out to be abundantly confirmed. Duchamp understood that this historical alternative existed. He often pointed out that the era of what he called "retinal" painting was very short, having been introduced by Gustave Courbet in the mid-nineteenth century. Before then, "painting had other functions: it could be religious, philosophical, moral." If it is true that painting hasn't always been "retinal" in the modern sense, then it is tame at best and misguided at worst to give up on painting altogether and to turn only to "literal" indexical alternatives—imprints, casts, trace-markings, etc. To work within that binary is in fact to comply with a structure of modern thought. It starts to look as if the "ineluctable modality of the visible" is not a paradigm that preceded modernism so much as something that runs parallel to modernism—or rather an artifact of modernism itself, negatively inscribed into its polemics.

In a treatise of around 1540 entitled *On Human Deification*, the sixteenth-century rhetorician, neo-Platonist, kabbalist, and mnemotechnician Giulio Camillo likened the different states of bodies to different forms of representation. In doing so, he loosely applied a dominant understanding of vision, according to which objects send out from all their surfaces images of themselves that are reconstituted in different media. He put a succession of the various phases of bodies in sequence: the "figure" of his body can appear in a mirror or in water, or in a painting (he mentions the "marvelous" portrait made of him by Titian, something like the illustration overleaf). And if the air interposed between his body and the mirror were a somewhat more substantial medium (his term for this receiving medium is the subject or *suggetto*, traditional Aristotelian terminology), the figure or image of his body would be visible there too. And yet it is there only in very subtle form. The eye can

16.3
Titian, *Portrait of a Young Man*, c. 1515, oil on canvas, 19¾ × 17¾ in (50.2 × 45.1 cm)

grasp the figure or image more easily when it appears in more substantial media, such as a painting, or, even more easily, in a sculpture, where one can grasp the image from all sides, as if it were his very body. He extrapolates from this to imagine how the soul that is imprinted in us by divinity can make itself manifest in various media, some more ethereal than others.

This brief passage is startling, and probably unsettling to anyone brought up on modern discussions of painting and visuality. In Camillo's view of things, images and bodies are connected in more fluid and direct ways than the terms "representation" and "picture" or even "likeness" are able to

suggest. Iconic representation does not merely refer, it *carries*. This conception returns us to the root of the word "refer" in the Latin *ferre*, to transport, to convey. The image is not a representation of its referent, but a version or phase of it, a means by which it moves. In this account, sight encounters not a mere two-dimensional illustration of a thing but traces of that thing that have been released into the air, bringing sight closer to the functionality of smell.

In Camillo's view, the ethereal, volatile phases of the object—the image in the mirror, or its invisible form as it travels through the air—are not the inferior versions but rather the privileged ones, the purer ones. In other words, Camillo does not understand the two-dimensionality of painting as secondary or subordinate; the surface of painting is not something that needs to be denied in order to press a convincing illusionism. Camillo off-handedly invoked the portrait made of him by Titian, an example of painting especially important to him, but the tenor of his remarks do in fact apply well to painting in general after 1500, that is, to Titian and other painters of his generation. The early fifteenth-century artists were concerned with transparency (see, for example, the works by Gentile, Masaccio, Carpaccio reproduced in this book). The innovations of Leonardo and Giorgione introduced not only technical changes, but also a fundamental change in the status of the picture. The pictorial field acquired a new density and opacity that was never to leave it. The settings for the figures—dense atmospheres, dark shadows, lush landscapes, even interiors—now behaved like a ground from which figures emerged, which is to say they recapitulated, again and again, the ambiguities of the pictorial field. Figures became pictorial "figurations," instances of painting at work. Later experiments with brushwork and the material thickness of paint were a literal exploration of the new understanding of the pictorial field, or of painting *as* field.

In Parmigianino's *Portrait of a Collector* of the mid-1520s, we see a culti- 16.4
vated man in the company of his beloved art works, a range of figurations not unlike those that Camillo enumerates in his discussion of the different phases of the body's figurations. Behind the collector is a marble relief sculpture of *Mars and Venus* (presented as a fragment, an antiquity), and before him on the table is a bronze statuette and ancient coins. In his hand is a precious book. The landscape is a quite up-to-date painting, in the latest mode of landscape depiction introduced by Giorgione. The art-filled

16.4
Parmigianino, *Portrait
of a Collector (Man with
a Book)*, c. 1523, oil on
panel, 35¼ × 25¼ in
(89.5 × 63.8 cm)

interior is not unlike the collections in Venice and Padua described at exactly this time by the Venetian connoisseur Marcantanio Michiel, and the way Parmigianino describes this interactive world suggests something of Camillo's way of seeing things. Everything here seems to be involved in animated exchange. The relief is in grisaille, clearly a work of sculpture, and yet the figures seem alive, acting on each other in the heat of love. The landscape, too, seems to breathe and move, and we are in fact never quite certain whether it is a painting or a view through a window. Even the book the collector holds in his hand is a Book of Hours (it has been identified with an existing, lavishly illustrated volume in Durazzo, or Durrës, Albania):

It contains prayers to be said at given times, words that were understood to
have what we could call performative power, efficacy of a real sort. But it is
also a beautiful object, an example of its kind, to be admired as an artifact at
least as much as it is meant to be used. The bronze statuette, probably of the
earth goddess Ceres, is barefoot, once standing, but now lying on the table,
like a not-quite-dead insect on its back. The coins, once active pieces of
exchange that produced real-world conversions, are now collectors' items,
worth much more than their original exchange value. And yet they lie still
close to the hand, ready to be handed to an appreciative companion. These
objets d'art, displaced, reassembled, now openly bought and sold in an
emerging art market, are still buzzing with the memory of active life. Even
the fur of the collector's coat seems to thrill in sympathy with the brush that
was used to paint it, itself made out of the softest animal hair. In the lower
right corner the fur reappears, uncannily lining the table leg as if it were a
limb. All these once active things refuse quite to settle down. It is as if the
latent animation in them is released *as a result* of their inhabiting the space
of painting.

Camillo's way of talking about images opens up a fluid continuity
between the iconic and indexical—it suggests, in fact, a displacement of the
categories altogether. Images in Camillo's description do not merely resem-
ble their objects so much as emanate from them. When we see, we come into
contact with and incorporate something of the object we perceive. That
seeing is a form of touching was a centuries-old idea. An image-defending
Byzantine theologian of the ninth century stated that "the thing seen is
touched and caressed by the outpouring and emanation of the optical rays"
and thus was reliably sent on to the mind and the memory, grounding "the
accumulation of knowledge." Even René Descartes, considered by many
to be the founder of a modern epistemology, claimed in his 1637 treatise
on optics that an image taken into the eye can "pass through the arteries of
a pregnant woman, right to some specific member of the infant which she
carries in her womb, and there forms these birthmarks which cause learned
men to marvel so." There were even more robust assertions of the physical-
ity of visual perception in the pre-Enlightenment period. For example,
the Greek philosopher Epicurus, in an account elaborated by Lucretius and
periodically revived in later centuries, explained perception in terms of the
interaction of atoms with the sense organs. Objects continually throw off

one-atom-thick layers, like skins peeling off bodies. These images or *eidola* fly through the air and strike our eyes, giving us, literally, an impression of the properties of the objects that produced the *eidola*.

Such an understanding of things was helpful in explaining the extraordinary power that sight has in people's lives—the impact it has on emotional or erotic life, for instance. When medieval and Renaissance poets speak of the image of the beloved having been impressed on the heart, as they often do, they are not merely adopting a metaphor. What sounds like a conceit was closer to a description based in period conceptions of psychology and pathology. According to these, under normal circumstances the image travels through the air, enters the eye, and is projected in a chamber in the brain, called the *imaginativa* or the *fantasia*, where it is then processed and ultimately turned into memory. But if the image arouses desire, then the heart is made to beat faster and the rising heat burns the image into the *imaginativa*. If the heat is too strong, the image imprints indelibly. Transfixed by the image, unable to process it and turn it into memory, the afflicted person is sent into a spiral of obsession, madness, and sometimes death.

No early Italian poet was more devoted to the physio-psychology of love than Guido Cavalcanti, Dante's immediate precursor. Rather than speak of images or figures flying through the air, he preferred to speak in pneumatic terms of subtle spirits and spirits of love (Rime XXII, XXVI) or even spirit-sighs emitted through the eyes (Rima XXI) or through a "spirital [sic] gaze," *sguardo spiritale* (Rima XXIV). Sometimes *spiritelli* spout other *spiriti*, producing a "rain" of spirits (Rima XXVIII). These were understood as actual ethereal beings that lit up the flashing eyes of the beloved as they flew out of them through the air and into the heart and mind of the lover. Cavalcanti even wrote a poem attempting to explain them—what we would call a meta-poem—called *Donna me prega* because it takes its occasion from a request for explanation on the part of a lady curious to know how love works its power. The poetic answer, full of freely adapted ideas from current theories of medicine, optics, philosophy, and theology, has beguiled a long list of distinguished interpreters from the Renaissance to this day. In the most difficult lines of the poem, Cavalcanti describes how love takes up its abode in the "possible intellect," the thinking faculty of the mind for Aristotle and thus the immortal part of the human soul. The poet also says love takes shape "in that part where the memory is," formed there "*chome Diafan*

dal lume d'una schiuritade," like the transparent medium is formed (made visible) through light from a darkness. Cavalcanti takes impressive poetic freedom in using a philosophical concept, the diaphane, as a metaphor for the way love is both invisible and able to take form in places like the memory. Without getting into the later interpretations of Averroes and Saint Thomas Aquinas, the primary philosophical reference here is again to Aristotle, who explains that the transparent medium in which things appear (sometimes called the "diaphane" or "diaphanous" or the "transparent medium") is light when actualized and darkness when potential; it is the medium that makes color visible, while color makes the diaphane itself visible. (The idea was well known among others to Dante, who adapts it in the *Convivio*).

The "*Diafan*" that Cavalcanti is invoking here in his own highly independent way is exactly the same "Diaphane" famously mused over by Stephen Dedalus in the stream-of-consciousness paragraph that opens the third episode of James Joyce's *Ulysses*:

Ineluctable modality of the visible: at least that if no more, thought through my eyes. Signatures of all things I am here to read, seaspawn and seawrack, the nearing tide, that rusty boot. Snotgreen, bluesilver, rust: coloured signs. Limits of the diaphane. But he adds: in bodies. Then he was aware of them bodies before of them coloured. How? By knocking his sconce against them, sure. Go easy. Bald he was and a millionaire, maestro di color che sanno. Limit of the diaphane in. Why in? Diaphane, adiaphane. If you can put your five fingers through it, it is a gate, if not a door. Shut your eyes and see.

"Maestro di color che sanno," master of those who know, is a quotation from Dante's *Inferno* making reference to Aristotle, and "the limits of the diaphane" and "Diaphane, adiaphane" are fairly clear allusions to the question of the invisibility/visibility of the diaphane discussed in *De Anima*.

If Dante was the primary reference in these matters for Joyce, for Ezra Pound, right from his earliest days, it was Cavalcanti who really understood the modality of the visible. In a multi-part essay published in 1928 in the literary artistic magazine *The Dial*, Pound offered his most sustained assessment of Cavalcanti, together with a new translation of *Donna me prega* (he had published an earlier version in 1912). In the first part of the essay, entitled "Medievalism," Pound presents Cavalcanti's poetry as an embodiment of an understanding of the world that had never existed before him and has not been seen since. Already severely reduced in the much more orthodox Dante and then completely lost to Petrarch, who really was just spinning

conceits in "fustian and ornament," Cavalcanti's "Mediterranean sanity" was foreign to dogmatic Christian asceticism but at the same time was no return to mere pagan plasticity ("moving toward coitus, and limited by incest, which is the sole Greek taboo"). Cavalcanti captured instead that radiance and registration of bodies, the awareness of an "interactive force," whereby "the senses at first seem to project for a few yards from the body." It is an animation that increases clarity—intellectual and yet not ascetic, bodily and yet not merely fleshly. You can see it, Pound says, in the early Italian painters, through Botticelli, Ambrogio de Predis, and Nic. [sic] del Cossa, but "somewhere about 1527" (the date of the Sack of Rome, sometimes taken to herald the end of the Renaissance) the bodies stop giving light back: "The people are corpus, corpuscular, but not in the strict sense 'animate,' it is no longer the body of air clothed in the body of fire; it no longer radiates, lights no longer move from the eye, there is a great deal of meat, shock absorbing, perhaps—at any rate absorbent." He goes on:

We appear to have lost the radiant world where one thought cuts through another with clean edge, a world of moving energies *"mezzo oscuro rade,"* *"risplende in sè perpetuale effecto,"* magnetisms that take form, that are seen, or that border the visible, the matter of Dante's *paradiso*, the glass under water, the form that seems a form seen in a mirror, these realities perceptible to the sense, interacting.

If a medieval natural philosopher were to return today, Pound muses, "not only the light in the electric bulb, but the thought of the current hidden in air and in wire would give him a mind full of forms, 'Fuor di color' or having their hyper-colours." But modern scientists have stupidly "reduced all 'energy' to unbounded, undistinguished abstraction." We are far removed from Cavalcanti's brief season of Mediterranean sanity, so it seems. "Or possibly this will fall under the eye of a contemporary scientist of genius who will answer: But, damn you, that is exactly what we do feel; or under the eye of a painter who will answer: Confound you, you *ought* to find just that in my painting."

That is, as Pound well knew, exactly how a number of early twentieth-century painters would have responded, and not just the Vorticists that he had championed. Linda Dalrymple Henderson has pointed to a range of artists of the 1910s and 1920s—as diverse as Boccioni, Kupka, Kandinsky, Miró, and Duchamp—who were motivated by the effort to paint the ether and the ways in which it communicates between bodies. Their "Vibratory

Modernism" was indeed, she showed, largely inspired by those electric bulbs and currents hidden in air and wire to which Pound alluded, technologies that made contact with a realm of invisible forces that was frequently associated with the so-called fourth dimension. The point was not simply to paint the intervening medium of the air but to make painting alive to that part of the world that is intersected by the invisible order of things, whether that is understood as cosmic energy or, in the words of the nineteenth-century theosophist and spiritualist "Madame" Helena Blavatsky, astral light. All of which starts to sound not very different from Camillo's figures and images and souls flying through the air and taking up residence in various media, some more diaphanous than others, or from Cavalcanti's *spiritelli*, nothing other than the soul's astral casings, leaping across the ether and penetrating eyes, hearts, and minds. Quoting the contemporary American geologist Edward Hitchcock, Blavatsky put it in highly modern terms: the ether or astral light might be storing imprints or "daguerreotype impressions of all our actions," allowing for the transference of thoughts and feelings. Centuries after Cavalcanti and Camillo, the air was alive again with "magnetisms that take form, that are seen, or that border the visible" (Pound), that border being the "Limit of the diaphane in. Why in? Diaphane, adiaphane" (Joyce).

Duchamp, of course, found his solution beyond painting, and in *Tu m'* of 1918 he offered the much-abused art his indexically loaded farewell. After which point, he might well have responded to Pound, "Confound you, you *ought* to find what you are looking for in my *Large Glass.*" The Bride Stripped Bare by Her Bachelors, Even, on which Duchamp worked from 1915 to 1923, **16.5** is the *Donna me prega* for the modern age, a philosophical poem that, like Cavalcanti, takes the workings of desire as the framework for a demonstration of the generation and transmission of energies. Or perhaps the real equivalent to *The Large Glass* is Pound's translation/rewriting of *Donna me prega*. Pound both antiquated his English and modernized Cavalcanti, producing a strange modernist monument to a nearly forgotten system of relations. In *The Large Glass*, alchemical ideas (to name just one undeniable set of references) are run through the instruments of modern technology and through modern conceptions of energy transmission. The work was developed in close proximity to Duchamp's patron Walter Arensberg, a collector of modern art and also a Dante expert and a scholar of Elizabethan literature.

Although close to artists in Duchamp's immediate orbit, such as Brancusi and Picabia, Pound admired Duchamp from a distance, and the admiration reached a height in the early 1920s, just as *The Large Glass* was achieving the form that we know today. As Pound recalled in his memoir *A Guide to Kulchur*: "A definite philosophical act or series of acts was performed along in 1916 to '21 by, as I see it, Francis Picabia. If he had any help or stimulus it may have come from Marcel Duchamp." As advisory editor for the American literary magazine *Little Review*, Pound wanted to publish a number devoted to Duchamp. In December 1922, he wrote one of the magazine's editors, Margaret Anderson: "Duchamp wd. be the most valuable collaborator you cd. get IF you can get him." The Duchamp issue never materialized; if it had, it probably would have been fairly noisy with talk derived from the notes for *The Large Glass*, talk of cinematic blossoming and electrical stripping and love gasoline. Conversely, interest in the sort of early Italian literature that preoccupied Pound was quite lively in Duchamp's circle during these years. Arensberg, Duchamp's close friend and the patron behind *The Large Glass*, published his book *The Cryptography of Dante* in 1921. This is not to claim that somehow *The Large Glass* is Cavalcanti- or Dante-inspired, or that Pound wrote the way he did about Cavalcanti because he had in fact found what he was looking for in Duchamp's engines and chocolate grinders. It is to point out that an element of medieval anachronism is part of what made these two artists so contemporary to each other in the 1920s.

Even at the basic level of the archaic-sounding title and the emphatic invitation to allegorical reading, the *Bride Stripped Bare by Her Bachelors, Even* loudly announced that its modernism was bound up with its medievalism. In the case of Cavalcanti's poem the challenges of interpretation are in part to do with the inherent difficulty of the text, which posed serious challenges even to its earliest readers, but were also "artifactual," exacerbated by sheer temporal distance and fundamental uncertainties of transcription at the level of the surviving manuscripts. Pound had to excavate in order to make Cavalcanti radiate. In the case of *The Large Glass* we are in the hands of an artist who knowingly kept things obscure, or at least unresolved, and then pointedly left the work unfinished. It had archeological-enigma status from the start. It even famously spent some time submerged under a layer of dust!

Opposite
16.5
Marcel Duchamp, *The Bride Stripped Bare by her Bachelors, Even* (also known as *The Large Glass*), 1915–23, oil, varnish, lead foil, lead wire, and dust on two glass panels (cracked), each mounted between two glass panels, with five glass strips, aluminum foil, and a wood-and-steel frame, overall 109¼ × 69¼ in (277.5 × 175.8 cm) including frame

I am offering no new interpretation here but only pointing to some basic "operational themes" that move within a context that is by now familiar. If we take the work in fundamental terms as the fruit of a sustained search for an alternative to an impoverished conception of painting (let us say that Duchamp's "retinal painting," what he sometimes called the physical or "animal" side of painting, corresponds roughly to Pound's post-1527 "corpuscular" painting, "a great deal of meat, shock absorbing, perhaps—at any rate absorbent"), then the main thing that strikes one is the emphasis on multiplicity, mobility, transformation, and transparency—not transparency in itself but precisely the emergent visibility of the diaphane, the phenomenon of figures becoming visible in an otherwise transparent medium through the activity of light. It is a glass and it is meant to be seen from both sides, fundamentally undoing the static face-to-face picture–viewer relation associated with museum settings. That is, forms are "resolved" in more than one orientation, which immediately makes the viewer aware that the forms being seen are not simply "there," in the work, but have taken up residence here, as it were provisionally. They are here only in one of their possible "phases," not unlike Camillo's migratory "figures" of the body that show up, and show up differently, in different media.

In his notes on the work, published in 1934 as *The Green Box*, Duchamp suggests that, rather than call it a picture or painting, one use the word "delay": "*Retard en verre*," or "Delay in Glass," the registration of an incident of light intersecting a pane of glass. Rather than a two-dimensional surface that is being put to the task of representing three-dimensional objects, things here have been resolved from three dimensions to two, and are appearing in thin or compressed form, provisionally sandwiched between the glass. As Duchamp put it, in note 22 of *The Green Box*, "The whole of this representation is the sketch (*like a mould*) for a *reality which would be possible by slightly distending* the laws of physics and chemistry." Duchamp outlined a language for these projections, drawing a distinction between "appearances," the ensemble of the usual sensorial data that make it possible to have a perception of the normal kind, and "apparitions," which are instantiations of visual data under particular conditions of lighting and projection. Sometimes he speaks of the apparition only being revealed in an "*image miroir*," or that it is the "mold" of the appearance of the object. These ideas were related to his interest in the fourth dimension, in particular the

idea that just as three-dimensional objects cast two-dimensional shadows, the three-dimensional objects might themselves be projections or "emanations" of invisible fourth-dimensional realities. Such relations were meant to be elaborately played out between the bottom and top panels: the "Splashes" intended for the lower (Bachelor) half but never executed were meant to find their "*renvoi miroirique*" in the "Sculpture of Drops" in the upper half, also never executed. In note 36 of *The Green Box* he says that *The Large Glass* is "*l'apparition d'une apparence.*" Glass, mirror, and foil take the place of paint and canvas so that "apparitions" can take the place of "appearances."

Linda Dalrymple Henderson has ably related this language of apparitions and emanations to contemporary occultist applications of modern technologies, and John Moffitt has indefatigably teased out the alchemical themes that pervade *The Large Glass*. There is no way to come to terms with the work without taking into account these massive recent labors of contextualization. And yet in the welter of modern and premodern technological references, the *Mariée* and the *Célibataires* do tend to disappear. The "characters" of the allegory function as little more than a pretext for the demonstration of principles, whether scientific, occultist, or alchemical, just as those nude figures one finds in the old alchemical treatises represent processes: the conjunction of opposites, the transmutation of materials, etc. And maybe *The Bride Stripped Bare by Her Bachelors, Even* is in fact no more than that kind of illustrative allegory, a demonstration of principles using picturesquely named figures. But there is that *Even*, which I can't help but hear as an admonition, a recall to the literal sense. *Même* what? *Même la Mariée? Même les Célibataires? Mise à Nue, Même?* Or maybe it is *Même le Verre,* in the same way that to eat without setting plates, straight out of the pan, is to eat *même le plat*: she is getting stripped and is realizing her *jouissance-épanouissement,* her pleasure-satisfaction, here, right here, in the glass's interactivity with light as perceived by us, the circumambulating witnesses.

In the late medieval love lyric, particularly in Pound's modernist application of it, we have a curiously fitting analogy to *The Large Glass* that works at the levels of both mechanisms *and* theme. The "interactive forces," to use Pound's term, are in fact set in motion by the workings of love and desire, just as they are in the *Glass,* particularly in the part of the lower half that Duchamp called "eros's matrix." For Cavalcanti and his contemporaries, the imagination really is the seat of the soul, and is directly connected to

225

RELICS AND
REPRODUCIBLES

Although a spectrum connected them, the relation between icon and index had been a meaningful and contested one in earlier periods, becoming especially urgent at those critical moments when images came under attack. Here, crucially, the debate was not a contest of iconic versus indexical reference, but between reference and fiction. Iconoclasts did not criticize painting and image-making as too "visual" but as insufficiently referential, unable really to refer to the personages represented, whereas the defenders of images insisted that through conformity to the visible properties of Christ and the saints images did their job reliably, and thus could serve as mediating objects of worship. The best way to argue for reliability was to insist on an indexical or quasi-indexical grounding of images. Iconophiles argued that sacred images were strongly connected to their referents through processes of quasi-mechanical replication. They attempted in various ways to minimize the role of the "author" in sacred images, or to assign images to sacred authors, such as Saint Luke, who were divinely inspired and thus not subject to the charge that they were mere fabricators, that is, fiction-makers. During the sixteenth-century Reformation, these debates also served to clarify a position that released painting from its sacred functions. According to John Calvin, the visual arts are not in themselves bad; they should simply be kept entirely clear of religious uses. Their job is to represent the world—to paint visual appearances only—but not to attempt to depict the sacred: "It therefore remains to paint and sculpt only that of which our eyes are capable, lest God's majesty, which far surpasses our sight, be corrupted by unseemly forms." The ascendancy of painting since the Renaissance, and the corresponding idea that it served a purely visual and "aesthetic" interest, was itself, in many ways, an outcome of the Reformation controversy of the sixteenth century. A disenchanted conception of pure visuality clarified the task of painting, severing it from the direct and magical workings of the index—what Peirce called the index's "blind compulsion." The twentieth century is, on this longer view, the latest iconoclastic episode, forcing a new round of contentions between the image and the index.

The sixth-century box in the Vatican discussed in chapter ten sets off the icon against the index with virtually diagrammatic clarity. The box contains stones and wood from holy sites in Palestine—from a visual point of view rubble of the most ordinary sort, except that these stones are now put on display, presented as testimony of their original sacred location. They now function as *signs*, relics of holy places, whose names are inscribed in Greek on each object. Relics are an especially strong form of index known as a *sample*. These stones, like good Peircean indexes, refer to their objects "not so much by any similarity or analogy with it": they are visually undifferentiated, visually indistinguishable from stones or wood that could be found in many places. Nor do they refer to their objects because they are, again in Peirce's words, "associated with general characters which that object happens to possess": they do not give a general impression of Bethlehem, or of Golgotha. Instead, they refer to their objects because they are "in dynamical (including spatial) connection both with the individual object, on the one hand, and with the senses or memory of the person for whom it serves as a sign, on the other hand."

On the lid of the box, by contrast, we have icons, scenes from the story of Christ, an illustrative complement to the material remains inside the box. The images are on the lid, practically contiguous with the stones that lie "underneath" them, as if the "dumb" but authentic relation to the holy sites presented by the stones is made to speak in legible and visible terms in the images: the painted lid makes this a "historiated" box. The connection between the stones and the images covering them is occasionally but not consistently a one-to-one relation—there is no image-equivalent to the stone from Zion, and conversely there is a stone from Mount of Olives but no scene of the Agony in the Garden—and yet in general terms the images here read as if they are more than mere illustrations, as if they are *brought forth* by the material samples. The stones are physically far from their original locations and yet are directly connected to those sites; since they are extracts there is, in fact, no distance between them and their sites. They are *samples* of those sites. By contrast the images are, semiotically speaking, much further removed from what they represent, and yet they sit on the lid directly covering the stones, practically touching them. Underlying the image, the stones are a concrete link between the image and what it represents. The index grounds the image.

With this relationship in mind, it starts to look as if the rise of independent panel painting to a preeminent position in early modern Europe was a highly improbable, even surprise victory. Until the later Middle Ages, painting in the West was most often used, as it is here, to adorn the surfaces of other, more sacred things, like reliquaries, altar frontals, and church walls—that is, it decorated objects that had a more powerful, because indexical, charge. The reliquary carried the relic, the altar needed to have either a relic or the eucharistic host embedded in it in order to be consecrated, and the church masonry was part of a consecrated house of God. But especially in Italy from the thirteenth century, and in good measure under the inspiration of a new influx of Byzantine painted panels, painting began to assert its autonomy, as it were peeling itself away from those surfaces and increasingly coming to occupy the center of Christian worship.

Even in Byzantium special efforts were made to give painted panels a material grounding—that is, to enhance their referential claims through indexical reinforcement. Unlike the pagan gods, who do not have bodies in the usual sense, the Christian god assumed a human form. The saints were holy mortals. This basic fact endowed images of them with a powerful "real-world" referentiality. However, Christian doctrine teaches that Christ's body did not remain on Earth but returned to heaven, and that it will become visible again only at the end of time. With the possible exception of the foreskin removed at the Circumcision, no part of it remains, putting a special onus on images as testimony to its temporary but all-important presence. The image, as Hans Belting has said, was not only justified but also specifically called for as a witness of this now absent historical figure. The same applies, according to Christian doctrine, to the image of his mother, whose physical form was assumed to heaven three days after her death.

Especially after the eighth-century iconoclasm, authorities propagated powerful legends concerning the likenesses of these two foundational personages, all of which were intended to bolster their evidentiary authority as portraits. In almost every case, the image-function was reinforced through association with another means of verification. The legends of Saint Luke as painter made him the portraitist of both the Virgin and of Christ (as well as the illustrator of all the principal scenes of the Gospel story). By this means, Christian image-making was given a footing that was meant to carry an authority equal to that of the evangelist's texts. Even as the Gospels are to

be believed as testimony of Christ's life, so are these visual testimonies. In the closely related yet separate legends of the Mandylion and the veil of Veronica, according to which Christ's face was impressed "mechanically" **17.1** on a piece of cloth, the resemblance-function of the image is a function of the indexical imprint. The Mandylion (a word based on the Arab *mandil* or towel) is an image that is also a contact relic. In all of these cases, the fallibility of the man-made portrait is supplemented by a more reliable authority, the divinely inspired hand of the evangelist, or the complete elimination of human handiwork.

The peculiar claims of the images of Christ and the Virgin established a precedent for Christian imagery in general, despite the fact that the bodies of saints, unlike those of the Virgin and Christ, were not in principle absent, and indeed relics of those bodies competed for attention with their images. Here again the efficacy of the icons of the saints stemmed from the authenticity with which their likeness was captured in a presumed original moment of portraiture. Henry Maguire has shown just how stringent were the criteria for successful portrayal. If the saint was alive, it was necessary that the portrait originate in a "sitting" with the portrayed person. If the saint was dead, accuracy was maintained through the activity of copying earlier authentic images, or through a miraculous postmortem visitation. Such a story is told about the icon of the eleventh-century Saint Nikon the Metanoeite, a legend recounted and analyzed by Maguire. After being saved by Nikon from conviction for treason, a local grandee wanted a portrait of his savior. He described Nikon's appearance to a skillful artist and asked the painter to produce the likeness. But the artist could not paint it as he had never seen him. At that point a monk entered his house claiming a perfect similarity to Nikon. The artist rushed to his panel to prepare himself, only to find the holy appearance of the saint already automatically impressed upon the wood. When the artist turned back to look at the mysterious monk, he had vanished. Finally, when he brought it to the man who commissioned the portrait, it was found to be an indistinguishable likeness of Nikon.

The mechanics of photography may not have been invented until the nineteenth century, but the idea of a photograph—an image not invented by a human agent but captured from reality and then transmissible in mechanically generated copies—was already well conceptualized centuries earlier. Photography provided a new mechanical application of an old

17.1
Mandylion of Edessa
(also known as the
relic of Saint Veronica),
unknown date and
place of origin,
painted cloth, 11 × 7½ in
(28 × 19 cm); frame
added in 1623, silver
gilt, enamel, 25⅝ ×
17¾ in (65 × 45 cm).
The legend of the cloth
of Veronica, used to
wipe Christ's face and
preserving an impress
of his likeness, was
adapted in the West
from Byzantine legends
of the Mandylion, and
took many forms.
The cult of the relic
in Rome was fully
established in the
thirteenth century. The
relic in Saint Peter's,
a major pilgrimage
target, was lost in the
early sixteenth century.
This likeness, which
some scholars believe
to be an early medieval
work, is similar to the
lost Veronica. It was
relocated to Saint
Peter's in the sixteenth
century from the
Roman church of San
Silvestro in Capite.

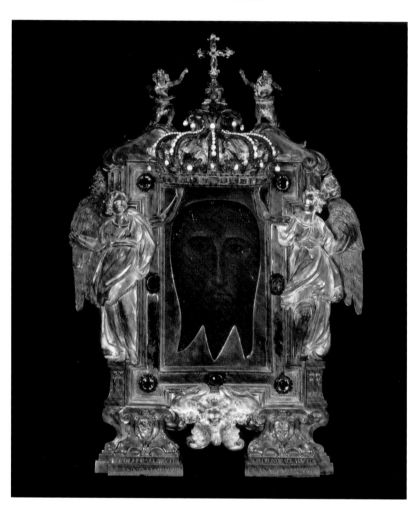

idea. The old opposition between photography and painting, lampooned
by Gustave Flaubert in the 1870s and still stridently insisted on by post-
modernists a century later, is now fading away, and only in part because of
the possibilities opened up by digital manipulation. Rather, it is now again
possible to think of them as part of one field of image-making, as Roland
Barthes understood when invoking the Mandylion and other images not
made with human hands in his 1980 discussion of photography, *Camera
Lucida*. (In his mention of "skins" and "emanations" he even appears to be

232

making reference to the theory of the decortications described by Lucretius and others, mentioned in the previous chapter.)

The Byzantine iconoclasm began, reputedly, with the destruction of the icon of Christ at the Chalke gate of the imperial palace of Constantinople, and in the place of images the iconoclasts promoted the Eucharist, which upon consecration in the mass is transferred from the domain of the "hand-made" to that of "made without hands" and becomes the true image (*eikon*) of Christ—a non-figurative and thus non-idolatrous image, instituted by Christ himself. The defense from the iconophiles, as we have seen, was to have authentic images of saints, reliable foundations that would provide the conditions for reproduction of the image ad infinitum. Images of the Virgin existed in series, and legends of the Mandylion speak of its almost immediate self-replication.

The principle held true even for images made by human hands. If images are the authoritative transfer of the body onto a medium, then it also holds that this process could be repeated. Striking affirmations of the idea emerged in Byzantium in the wake of the iconoclastic controversy. The ninth-century theologian Saint Theodore of Stoudios, for example, compared the relation of image to prototype to the impress of a seal on different materials at different times: The likeness exists independent of the material icon, just as the image engraved on a signet ring can be impressed on different materials, such as wax, pitch or clay; the same image travels across the different media. For this reason, a recently produced icon could still claim the status of ancient testimony. "The same applies," he wrote, "to the likeness of Christ irrespective of the material upon which it is represented." Theodore of Stoudios's analysis of the image puts the claims of Walter Benjamin's essay "The work of art in the age of its technological reproducibility" in a usefully broad context. It is not only that the mechanical reproduction of artifacts was well known in premodern times (Benjamin himself points to certain examples of it, such as bronze casting); it is that serial production was, arguably, the primary model for thinking about the generation of images, even those images that were in fact manually produced.

The early twentieth century recuperated the notion of the multiple under the sign of the machine. In László Moholy-Nagy's *Malerei, Photographie, Film* of 1925 (with a second edition two years later), a book that Benjamin read attentively, the Bauhaus designer and typographer set out to come to

of art by paying slavish and grotesque obeisance to it, thus pushing the pleasurable protocols of viewing and connoisseurship—the making of fine discriminations—into nauseating paranoia.

Is it a coincidence that these terms, and these issues, came back with such strange force in the twentieth century? The *Einzelstück* is revealed to be a fetish of the bourgeoisie, nothing other than an idol, and, once again, we see a propagation of the image in the form of serial production. The structural companion to this move was the forceful return of the logic of the relic in the various stagings of the found object proposed by twentieth-century art. One need only think of Kurt Schwitters's reliquary-like chests filled with his patrons' personal memorabilia, Joseph Cornell's boxes, Robert Rauschenberg's early *Feticci* and *Scatole Personali*, Joseph Beuys's vitrines, Lucas Samaras's boxes, Paul Thek's *Technological reliquaries*, Daniel Spoerri's *Trap Paintings*, the central receptacle of Nancy Holt's *Spinwinder*, and Jeff Koons's vitrines, to name a few instances. The founding act of this lineage is Duchamp's *Bicycle Wheel*, placed upside down on a stool in 1913. Given his contempt for merely retinal painting, it seems natural that Duchamp would turn back to the logic of the relic. In the Middle Ages, relics often interacted with the images that encrusted their reliquaries, with images embedded in altarpiece structures that housed them, and with images in their larger surroundings. And yet relics also represented a limit case for images, and sometimes were conceived in opposition to images, as we have seen. Relics did things that images could not do, unless the image was itself a relic, such as the Mandylion. The readymade was a logical application of Duchamp's determination to set art "as far as possible from 'pleasing' and 'attractive' physical paintings"—that is, from the art of the bourgeois era. Before bourgeois art, Duchamp said, art "had been literary or religious: it had all been at the service of the mind." Relics are physical things, but they are also conceptual objects. They are both lower and higher than painting.

The point of setting these two terms into relation is not to claim that relics and readymades are the same thing, or that the precedent of the relic cult somehow influenced Duchamp, but to try to see both afresh. In the readymade as in the relic, an ordinary object, indistinguishable from many others like it, is set off as something extraordinary. One bone looks much like any other bone. This sandal is an ordinary example of its kind. These rocks are indistinguishable from mere rubble. And yet they were different

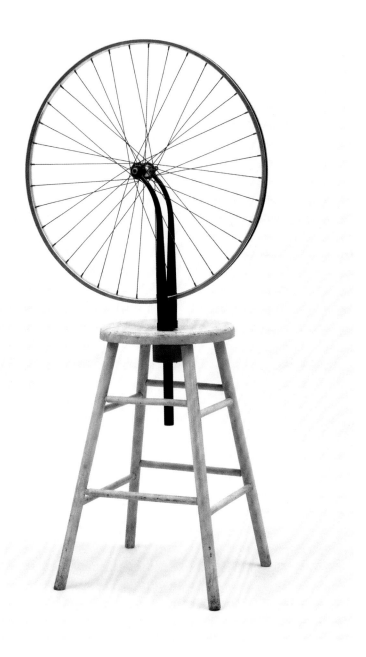

17.3
Saint Andrew's Altar,
c. AD 980, Trier
Cathedral, Germany,
oak, gold, jewels, ivory,
pearl, and enamel. This
portable reliquary altar
bearing a gilded model
of Saint Andrew the
Apostle's foot contains
the sole of one of the
saint's sandals, along
with other relics said to
have been brought from
the Holy Land to Trier
by Saint Helena in the
fourth century.

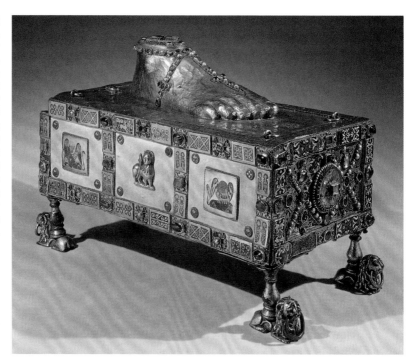

from other things much like them because they had a specific provenance,
having come into contact with sanctity. Relics were not consecrated at
all but rather recognized; they were inherently powerful as a result of the
histories that attached to them. The relic of Saint Andrew's sandal now pre-
served in Trier Cathedral is sacred because it was for some time in contact
with the saint's foot, the foot that traveled distances preaching the Gospel
and that was attached to a body that ended in martyrdom. In its presentation
at Trier, it is what Duchamp would have called a readymade-*aidé*: The relic
is presented in its reliquary, inside a golden box, with a golden foot pressing
down on it.

The readymade becomes special through the arbitrary act of the art-
ist's having selected it, named it, and put it on display. If the medieval
relic drew its significance from its link to sanctity, Duchamp used the art
system as a readily available (in fact readymade) consecrating mechanism.
The process of consecration is post hoc: the object does not live through a
history linked to a saint or to Christ but is arbitrarily designated, as it were

238

retroactively, by the artist and consecrated by the art gallery. Indeed, its history needs to be entirely ordinary (in principle) in order for the act of reassignment to be arbitrary and thus meaningful, as Duchamp insisted in various interviews and writings. The willful manipulation of a prevailing system, of course, carried different consequences, primary among which is to prompt reflection on the mechanisms of consecration themselves. This kind of critical reflection was not, typically, what reliquaries were designed to promote. But they were subjected to just such withering scrutiny during periods of iconoclasm. Thus, if there is a parallel to Duchamp's gesture it is not the medieval relic cult as a whole but those moments when its modalities came under criticism. The Reformation's dismantling of the relic cult is the mirror image of the Duchampian intervention.

But if that is true, then perhaps there is something about Duchamp's return to the modality of the relic that goes in the opposite direction—a reenchantment, and not merely a repetition of the Reformation disenchantment. It is easy to insist on the "critical" thrust of the readymade, the ways in which it shifts or unseats art-world pieties. But Duchamp's insistence on the anti-aesthetic character of the choice, and the rules he had to impose on himself in order not to lapse into the adoption of latent aesthetic judgment, have something of the quality of ritual. Moreover, the commemoration of the moment of the choice has parallels in the documentation and labeling of relics. Here are notes from *The Green Box* of 1934:

Specifications for "Readymades".
by planning for a moment to come (on such a day, such a date such a minute), "to inscribe a readymade."—The readymade can later be looked for. (with all kinds of delays).—
The important thing then is just this matter of timing, this snapshot effect, like a speech delivered on no matter what occasion but at such and such an hour. It is a kind of rendezvous. Naturally inscribe that date, hour, minute, on the readymade as information.
Also the serial characteristic of the readymade.

In 1961, speaking on a panel at MoMA gathered on the occasion of "The Art of Assemblage" exhibition (the other panelists were Lawrence Alloway, William Seitz, Robert Rauschenberg, Richard Huelsenbeck, and Roger Shattuck), Duchamp was asked what kind of reaction he aimed to elicit from the observer with his readymades. So far from administering a dose of early institutional critique, his answer emphasizes an effect of release, a productive opening of the associative imagination:

Well, very simple. The main point is disorientation for the spectator, as it was for myself when I did it. And then surprise comes in as an element. Connotation: meaning according to the observer's imagination—he can go into any field or any form of imagination he wants. And associations of ideas.

And in a 1956 interview with James Johnson Sweeney, the affirmative tone is even more general:

For me "intellect" is too dry a word. I like the word "belief." I think in general when people say "I know," they don't know, they believe. I believe that art is the only form of activity in which man as man shows himself to be a true individual. Only in art is he capable of going beyond the animal state, because art is an outlet toward regions which are not ruled by time and space.

CATHEDRAL THINKING

The Arts and Crafts movement had William Morris as spokesman and Ruskin as prophet. Art Nouveau and the Viennese Secession developed in symbiotic relation with Alois Riegl's interest in the flow of ornamental motifs through time, as well as his work on the "minor" arts and subordinated eras such as the "late Roman art industry." The first experiments with abstraction at the beginning of the twentieth century, widely recognized as an epochal break with a longstanding tradition of European bourgeois painting, unfolded, at least in some areas, in dialogue with Wilhelm Worringer's 1908 and 1911 books on abstraction and medieval and "northern" art. Meyer Schapiro in New York introduced artists from Fernand Léger to Allan Kaprow to the startling achievements of Romanesque art. McLuhan, Eco, and Steinberg found in medieval aesthetics and theology a curiously viable high road into the newly interconnected realm of the electronic media and into the new experiments with open structures, multimedia installation, and world- and viewer-involving art. It was, apparently, impossible to think of seeing an end to the gallery picture and to the modern category of the fine arts, or to think of site-specificity and viewer participation, or to question the category of the "viewer," or to propose to integrate art anew with the world, or to challenge humanistic art and traditional approaches to figuration, without working through one or another model of premodern art-making.

I wish now to return to one of the major matrices of medievalism in twentieth-century art, the Bauhaus, and I propose to start with the remarkable fact that the first Bauhaus manifesto of 1919, one of the founding documents of twentieth-century modernism, carries a banner image of a Gothic cathedral. The Bauhaus School in Weimar and the Arbeitsrat für Kunst in Berlin opened within months of the postwar declaration of the Weimar Republic in November 1918. The first Bauhaus manifesto appeared in April 1919, a single-folded, double-sided document of four pages announcing the opening of the Weimar Bauhaus school. Exemplars were printed in different colors—green, orange, and tan—on thin, cheap paper and so survive today in highly delicate condition. The text consists of a two-page statement of the principles, goals, and curriculum of the new

INSTEAD OF CATHEDRALS, MACHINES FOR LIVING

The cathedral thinking of the early Bauhaus did not last long. Already by 1922 there were clear signs of a materialist revanche, not least of all within Behne's own thinking. In Bruno Taut's short-lived journal *Frühlicht*, Behne explained in late 1921 that the first flush of utopianism after the war and the founding of the Republic was over, and now the "Utopists" were turning their attention from the fantastical to lived experience and to the exploration of the "New," free from all tradition. A few months later he reacted with disgust to Peter Behrens's *Dombauhütte* (cathedral lodge) erected for the Munich Gewerbeschau in 1922, which displayed a crucifix by Ludwig Gies that can only be described as a caricature of late Gothic devotional art. The "so-called religious art of Expressionism," Behne now declared, "is for the most part impious self-deceit, no more than a fashion." An artificial relationship between form and social reality, he argued, can only produce mannerism:

No one can simply find a form for a mode of "Cathedral lodge building." Form comes from thing. Where there is no thing, but instead only a word, an unclear, stillborn concept, then no form can take shape. Instead we have a complicated, arbitrary, senseless artifice, neither a house, nor a hall, nor a tent, nor a lodge, nor a hut, just a piece of mind-agitating, barren decoration.

A common front on this question seems to have formed at this time among the Bauhaus circle. In the same year, 1922, the designer Oskar Schlemmer entered a tart version of the sentiment in his diary: "Turn away from utopia. We can and should be allowed (to have) only the most real, we want to strive for the realization of ideas. Instead of cathedrals, machines for living."

Even as he was abjuring Expressionist-utopian medievalism, Behne was in fact still following the thinking of the guru of the Expressionist generation, Wilhelm Worringer, a historian of medieval art who had electrified the world of modern art with his 1908 thesis *Abstraktion und Einfühlung* (Abstraction and empathy) and the equally successful follow-up *Formproblemen der Gotik* (Form problems of the Gothic) of 1911. Worringer's strong associations with the avant-garde were solidified in the early Weimar period by his affiliation with the Arbeitsrat für Kunst and thus with Gropius, Taut, and Behne. But already in his 1921 essay "Künstlerische Zeitfragen" (Current artistic questions), which Behne quickly absorbed, Worringer

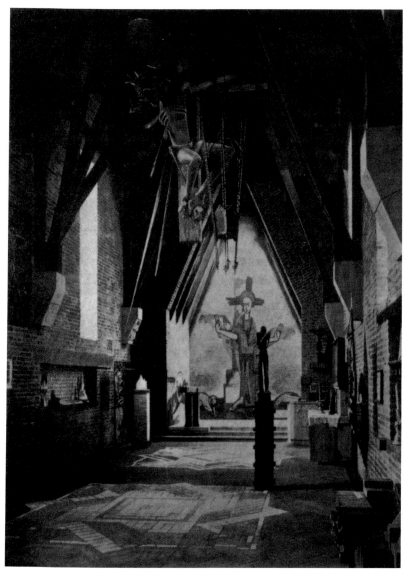

19.1
Peter Behrens, *Dombauhütte*, 1922, with Ludwig Gies's *Crucifix*. Designed by Gropius's teacher, this fantasy of cathedral combined with cathedral masons' lodge served as the exhibition space of the Munich Gewerbeschau in 1922. It came under fire from both right-wing critics, who succeeded in getting Ludwig Gies's Expressionist crucifix removed, and left-wing critics such as Adolf Behne, who called it a "piece of mind-agitating, barren decoration."

19.5
El Lissitzky, design for
Abstract Cabinet, 1927,
gouache, collage,
15¾ × 20⅝ in
(39.9 × 52.3 cm)

was understood by contemporaries to be consistent with the *Prounen-Raum* or the *Abstract Cabinet*; Dorner was disgusted by the "social irresponsibility" of the *Merzbau*, which he deemed an infantile regression to playing with fecal matter.

Behne's rhetoric in *Von Kunst zur Gestaltung* is close not only to El Lissitzky but also to Moholy-Nagy, with whom Behne was in contact in these years. The coincidences with Moholy-Nagy's *Malerei, Photographie, Film*, also of 1925, are so close that we have to imagine a fairly concerted exchange of ideas between the two. Attempting to come to grips with the implications of new technologies in image media and new means of production, Moholy-Nagy elaborated a series of distinctions between the static *Pigmentbild* of former times and the kinetic *Lichtbild* now coming into being. The easel painting, he

asserts, is being replaced by *Lichtspiele*, and fresco painting is being replaced by film, developments that bring with them two major consequences: serialization and dynamization. In the second edition of 1927, Moholy-Nagy added the more pointed assertion: "Painters of genius don't know technical matters that every technician knows." It is this knowledge that now matters, as a preoccupation with "artistic" manual production gives way to a more conceptual concern with the "generation of the work."

The argument was to have an important effect on Walter Benjamin as he elaborated his essay on the work of art in the age of its technological reproducibility. But in their moment Moholy-Nagy's views were above all in dialogue with Behne's 1925 book, and nowhere more clearly than in the sharp polemic in favor of serial production, discussed in chapter seventeen. As for dynamism, if Behne preached the effacement of the boundary between art and society and the virtues of an active art of *Konstruktion* that would overthrow the static *Komposition* of the bourgeois easel picture, Moholy-Nagy embraced film and other experiments with moving projected images or *Lichtbilder*. During the 1920s Moholy-Nagy was at work on the *Licht-Raum-Modulator*, a metal-and-mirror construction of movable mechanical parts 19.6 designed to throw colored light into changing configurations. Alexander Dorner had intended to set it up in a "Contemporary Room" within Hannover State Museum, a project that was never realized. If pigment had been the primary medium for color construction in traditional easel painting, in the new world of *Gestaltung* light itself would play that role.

This seems a far cry from the cathedral thinking of a few years earlier, and yet in the conceptualization of alternatives to the traditional *Pigmentbild* medieval models of art continued to be acutely relevant. Only in medieval art, namely in stained glass, did Moholy Nagy find a precursor for the 19.7 modern projected and moving colored image, a precursor whose promise would now be realized:

Medieval stained glass alone points to another concept that has not been fully worked through. Here, the coloring of the surfaces is supplemented by a certain spatial-reflective radiation. In comparison, the deliberate contemporary experiments with reflectively and projectively thrown dynamic colored construction (continuous light construction) open up new possibilities of expression and thus new principles.

Thus, medieval models continued to be effective, but they became more process-oriented, in keeping with the new dynamic aesthetic and the new

19.6
Lászlo Moholy-Nagy,
Licht-Raum-Modulator,
1922–30, steel, plastic,
wood, and other
materials with
electric motor,
59½ × 27½ × 27½ in
(151 × 70 × 70 cm)

Opposite
19.7
Refraction of light
through stained-
glass window, Saint
Stephen's Cathedral,
Vienna

real-world emphasis. As early as his 1922 article "Art, craft, technology," Behne declared: "The static god will become a dynamic god. If until now god was complete for each person taken individually, now totality will be an immediate god, of which each person will be a function." A different model of medieval art now emerged, one that needed to be worked through.

The shift was accompanied by a shift from the tutelage of Worringer to that of Wilhelm Pinder, who spoke to the new concerns. One of the most widely read art historians of Weimar Germany, he was a defender of the modern German architecture or Neues Bauen. (His most famous pupil was Niklaus Pevsner, whose *Pioneers of the Modern Movement: From William Morris to Walter Gropius* appeared in 1936.) For Pinder, the late medieval church space underwent a development very similar to what was happening in his own time, only in the opposite direction and at a somewhat slower pace. Between 1200 and 1500, work in the medieval church went from being a product of the collective *Bauhütte* or worker's lodge to being the product of the individual master's workshop. Sculpture, the most important arena of image production, registered the shift with great sensitivity: In the earlier period it was bound to its built environment, whereas in the later period it was focused on the individual work. Altarpieces, microcosms of the larger architecture, became independent entities demanding autonomous attention. "Behind the earlier sculpture we feel the presence of the art of architecture," Pinder wrote, "behind the later sculpture we feel the presence of painting."

The fourteenth and fifteenth centuries, according to Pinder, would see the rise of the modern artist and the paradigm of the new conception of the art work: the *Tafelbild* or easel picture. This was a long and complex process with a good deal of overlap in the various modes of practice, and yet Pinder pinpoints a dramatic moment of conversion in the middle of the fourteenth century, in particular in the sphere of the great sculptor Peter Parler, an early example of the new type of artist. The medieval church went from being a space of episodes of kinaesthetic proprioception to a unified space of contemplative optical experience. This was, for Pinder:

the beginning of a turn away from rhythmicized [*rhythmisierten*] space to a unified visualization of space, from the motorically experienced to a stilled, laid-out [*hingebreiteten*] space. Here [in the new conception of architecture] one sees that the whole wants to be there before the parts, rather than through them.

In the place of malleable configurations that coalesce and dissolve in the course of perambulation, we now move toward a plottable, clear space that "heralds the Renaissance." The church now became a theater of visual experiences focused on the high altar, which created a separation between a spectacle and a congregation, a congregation now understood as an (immobile) public of *viewers*. The predominance of visual experience in modernity and the corresponding hegemony of the "picture" as the primary form of visual art were prefigured and prepared by the tendency toward "unified visualization" in late-medieval spirituality and church design.

As Worringer had done in his own way, Pinder here is offering an inventive adaptation of Alois Riegl's basic distinction between the haptic and optic modes in artistic experience. But whereas for Riegl the two modes were both forms of visual appropriation, Pinder elaborated on the tactile side of the question by emphasizing the actual movement of the perceiver's body through space. In this sense he was drawing on the lessons of his teacher August Schmarsow, who had developed a theory of architectural space and bodily movement based on the idea of *Körperempfindung*, or body sensation. In his 1904 thesis on the "rhythm of the Romanesque church interior," written under the direction of Schmarsow, Pinder had already developed his conception of dynamic experience of architectural space. Pinder's main move in the 1920s was to historicize and dramatize the relation between haptic and optic, or rather between the kinaesthetic mode and the visual mode, by staging a momentous historical "turn" (*Abkehr*) from one to the other at the threshold of modernity. Pinder was in fact describing a transition from *Gestaltung* to *Kunst*, nothing other than a reverse image of the transition from *Kunst* to *Gestaltung* discussed and debated in contemporary avant-garde writing.

All of this, incidentally, reveals just how crudely conceived was Behne's one-liner photomontage, discussed above, which overlaid Watteau's connoisseurs on a church space in order to illustrate the point that both the bourgeois and the medieval modes of art-making and art-viewing are forms of cultic contemplation, to be superseded by modern, participatory *Gestaltung*. The setting in Behne's montage is, in fact, a Counter-Reformation church with the medieval multiplicity and chaos cleaned out of it and with all attention now focused on the tabernacle on the high altar. It stands, in other words, clearly on the modern side of Pinder's

medieval–modern divide, already participating in "pictorial" ways of seeing. And Watteau's painting, as we have seen, is not merely an instance of traditional old master painting but a meta-painting that comments critically on the new protocols of viewing and buying paintings. Moreover, it was made as a shop sign facing the street, not an easel painting, and so assumes an oblique relation to the rituals it represents. It stands, conceptually, on Behne's side, anticipating his critique of the easel picture. Behne's montage is a multiple misfire.

Pinder's "motorically experienced" premodern church space resonates with Moholy-Nagy's conception of the dynamic experience of the new media, where we find, as he described it, a "state of increased activity in the observer, who, instead of meditating upon a static image and instead of immersing himself in it" is forced "simultaneously to comprehend and to participate in the optical events." This was an adamant modernism of new media and technologies, and yet as we have seen, Moholy-Nagy was able to see a medieval connection, seeing the modern *Lichtbilder*, including film, as a fulfillment of the kinaesthetic potential implicit in the "spatial-reflective radiation" of stained glass.

Moholy-Nagy's book was nothing less than an attempt to "come to grips with the problematic of the new optical configuration [*Gestaltung*] of today." As he describes it, this was a configuration that involved mechanization, serial production, and new experiences of spatial and temporal immersion in image-environments. It is not hard to see why the book was of some significance for Benjamin, immediately informing his 1927 *One Way Street* even at the level of typographical layout, and in a more indirect way "The work of art in the age of its technological reproducibility" of 1936. In that essay, Benjamin saw the experiments of the Dadaists and Surrealists fulfilled and turned into a thoroughgoing social phenomenon in film. The key was what he called, in a 1929 text on Surrealism, the discovery of "one hundred percent image space" as a field of political action. This new image-space is no longer separate from the "space of the body." It no longer involves the contemplative distance of the traditional bourgeois work of art. "What we used to call art begins at a distance of two meters from the body," Benjamin wrote in another essay on Surrealism of 1927, "but now, in kitsch, the world of things advances on the human being; it yields to his uncertain grasp and ultimately fashions its figures in his interior."

In his celebrated essay of 1936, Benjamin offered a more sustained account of the new mode of perception that accompanies the age of photography and film, contrasting it (inevitably!) to the contemplative attention demanded by easel painting. "Panel painting is a creation of the Middle Ages, and nothing guarantees its uninterrupted existence." But in order to articulate the contrast, and to elaborate on the new perceptual mode, what he now describes as receptivity "in a state of distraction," Benjamin turns to architecture, and in a way that recalls Pinder's conception of dynamically experienced space. Benjamin makes a point of saying that he is referring to something distinctly unmodern—he does not invoke modern architecture but an unspecified general, even archaic, conception of architecture, now understood as the guide to the most modern of experiences: "Architecture has always represented the prototype of a work of art the reception of which is consummated by a collectivity in a state of distraction." Although without reference to a particular period, this passage reads as if Pinder's medieval church space has been recruited into the new terms of "distraction." In Benjamin's hands, Pinder's episodic proprioceptions are theorized in urban, modern terms as a mode of attention that is routine, active, piecemeal, and not absorbed:

Buildings are appropriated in a twofold manner: by use and by perception – or rather, by touch and sight.... On the tactile side there is no counterpart to contemplation on the optical side. Tactile appropriation is accomplished not so much by attention as by habit. As regards architecture, habit determines to a large extent even optical reception. The latter, too, occurs much less through rapt attention than by noticing the object in incidental fashion.

Frederic J. Schwartz has shown that this passage was directly informed by the art historian Carl Linfert, in particular Linfert's analysis of architectural drawing published in 1931, itself an effort to apply the ideas about the allegorical imagination developed by Benjamin in his 1925 professorial thesis *Ursprung des deutschen Trauerspiels* (The origins of German tragic drama). Linfert contrasted the synoptic view of a building offered by a perspectival drawing with the composite assembly required by drawings of buildings in plan and elevation, which construct a totality independent of a viewing position. For Linfert this spoke to the fundamentally apictorial (*unbildlilch*) nature of architecture: "Instead of seeing, the eye must feel its way through [*durchspüren*] structures." The language is not far from Pinder's, and for good reasons. This text, Linfert's doctoral thesis, was written under the direction

20.1

Spread from *Frühlicht*, vol. 1, no. 3, 1922, showing on the right Schwitters's explanation of his work *Schloss und Kathedrale mit Hofbrunnen*

beech-tree stump, a "cathedral" made up of an irregular and pointy pine-tree stump, and a "fountain" made out of a medicine-bottle cork, all nailed onto a cheap piece of board. This was, he explained, *Merzarchitektur*, intended as a spur to the imagination of architects, the primary readers of this journal. *Merz*, he says, is the use of already existing materials for new art works, and thus architecture is a signal instance, perhaps *the* signal instance, of *Merz* at work. Due to the durability of its materials, architecture is always forced to reuse older materials in new projects, endlessly producing rich and beautiful buildings. The style of the older piece did not matter to the architect, only the new unity. Continual reuse is the history of architecture. Entire cities, Berlin for example, should be rebuilt this way and so be turned into huge *Merzkunstwerke*. The article with its illustration takes up one page, and this is the page usually reproduced in studies on Schwitters. But the facing page was intended as part of the visual and conceptual impact of the spread. There Taut placed an array of photographs of the architecture of Antonio Gaudì, including an image of his real cathedral, the Sagrada Familia in Barcelona.

Within a few years Schwitters was embarked on building his own cathe-
dral, the *Kathedrale des erotischen Elends*, or Cathedral of Erotic Suffering, a
cumulative column that would develop into the *Merzbau* in the 1930s. The 20.3
process, which began by his own account in 1923, was a three-dimension-
alization of the collage activity Schwitters had been engaged in for several
years. Just as bits and pieces of refuse were assembled into two-dimensional
compositions, whole objects and works of art were assembled and embed-
ded in the space of his studio, beneath his living quarters. A collage entitled
Der erste Tag (The first day) that once occupied the base of one of the early 20.2
columns (not in fact the column called *Kathedrale des erotischen Elends*)
eventually served as the frontispiece to Schwitters's 1931 essay "Ich und
meine Ziele" ("Myself and my aims"), the most comprehensive statement
he made about the *Kathedrale* and what was to become the *Merzbau*. Why
would he have put it at the head of an essay describing a work to which
it did not belong? Perhaps it was because the other column to which the
collage belonged was just then joining the column of the *Kathedrale* in a
more comprehensive installation. Or perhaps the now-lost collage, which
figures among other things a column, could be seen retrospectively as a sort
of germ, a fractal emblem of the whole project. To the left we see angels
from two different sixteenth-century paintings, and to the right a detail
of drapery from a painting in the vicinity of the fifteenth-century painter
Robert Campin. Toward the center, adjoining the photo of the column,
is a detail of yet more angels, in this case from Stefan Lochner's *Virgin in a
Rose Garden* of the mid-fifteenth century. The angels, flowers, cloud, and 20.4
drapery are forms of what could be called *Beiwerk*—beautiful, complex,
self-similar, which is to say infinitely repeatable, they are supplementary to
a central image that they adorn and celebrate. But here there is no Virgin or
any other central image, apart from the column with its attendant female
figure. Thus we have the basic elements of a generative interactivity: the
column that has already attracted the female figure, and then these supple-
mentary elements that can be multiplied at will. All of it might amount to
"Kunst," as the only textual element in the collage reads.

The messiness of the *Kathedrale*, and eventually the *Merzbau*, its hidden
reaches, its layerings, may seem a far cry from the clarity of Gropius's vision
for the Bauhaus. But in fact Feininger's woodcut shows us a cathedral that
is porous, resonating with its environment. And the glass architecture of

20.2
Kurt Schwitters,
Der erste Tag
(The first day),
collage, as reproduced
in *Merz*, no. 21, 1931

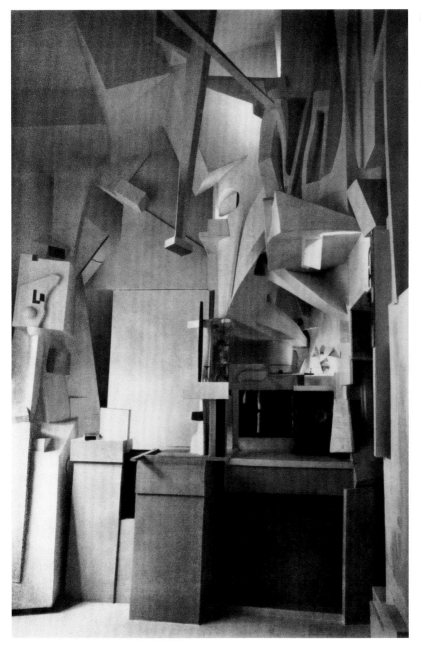

20.3
Kurt Schwitters,
Merzbau installation,
5 Waldhausenstrasse,
Hannover, c. 1923–36,
photograph taken
1932/3

20.4
Stefan Lochner,
Virgin in a Rose Garden,
c. 1440–2, oil on panel,
19⅞ × 15¾ in
(50.5 × 40 cm)

Bruno Taut was conceived as a model for a world without borders and without governments, an architecture in touch with the rhythms of nature and with the organic life inhabiting it: his houses were designed with flexible and multi-directional parts which could be arranged to afford smaller enclosures in contemplative moments and open up for more social

activity. Some of the buildings were even designed to be mobile, a true accompaniment to the nomadic body. It was architecture conceived as "an outer, living skin, which responds to and echoes the moods of those within." This architecture of changing functions and shapes was decried as "formless" in the later 1920s. We are not far from the *Merzbau* after all.

According to Schwitters's son Ernst, the process began as an art installation:

His pictures would decorate the walls, his sculptures standing along the walls. As anybody who has ever hung pictures knows an interrelation between the pictures results. KS, with his particular interest in the interactions of the components of his work, quite naturally reacted on this. He started by tying strings to emphasize this interaction. Eventually they became wires, then were replaced with wooden structures, which, in term, were joined with plaster of paris. This structure grew and grew and eventually filled several rooms on various floors of our home, resembling a huge, abstract grotto.

This origin-legend can be challenged; we know from Schwitters's own account in "Myself and my aims" of 1931 that there were columns that he called cathedrals, conglomerations of objects and of works of art, and that these were in some sense the kernel of the project. But in either case it is clear that the *Kathedrale des erotischen Elends*, "or, abbreviated, KdeE—we live in the time of abbreviations," is the result of an embedding process, as works of art composed of multiple elements themselves were integrated into larger wholes. The term "cathedral" clearly designates the one column of that name, but it is also the emblem of a larger principle of integration. A story told by Robert Motherwell reports that Mies van der Rohe once witnessed Schwitters on a train carrying the limbs and roots of a tree, no doubt intended to be integrated into the *Kathedrale* or another column. Someone asked him what the roots were "and he replied that they constituted a cathedral. 'But that is not a cathedral, that is only wood' the stranger exclaimed; to which Schwitters replied: 'But don't you know that cathedrals are made out of wood?'" Wood makes a cathedral, it is itself a cathedral, and it is about to be integrated into a *Kathedrale*.

In his 1931 account, he said the work was unfinished, "and on principle." It was conceived as an open-ended project, constantly undergoing change and growth as new elements were brought in from the world into the work: "Thus I find an object of some sort, take it along, glue it on, paste it, paint it into the rhythm of the total effect, and then one day it happens that some

new direction must be taken that wholly or partially **covers over the dead body of the object.**" [Bold in the original]. Moholy-Nagy's wife recalled that Schwitters took a pair of socks discarded by her husband, dipped them in plaster, and added them to the grotto. The process of embedding and of converting things into relics was the guiding principle of the work and thus fundamentally shapes its thematics, which involve grottoes, shrines, treasures, commemorations, reliquaries, and so on. Here is part of Schwitters's description of 1931:

There is the **Nibelungen hoard** with its gleaming treasure; the **Kyffhaüser** mountain range with the stone table; the Goethe grotto with one of Goethe's legs as a relic with the many pencils worn to their stubs by writing poetry; ... the sadistic murder cavern with the sorely mutilated body of a pitiful young girl stained with tomatoes and many votive offerings; the Ruhr region with genuine anthracite and genuine coke; the art-exhibition with paintings and sculptures by Michelangelo and myself, the only visitor to which is a dog with a veil. [Bolds in the original.]

And then there is the Love Grotto, which alone "takes up about one-quarter of the base of the column." Some grottoes like the Luther corner, he says, "have already disappeared beneath the present surface."

The *Kathedrale* had begun to assume the appearance that we know from the reconstruction now on view in the Sprengel Museum in Hannover (which restored the work to its state in 1933, after the time of this description). In mid-1931, the writer Paul Bowles visited Schwitters; his account (admittedly written forty years later) describes an extension well beyond the column stage: "The Merzbau was a house within an apartment, a personal museum in which both the objects displayed and the exhibit rooms were inseparable parts of the same patiently constructed work of art." Schwitters says in 1931 that the "overall impression is now more or less reminiscent of a cubist painting or of Gothic architecture"—and then he immediately adds the parenthetical caveat: "(not one bit!)." He had every reason to give, descriptively, with one hand while taking away with the other. The work is both exhibition space and cathedral, and it is neither. It is an anti-museum and an anti-cathedral. Schwitters does not shy away from cathedral references either in his title for the major column of that name or in his description of the parts, such as the various "relics." The references are both overt and overtly ironical and Dadaist: the *Cathedral of Erotic Suffering*. The Dada elements were clear enough (raped girl with votive offerings, Mona Lisa with

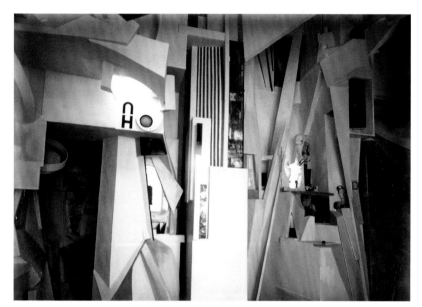

20.5
Kurt Schwitters,
Merzbau installation,
5 Waldhausenstrasse,
Hannover, c. 1923–36,
photograph taken
1932/3

the head of Raoul Hausmann, the little round bottle containing Schwitters's urine in which immortelles have dissolved, etc.), but at the same time Schwitters would not allow the project to be represented as mere avant-gardist profanation, any more than he allowed himself to be associated with the anti-art position of some of the Berlin Dadaists:

Do not take this work to be a blasphemy, for the concept of divinity, which has blessed humanity for millennia and which has broken down national and social barriers, is closely associated with the concept of art. **The self-absorption in art comes very close to the divine liturgy** in the releasing of human beings from the cares of business-as-usual. [Bold in the original.]

The most determined effort to compare Schwitters's great work to the structure and function of actual Gothic cathedrals, by Elizabeth Burns Gamard, relies on Otto von Simson's *The Gothic Cathedral* as its basis of comparison. Simson's book appeared in 1956, when iconographical studies ruled the field, and accordingly it presents the cathedral as a perfectly coordinated and theologically ordered built encyclopedia in stone—not a conception very amenable to Schwitters's *Merzarchitektur*. Closer to the rethinking of space in the modernist 1920s was the conception of malleable and emergent spaces developed by Wilhelm Pinder in his discussion of the

medieval church, discussed in the previous chapter. Recent studies in the art of the medieval period have brought into view a pre-Reformation church interior that is not necessarily regulated by a governing author- ity, a church of competing shrines and uncoordinated image programs, a church space that was to be explored by a moving body, a sequence of tactile encounters (touching, kissing, prostration, attaching ex-votos, etc.), an accretive space constantly reshaped by its users—a dynamic organism, in other words, with multiple centers of activity and attention. That would be the model of the cathedral to bring to Schwitters's *Kathedrale*—that is, if the goal were to propose a cathedral-model.

To compare Schwitters's ongoing installation to medieval cathedrals is to reify both terms. Rather than offering a re-creation of a Gothic church, the *Kathedrale/Merzbau* offered instead an archeology of display practices from a post-museum future, an archeology that incorporates the medieval cathe- dral among other, later kinds of accretive spaces, such as the *Kunstkammer*. Rather than a revival, the *Kathedrale/Merzbau* offers an estranged and anachronistic installation, capturing a moment when museums started to look like crypts and cathedrals, like art installations. The idea that museums are tombs was as old as museums themselves. Quatremère de Quincy, father of museum criticism, invoked the parallel in 1796, when the Louvre was barely three years old, as we saw in chapter six. In the early twentieth century, Marinetti and Kandinsky described the museum as a phantasma- goric space of exanimate fragments, virtually predicting Schwitters's own post-museum, as we saw in chapter five.

Reports tell of Schwitters's legendarily exhaustive, hours-long tours of his *Kathedrale*, carried out in mock tour-guide mode. The closest we have to those performances is the 1931 written description in part quoted above, and which I now quote a little further:

Mona Hausmann, consisting of a picture of the Mona Lisa with the pasted-on face of Raoul Hausmann whereby she has lost her stereotyped smile; the **bordello** with a three-legged lady, done by Hannah Höch; and the great Grotto of Love.... [B]elow stands the **female lavatory attendant of life** in a long, narrow corridor that also contains camel wool. Two children greet us and step into life; of a mother with her child there only a fragment has survived the wear and tear. Magnificent as well as mutilated objects set the general mood. [Bolds in the original.]

As museological forms of display undergo an iconoclastic dismantling, or rather a defamiliarizing *détournement*, the museum becomes a cryptlike

space, with strange, disjointed exhibits inviting a perverse form of cult, or rather exposing the inherent perversity of all cults. This is the fantasy that Schwitters's *Kathedrale* made real. It is a cathedral excavated out of the museum's ruins, and thus a cathedral that is itself under excavation. (The excavation process was a very real one: In 1936 Schwitters's digging brought to light a cistern below the *Merzbau*, a cistern not unlike those found in church sites—an archeological discovery that Schwitters proclaimed as a confirmation of his entire enterprise.)

The ongoing experiment of Schwitters's *Kathedrale/Merzbau* was thus neither museum nor cathedral but a dismantling of both. It dug into the prehistory of the cathedral itself. To go back to the example from the beginning of this book, the chapel of Saint Helena was, as we have seen, the archeological kernel of the church of Santa Croce in Gerusalemme. The shrine, in other words, did not begin as a church, or even as a chapel. It began as a room in a private dwelling, a room that changed its function as it became a display chamber for relics brought from the Holy Land (not very different from the room Schwitters claimed as a studio space within the family dwelling, which shifted location within the house until in 1926 it was stably located in a high-ceilinged back room on the ground floor). The Helena chapel takes us back to a time before the rise of official church architecture. Transformed into a capsule that carried the seeds of a second Jerusalem, the room, transformed into a display chamber, generated the church that grew up around it. The exhibition function *preceded* the church.

Though in many ways an unusual case, the history of Santa Croce is typical of the transition from an early Christian worship located in private homes to a more public church worship after the official recognition of the Christian religion. To bring this example up against Schwitters's *Kathedrale* (and ensuing *Merzbau*) is to open up a dizzying pattern of recursions. The church is not merely the prefiguration of the museum; it is itself grounded in a prehistory of collecting, conservation, and display. Schwitters in one sense moved in the opposite direction, from the far side of the history of the museum "back" through the cathedral to the pre-cathedral domestic space. Far stranger than a stratified archeology, he proposed a form of condensation in which all the stages mingle simultaneously: it is a private dwelling that is a shrine space *and* an exhibition space, besides being a studio. It is above all malleable and open-ended—'and on principle.' It is a space that

The artists' various engagements with medieval art also brought features and qualities of the art into conceptual definition, even for the historians. Wilhelm Worringer's writings had a great impact on artists, but he would not have come to his fundamental ideas about abstraction without the provocations of the most contemporary art, an art that was already putting the lessons of medieval carving and painting to work. Something similar could be said of Wilhelm Pinder, whose understanding of late medieval art as a transition from kinaesthetic proprioception to optical visualization formed a bookend to the momentous developments being proclaimed by Bauhaus artists in his day—namely that this was the end of the self-sufficient and individualist "*Salonkunst*" inherited from the bourgeois era and a return to an integrated, site-specific art in tune with its surroundings, modeled on the medieval cathedral works. Similar observations, adapted to each case, could be made about Leo Steinberg, as well as Hans Belting, Horst Bredekamp, Georges Didi-Huberman, and Michael Camille. There is no need to insist on the fact that the historiography of any field is shaped by the pressing debates and concerns of its era. Meyer Schapiro's ability to discern registrations of social conflict and spaces of critical artistic freedom in Romanesque art are unimaginable without his ongoing involvement with contemporary artists, though here it is more accurate to say that he modernized medieval art rather than recognizing medievalism in the art of his contemporaries. That may be one of the reasons he plays a less prominent role in this account.

We thus have a cat's cradle that served to bring both the contemporary situation and episodes of medieval art into definition—a series of highly effective historical "constellations" reinforced by the interactivity of artists acting on historians and historians acting on artists. Many of these constellations, as we have seen, put to work a three-era scheme, whereby a "father" era is unseated by radical movements responsive to the upheavals of the times, bringing into view a preceding era of art that serves as a liberating model in the present. But then this schema was broken down again and again by the very effectiveness of the resulting new constellation. The recourse to medieval art continually complicated the idea that it could serve as an alternative in the modern situation. Medieval art was not a simple model in the battle between the "autonomous" work of art and a new art of site-specificity, since its site-specificity operated within a larger

conception of topographical instability whereby sites themselves were movable. Rather than modeling a form of installation art *avant la lettre*, premodern art presents a pattern of commutation between art works and their settings that reframes the modernist opposition. Similarly, medieval art did not simply provide an "indexical," bodily alternative to the optical dominion of post-Enlightenment art. Rather, it modeled a continuum whereby even vision, and therefore painting, are understood in indexical terms, thus displacing the battle lines drawn by the modernists (and post-modernists). Something similar could be said of the multiple nature of so much medieval art. To multiply works in replicas and series was not to drain them of aura but to propagate their aura. To fabricate works in multiples was not a denial of authorship so much as an application of a different conception of authorship.

Were the artists aware of these complications? Not always, but in creating their constellations they raised the questions for us, finally moving us beyond the enabling schema. It is now actually difficult to imagine that twentieth-century artists really believed that the museum picture, only a century or two old, to be such a dominant, crushing institution. From our vantage, the three-era schema seems like the supreme fiction. If one follows through on the questions raised by the twentieth-century medievalisms, the middle era emerges criss-crossed with alternations and intermittences, nothing like the paternal fortress it once appeared to be. On occasion this book forces the issue, unfolding the contradictions involved in the documented encounters, and then staging its own encounters between medieval and modern materials for the simple purpose of opening a different space of thinking about both. One reason to write it is both to make clear a phenomenon and to argue that we are no longer in a position to perpetuate it.

Medievalism in the twentieth century is not a succession of individual encounters with medieval art works but rather a layering process, and this book is the latest layer. Bauhaus medievalism was modeled in part on Arts and Crafts medievalism. Much of 1960s medievalism was modeled on the medieval preoccupations of the teens and twenties. This was one aspect of the pervasive recuperation of elements of the art of that era, from neo-Dada and neo-Constructivism to the new collectives and the renewed emphasis on environments rather than art works. Flavin reconnected with Malevich over icons and with Albers over stained glass; Jean Tinguely honored the

in Byzantium and the Dar al-Islam," *Medieval History Journal*, vol. 9:1 (2006), pp. 143–66. Alfred Gell's *Art and Agency: An Anthropological Theory* (Oxford: Clarendon, 1998) has had an incalculable influence on medieval art studies since its appearance.

"Temporal and spatial distributions rather than of chronologies": Richard Krautheimer, "Introduction to an iconography of medieval architecture," *Journal of the Warburg and Courtauld Institutes*, vol. 5 (1942), pp. 1–33. Alexander Nagel and Christopher S. Wood, *Anachronic Renaissance* (New York: Zone Books, 2010).

"Interpenetrations between images and their environments rather than of divides, or bridges, between art work and 'world'": the literature of this sort is too vast to list. Synthetic statements can be found in V. C. Raguin, K. Brush, and P. Draper (eds.), *Artistic Integration in Gothic Buildings* (Toronto: University of Toronto Press, 1995); more generally, see David Summers, *Real Spaces: World Art History and the Rise of Western Modernism* (London: Phaidon, 2003).

"Scholarly traffic across the fields"
The publications of Hans Belting, Jean-Claude Lebensztejn, Hubert Damisch, and Georges Didi-Huberman are too numerous to list.
T. J. Clark, *The Sight of Death: An Experiment in Art Writing* (New Haven: Yale University Press, 2006); Michael Fried, *The Moment of Caravaggio* (Princeton: Princeton University Press, 2010); Mieke Bal, *Quoting Caravaggio: Contemporary Art, Preposterous History* (Chicago: University of Chicago Press, 1999); Michael Camille, "'How New York stole the idea of romanesque art': medieval, modern and postmodern in Meyer Schapiro," *Oxford Art Journal*, vol. 17, no. 1 (1994), pp. 65–75; Finbarr Barry Flood, "From the Prophet to postmodernism? New world orders and the end of Islamic art," in Elizabeth C. Mansfield (ed.), *Making Art History: A Changing Discipline and its Institutions* (New York and London: Routledge, 2007), pp. 31–53; Cynthia Hahn, *Objects of Devotion and Desire: Medieval Relic to Contemporary Art* (New York: Hunter College and the Bertha and Karl Leubsdorf Art Gallery, 2011);

Jeffrey Hamburger, "Art History Reviewed XI: Hans Belting's 'Bild und Kult,' 1990," *Burlington Magazine*, no. 1294 (January 2011), pp. 40–5; Madeline Caviness, *Visualizing Women in the Middle Ages: Sight, Spectacle and Scopic Economy* (Philadelphia: University of Pennsylvania Press, 2001); Glenn Peers, "Utopia and heterotopia: Byzantine modernisms in America," in K. Fugelso (ed.), *Defining Neomedievalism(s)*, *Studies in Medievalism*, vol. 19 (Cambridge: D. S. Brewer, 2010), pp. 77–113.

Earlier field crossers
Wilhelm Worringer, *Abstraction and Empathy: A Contribution to the Psychology of Style*, dissertation completed in 1907, originally published as *Abstraktion und Einfühlung, ein Beitrag zur Stilpsychologie* (Munich: R. Piper, 1908).
For an account of Lionello Venturi's involvement with modern art, see Romy Golan, "The critical moment: Lionello Venturi in America," in Christopher E. G. Benfey and Karen Remmler (eds.), *Artists, Intellectuals, and World War II: The Pontigny Encounters at Mount Holyoke College, 1942–1944* (Amherst: University of Massachusetts Press, 2006). Schapiro was close to many New York artists and often acquainted them with medieval manuscripts: Schapiro, "The Beatus Apocalypse of Gerona" (1963), reprinted in *Late Antique, Early Christian, and Mediaeval Art: Selected Papers* (New York: George Braziller, 1979), p. 326. Eugenio Battisti's production is too vast to select from here; see the materials presented at the conference "Eugenio Battisti e il contemporaneo," Università Tor Vergata, Rome, December 1993. Leo Steinberg and Umberto Eco's work will be considered extensively in chapters 13, 14, and 15 below.

Recent exhibitions and publications that combine medieval and modern art
Bruno Latour, Peter Weibel, et al., *Iconoclash: Beyond the Image Wars in Science, Religion, and Art* (Karlsruhe: ZKM, 2002); Christoph Geissmar and Eleonora Louis, *Glaube, Hoffnung, Liebe, Tod* (Vienna: Kunsthalle Wien, 1995); Georges Didi-Huberman, *La Ressemblance par contact: archéologie, anachronisme et modernité de l'empreinte,*

exhibition held at the Centre Georges Pompidou in Paris, 1996, book published by Éditions de Minuit, 2008; Alfred Pacquement, Jean de Loisy, and Angela Lampe, *Traces du sacré*, exhibition catalogue (Paris: Centre Georges Pompidou, 2008); from the Pompidou, see also "Les 'Moyen Age' de l'art contemporain," issue of *Cahiers de la villa gillet*, no. 17 (February 2003); Hiltrud Westermann-Angerhausen, Dagmar R. Täube, and Johannes Cladders, *Joseph Beuys und das Mittelalter*, exhibition catalogue (Cologne: Schnütgen Museum, 1997); Stefan Weppelmann and Gerhard Wolf, *Rothko / Giotto: Die Berührbarkeit des Bildes*, exhibition catalogue, Gemäldegalerie, Berlin (Munich: Hirmer, 2009).

Werner Hofmann, *Die Moderne im Rückspiegel: Hauptwege der Kunstgeschichte* (Munich: Beck, 1998).

Hans Belting, *Bild-Anthropologie: Entwürfe für Eine Bildwissenschaft* (Munich: Fink, 2001); English edition, *An Anthropology of Images*, trans. Thomas Dunlap (Princeton and Oxford: Princeton University Press, 2011).

Horst Bredekamp, *Theorie des Bildakts* (Frankfurt: Suhrkamp, 2010).

Gottfried Böhm introduced the notion of an "iconic turn" in his essay "Die Wiederkehr der Bilder," in Gottfried Böhm (ed.), *Was ist ein Bild?* (Munich: W. Fink, 1994), pp. 11–38.

Marie-José Mondzain, *Image, Icon, Economy: The Byzantine Origins of the Contemporary Imaginary* (Stanford: Stanford University Press, 2005).

Bruce W. Holsinger, *The Premodern Condition: Medievalism and the Making of Theory* (Chicago: University of Chicago Press, 2005).

Andrew Cole and D. Vance Smith, *The Legitimacy of the Middle Ages: On the Unwritten History of Theory* (Durham, N.C.: Duke University Press, 2010).

Victoria von Flemming, *Modell Mittelalter* (Cologne: Salon Verlag, 2010).

The advent of *Bildwissenschaft* and *Bild-anthropologie*
In addition to works by Belting, Bredekamp, and Böhm cited above, see also Hans Belting (ed.), *Bildfragen:*

Die Bildwissenschaften im Aufbruch (Munich: W. Fink, 2007).

Jarry's early publications of medieval imagery
Jill Fell, *Alfred Jarry: An Imagination in Revolt* (Madison, N.J.: Fairleigh Dickinson University Press, 2005), ch. 3. My thanks to Robert Brennan for bringing this example to my attention.

Fry on Byzantine art
See, for example, "Henri Matisse" (1930), in Christopher Reed (ed.), *A Roger Fry Reader* (Chicago: University of Chicago Press, 1996), pp. 401–2; or "The last phase of Impressionism" in ibid., pp. 72–3.

T. S. Eliot and the metaphysical poets
T. S. Eliot, "The metaphysical poets" (1921), reprinted in *Selected Essays* (New York: Harcourt, Brace 1950), pp. 241–50.

Pound's relationship with Cavalcanti
See chapter 16 below. For one example of his regard for Villon, see Ezra Pound, *The Spirit of Romance* (New York: New Directions, 1952), chapter VIII.

Worringer, Die Brücke, and German late medieval art
Magdalena Bushart, *Der Geist der Gotik und die expressionistische Kunst: Kunstgeschichte und Kunsttheorie, 1911–1925* (Munich: S. Schreiber, 1990); Neil H. Donahue (ed.), *Invisible Cathedrals: The Expressionist Art History of Wilhelm Worringer* (University Park, Pa.: Pennsylvania State University Press, 1995).

Malevich and the icon
Andrew Spira, *The Avant-Garde Icon: Russian Avant-Garde Art and the Icon Painting Tradition* (Aldershot: Lund Humphries, 2008). Also Camilla Gray, *The Great Experiment* (London: Thames & Hudson, 1962).

Joyce's Thomism
Umberto Eco, *The Aesthetics of Chaosmos: The Middle Ages of James Joyce*, trans. Ellen Esrock (Tulsa: University of Tulsa Press, 1982); W. T. Noon, *Joyce and Aquinas* (New Haven: Yale University Press, 1957); Marshall McLuhan, "Joyce, Aquinas, and the Poetic Process," in T. E. Connolly (ed.), *Joyce's Portrait: Criticisms and Critiques* (New York: Appleton, Century, Crofts, 1962), pp. 249–65.

Schwitters's reliquaries
Elizabeth Burns Gamard, *Kurt Schwitters' Merzbau: The Cathedral of Erotic Misery* (New York: Princeton Architectural Press, 2000), pp. 104, 109; more generally, John Elderfield, *Kurt Schwitters* (London: Thames & Hudson, 1985).

Max Ernst's "alchemical compounds"
Max Ernst, "Au-delà de la peinture," in *Écritures* (Paris: Gallimard, 1970), pp. 253–6; see also M. E. Warlick, *Max Ernst and Alchemy: A Magician in Search of Myth* (Austin: University of Texas Press, 2001).

Picabia's *Transparences*
Sarah Wilson, *Francis Picabia: Accommodations of Desire: Transparencies, 1924–1932* (New York: Kent Fine Art, 1989).

Satie and Gregorian chant
See, for example, Léon Guichard, "Erik Satie et la musique grégorienne," *La Revue musicale*, vol. 169 (1936), pp. 334–5. András Wilheim, "Erik Satie's Gregorian Paraphrases," *Studia Musicologica Academiae Scientiarum Hungaricae*, vol. 25 (1983), pp. 229–37.

Sironi and corporate mural painting
Romy Golan, *Muralnomad: The Paradox of Wall Painting, Europe 1927–1957* (New Haven and London: Yale University Press, 2009).

Matisse and stained glass
Jean-Claude Bonne, "Un certain couleur des idées': Matisse et l'art medieval," *Cahiers de la villa gillet*, no. 17 (February 2003), pp. 49–84; Xavier Gerard, *Henri Matisse: La Chapelle du Rosaire* (Paris: Éditions de la Réunion des Musées Nationaux, 1992).

Anni and Josef Albers and stained glass
Peter Nisbet, "Joseph Albers, *Lattice Picture*, 1921," in Barry Bergdoll and Leah Dickerman (eds.), *Bauhaus 1919–1933* (New York: Museum of Modern Art, 2009), pp. 92–5. For Albers's work in the context of the German avant-garde's broader engagement with the medieval heritage of glass, see Maria-Katharina Schulz, *Glasmalerei der klassischen Moderne in Deutschland* (Frankfurt am Main: P. Lang, 1987).

Schapiro takes Léger and Matta to see the Beatus Apocalypse manuscript
Meyer Schapiro, "The Beatus Apocalypse of Gerona" (1963), in *Late Antique, Early Christian and Medieval Art: Selected Papers*, vol. 3 (New York: George Braziller, 1979), p. 326.

On Hanns Eisler and *Kirchentonarten*
Albrecht Betz, "Dynamisierung des Widerspruchs: über Eisler und Brecht," *Fragmentos*, vol. 5, no. 1 (1995), pp. 28–9.

Klein and the cathedral lodge
Nuit Banai, "Avant-garde or civil service? Yves Klein, Werner Runhau, and 'The European Situation,'" in *Europa! Europa? The Avant-Garde, Modernism, and the Fate of a Continent* (Berlin: Walter de Gruyter, 2009), pp. 244–63.

Barnett Newman's admiration for Byzantine art
Glenn Peers, "Utopia and heterotopia: Byzantine modernisms in America," in K. Fugelso (ed.), *Defining Neomedievalism(s), Studies in Medievalism*, vol. 19 (Cambridge: D. S. Brewer, 2010), pp. 78–85.

Ad Reinhardt's Greek crosses
Alexandra Munroe, "Art of perceptual experience: pure abstraction and ecstatic minimalism," in *The Third Mind: American Artists Contemplate Asia, 1860–1989* (New York: Guggenheim Museum, 2009), pp. 287–8. The relationship was made overt from an early date: "Is today's artist with or against the past?" *Artnews*, vol. 57, no. 5 (September 1958), pp. 28, 56.

McLuhan's "medieval sense-ratio"
Marshall McLuhan, *The Gutenberg Galaxy: The Making of Typographic Man* (Toronto: University of Toronto Press, 1962), and see chapter on him below.

Tony Conrad and Heinrich Biber
Branden Joseph, *Beyond the Dream Syndicate: Tony Conrad and the Arts after Cage: A "Minor" History* (New York: Zone Books, 2008), pp. 62–3.

Dan Flavin
On Flavin's icons, which he originally designed to be shown in rows, rather like an iconostasis, see Jeffrey Weiss, "Blunt in bright repose," in Weiss and Briony Fer, *Dan Flavin: New Light* (New Haven: Yale University Press; Washington: National Gallery of Art, 2006), pp. 60–4; Corinna Thierolf and Johannes Vogt, *Dan Flavin: Icons* (Munich: Schirmer/Mosel and Pinakothek der Moderne, 2009).

Mel Bochner
Mel Bochner, "Why would anyone want to draw on the wall?," *October*, no. 130 (Fall 2009), pp. 135–40.

Sol LeWitt's theological serialism
Sol LeWitt, "Sentences on conceptual art" (1969); reprinted in Charles Harrison and Paul Wood (eds.), *Art in Theory, 1900–2000: An Anthology of Changing Ideas* (Malden, Mass.: Blackwell, 2003), pp. 849–50.

Joseph Beuys and relics
Hiltrud Westermann-Angerhausen, "Joseph Beuys et le Moyen Age," *Cahiers de la villa gillet*, no. 17 (February 2003), pp. 21–36; Hiltrud Westermann-Angerhausen, Dagmar R. Täube, and Johannes Cladders, *Joseph Beuys und das Mittelalter*, exhibition catalogue (Cologne: Schnütgen Museum, 1997). See also Jean-Philippe Antoine, *La Traversée du XXe siècle: Joseph Beuys, l'image et le souvenir* (Paris: Les Presses du Réel, 2011), especially chapters 2 and 12.

Louise Bourgeois and the tradition of relics
See, for example, Madeline Harrison Caviness, *Visualizing Women in the Middle Ages: Sight, Spectacle, and Scopic Economy* (Philadelphia: University of Pennsylvania Press, 2001), p. 148.

Thomas Hirschhorn's altars
Benjamin H. D. Buchloh, "Cargo and cult: the displays of Thomas Hirschhorn," *Artforum*, vol. XL, no. 3 (November 2001); Carlos Basualdo, Benjamin H. D. Buchloh, and Alison Gingeras, *Thomas Hirschhorn* (London: Phaidon, 2004).

Relic-modes in contemporary art
Donald Hall, Thomas Walter Laqueur, and Helaine Posner, *Corporal Politics*, exhibition catalogue, MIT Visual Arts Center (Boston, Mass.: Beacon Press, 1993); Georges Didi-Huberman, *La Ressemblance par contact: archéologie, anachronisme et modernité de l'empreinte*, exhibition held at the Centre Georges Pompidou in Paris, 1996, book published by Éditions de Minuit, 2008; Alexander Nagel, "The afterlife of the reliquary," in Martina Bagnoli, Holger A. Klein, C. Griffith Mann, and James Robinson (eds.), *Treasures of Heaven: Saint, Relics, and Devotion in Medieval Europe* (Baltimore: Walters Art Museum, 2010), pp. 211–2; Cynthia Hahn, *Objects of Devotion and Desire: Medieval Relic to Contemporary Art*, exhibition catalogue, Bertha and Karl Leubsdorf Art Gallery, Hunter College (New York: Hunter College, 2011). A forthcoming book by Cynthia Hahn will offer a transhistorical treatment of the history of the relic.

The Bechers' typologies of architecture without architects
See in particular their early books Bernd and Hilla Becher, *Anonyme Industriebauten: Fotografische Dokumentation* (Stuttgart: Deutsche Verlags-Anstalt, 1967) and *Anonyme Skulpturen* (Düsseldorf: Verlag Michelpresse, 1969). See also Thierry de Duve, "Bernd and Hilla Becher or Monumentary Photography," in *Bernd and Hilla Becher: Basic Forms* (New York: te Neues Publishing Company, 1999), pp. 7–22.

Matthew Barney
For an introduction to Barney's work, see Nancy Spector (ed.), *Matthew Barney: The Cremaster Cycle* (New York: Guggenheim Museum, 2002).

Hugo Ball at the Cabaret Voltaire
Hugo Ball, "Flight out of time" (1927), in *Flight Out of Time: A Dada Diary* (Berkeley: University of California Press, 1996, p. 71.

Pasolini on Warhol and Byzantium
Pier Paolo Pasolini, *Écrits sur la peinture*, ed. Hervé Joubert-Laurencin (Paris: Carré, 1997), pp. 87–92; English translation, "Andy Warhol's Ladies and Gentlemen" (1975); reprinted in *Andy Warhol Ladies and Gentlemen* (New York: Skarstedt Gallery, 2009), p. 5.

Robert Smithson on Brecht
"From Ivan the Terrible to Roger Corman or paradoxes of conduct in mannerism as reflected in the cinema" (1967), reprinted in Jack Flam (ed.), *Robert Smithson: The Collected Writings* (Berkeley: University of California Press, 1996), p. 350.

Leon Golub, Picasso's *Guernica* and the eleventh-century Apocalypse manuscript
Leon Golub, "Guernica, the Apocalypse of Saint-Sever" (1958), in Hans Ulrich Obrist (ed.), *Leon Golub: Do Paintings Bite?* (Ostfildern: Cantz, 1997), pp. 184–8.

Adrian Piper on minimalism and anonymous artists "before Cimabue"
Contribution to "Questions of Style," *Artforum*, vol. XLIX, no. 1 (September 2010), p. 270.

Installation
James Meyer, "The functional site; or, the transformation of site-specificity," in Erika Suderberg (ed.), *Space, Site, Intervention: Situating Installation Art* (Minneapolis: University of Minnesota Press, 2000), pp. 23–37; Miwon Kwon, "One place after another: notes on site specificity," *October*, no. 80 (1997), pp. 85–110, and *One Place After Another: Site-Specific Art and Locational Identity* (Cambridge, Mass.: MIT Press, 2004), pp. 29–31; Claire Bishop, *Installation Art: A Critical History* (New York: Routledge, 2005); David Summers, *Real Spaces: World Art History and the Rise of Western Modernism* (London: Phaidon, 2003).

Indexicality
For Didi-Huberman's criticism of traditional art history's repression of the index, see *Confronting Images: Questioning the Ends of a Certain History of Art* (University Park, Pa.: Pennsylvania State University Press, 2005). See also his *La Ressemblance par contact: Archéologie, anachronisme et modernité de l'empreinte* (Paris: Éditions de Minuit, 2008). The classic text on the predominance of the index in twentieth-century art is Rosalind Krauss, "Notes on the index," parts 1 and 2 (1977), reprinted in *The Originality of the Avant-Garde and Other Modernist Myths* (Cambridge, Mass.: MIT Press, 1985), pp. 196–220.

Replication and the multiple
Walter Benjamin, "The work of art in the age of its technological reproducibility: second version" in *Selected Writings, Volume 3: 1935–38*, ed. Howard Eiland and Michael Jennings (Cambridge and London: The Belknap Press of Harvard University Press, 2002), pp. 101–33. For a challenge to this influential thesis from a medievalist perspective, see Horst Bredekamp, "Der simulierte Benjamin: Mittelalterliche Bemerkungen zu seiner Aktualität," in Andreas Berndt, Peter Kaiser, Angela Rosenburg, and Diana Trinker (eds.), *Frankfurter Schule und Kunstgeschichte* (Berlin: Dietrich Reimer Verlag, 1992), pp. 117–40. On the *Sacra Parallela*, see Kurt Weitzmann, *The Miniatures of the Sacra Parallela: Parisinus Graecus 923*

(Princeton: Princeton University Press, 1979), p. 213 for the passage quoted in the caption. On imitation in moral self-formation, see the magisterial work by Karl Morrison, *The Mimetic Tradition of Reform in the West* (Princeton: Princeton University Press, 1982). On modes of image replication before the modern culture of art, see Alexander Nagel and Christopher S. Wood, *Anachronic Renaissance* (New York: Zone Books, 2010).

Collage
On Max Ernst, see Warlick, *Max Ernst and Alchemy* (cited above). On Schapiro's "conglomerate," often stylistically and temporally "open" medieval works, see "Style" (1953), reprinted in *Selected Papers: Theory and Philosophy of Art* (New York: George Braziller, 1994), pp. 51–101, here pp. 62–3.

Conceptual art
Thomas Crow, "Art and its markets: historical returns," *Artforum*, vol. XLVI, no. 8 (April 2008), pp. 286–91, draws interesting associations between early art markets and the contemporary art market with reference to conceptual art. Significant juxtapositions between earlier and later contexts are also offered by Amy Powell, "Painting as blur: landscapes in paintings of the Dutch interior," *Oxford Art Journal*, vol. 33, no. 2 (2010), pp. 143–66, and now in her book *Depositions: Scenes from the Late Medieval Church and the Modern Museum* (New York: Zone Books, 2012). A basic reference for the consequences of the Protestant Reformation on art is Werner Hofmann, *Luther und die Folgen für die Kunst* (Munich: Prestel-Verlag, 1983).

2. Learning to live without artistic periods

Eisenstein and El Greco
Sergei Eisenstein, *The Film Sense*, trans. Jay Leyda (New York: Harcourt Brace, 1947), pp. 103–5; Yve-Alain Bois, "Introduction to Sergei Eisenstein, 'Montage and Architecture,'" *Assemblage*, no. 10 (1989), pp. 110–31, here p. 112.

Schwitters
See chapter 20, with further bibliography below.

Anni Albers
Albers's early applied abstractions were bound up with the broader program of Bauhaus medievalism. She remained aware of the medieval roots of her practice throughout her career, writing later that, "Today, hand weaving is practiced mainly on the medieval shaft loom." *On Designing* (Middletown, Conn.: Wesleyan University Press, 1965), p. 21.

Smithson's *Non-sites*
See chapter 10 below.

Klein's art of immaterial sensibility and its connection with the ex-voto
Thierry de Duve, "Yves Klein, or the dead dealer," *October*, no. 49 (Summer 1989), pp. 72–90.

Louise Bourgeois's memory-theaters
See *Louise Bourgeois: Memory and Architecture* (Madrid: Museo Nacional Centro de Arte Reina Sofía, 1999).

Nancy Holt
Alena J. Williams, Pamela M. Lee, and Nancy Holt, *Nancy Holt: Sightlines* (Berkeley and London: University of California Press, 2011).

Sol LeWitt on distributed authorship
"The aim of the artist would be to give viewers information.... The serial artist does not attempt to produce a beautiful or mysterious object but functions merely as a clerk cataloguing the results of his premise." Sol LeWitt, "Serial Project #1, 1966," in Brian O'Doherty (ed.), *Aspen Magazine*, nos. 5–6 (1967), no page numbers. For the explicitly more mystical formulations of his working premises, see the famous "Sentences on conceptual art" (1969); reprinted in Charles Harrison and Paul Wood (eds.), *Art in Theory, 1900–2000: An Anthology of Changing Ideas* (Malden, Mass.: Blackwell, 2003), pp. 849–50. Aside from their relation to authorship, Sol LeWitt's work has also been discussed in medieval and Renaissance terms on a formal basis: see Bernice Rose's comparisons between his early work and the sinopie of frescoes in *Drawing Now* (New York: Museum of Modern Art, 1976), p. 76.

Heiner Friedrich, Dia, and Giotto
See chapter 9, and related bibliography below.

Rothko's avowal of influence from Michelangelo
John Fischer, "The easy chair: Mark Rothko: portrait of the artist as as angry man", in Mark Rothko, *Writings on Art*, ed. Miguel López-Remiro (New Haven: Yale University Press, 2006), p. 131: David Anfam, *Mark Rothko: The Works on Canvas, Catalogue Raisonné* (New Haven and Washington: Yale University Press and the National Gallery of Art, 1998), p. 91; Sheldon Nodelman, *The Rothko Chapel Paintings: Origins, Structure, Meaning* (Austin: University of Texas Press, 1997), pp. 87–8.

Smithson on Brueghel
Robert Smithson, "From Ivan the Terrible to Roger Corman or paradoxes of conduct in mannerism as reflected in the cinema" (1967), reprinted in Jack Flam (ed.), *Robert Smithson: The Collected Writings* (Berkeley: University of California Press, 1996), p. 350. The interest stems from Brecht, see "Alienation effects in the narrative pictures of the elder Brueghel," in John Willett (ed. and trans.), *Brecht on Theater: The Development of an Aesthetic* (New York: Hill and Wang, 1964), pp. 157–9.

Smithson and icons
Thomas Crow, "Cosmic exile: prophetic turns in the life and art of Robert Smithson," in Eugenie Tsai (ed.), *Robert Smithson* (Berkeley, Los Angeles, and London: University of California Press, 2004), p. 37.

Smithson expresses admiration for Cavallini in an unpublished letter to George Lester, May 1961, Archives of American Art, Robert Smithson Letters to George Lester, reel 5438, frames 1280–5. The letter is undated but was certainly written in May 1961.

Smithson 1961 letter to Nancy Holt on seventeenth-century century candles, 24th July 1961, AAA, RSNHP reel 3832, frame 745 (hereafter cited as AAA, RSNHP).

On Smithson and Mannerism, see chapter 11, and related bibliography below.

Yves Klein and the cathedral lodge
Nuit Banai, "Avant-garde or civil service? Yves Klein, Werner Runhau, and 'The European Situation,'" in *Europa!*

Europa? The Avant-Garde, Modernism,
and the Fate of a Continent (Berlin:
Walter de Gruyter, 2009), pp. 244–63.

**Duchamp on art before classical
European painting**
Pierre Cabanne, Dialogues with Marcel
Duchamp (New York: The Viking Press,
1971), p. 43. See also, Marcel Duchamp,
interview with James Johnson Sweeney,
in "Eleven Europeans in America,"
Bulletin of the Museum of Modern Art,
no. 13 (1946), pp. 19–21, reprinted
as "The great trouble with art in this
century," in Michel Sanouillet and Elmer
Peterson (eds.), The Writings of Marcel
Duchamp (New York: Oxford University
Press, 1973), pp. 123–6, especially p. 125.

Benjamin on Baroque allegory
Walter Benjamin, The Origin of German
Tragic Drama, trans. John Osborne
(London, New York: Verso, 2003). On
Benjamin and Jewish mystical traditions,
a good starting point, with much further
bibliography, is Miriam Bratu Hansen,
"Benjamin's Aura," Critical Inquiry,
no. 34 (2008), pp. 336–75.

**3. If you go far enough back, the West
is not "Europe"**

**Recent contributions on the relation
between contemporary art and
classical imagery**
Isabelle Loring Wallace and Jennie
Hirsh, Contemporary Art and Classical
Myth (Farnham: Ashgate, 2011);
Nicholas Cullinan, Katharina Schmidt,
Xavier F. Salomon, Larry Gagosian,
and Ian Dejardin, Twombly and Poussin:
Arcadian Painters (London: Dulwich
Picture Gallery, in association with
Paul Holberton Publishing, 2011).

Aby Warburg, The Renewal of Pagan
Antiquity: Contributions to the Cultural
History of the European Renaissance
(Los Angeles: Getty Research
Institute for the History of Art and
the Humanities, 1999).

Horst Bredekamp, The Lure of
Antiquity and the Cult of the Machine:
the Kunstkammer and the Evolution of
Nature, Art, and Technology (Princeton:
M. Wiener Publishers, 1995).

**Pius II's role in the formation of the
notion of Europe**
Denys Hay, Europe: The Emergence
of an Idea (Edinburgh: University of

Edinburgh Press, 1957), pp. 83–7.
For the problem of the emergence of
Europe in general around this time,
see also Klaus Oschema, "Der Europa-
Begriff im Hoch- und Spätmittelalter.
Zwischen geographischem Weltbild und
kultureller Konnotatio," in Jahrbuch für
europäische Geschichte, no. 2 (2001),
pp. 191–234; Heinz Duchhardt and
Andreas Kunz (eds.), Europäische
Geschichte als historiographisches
Problem (Mainz: P. von Zabern, 1997);
Peter Burke, "Did Europe exist before
1700?" History of European Ideas,
no. 1 (1980), pp. 21–9.

**Surrogate pilgrimage, dramatic
restagings, the imitation of
authoritative, "Eastern" architecture-
and image-prototypes, and the use
of geographically compensatory
devices of pictorial realism**
Richard Krautheimer, "Introduction
to an iconography of medieval
architecture," Journal of the Warburg
and Courtauld Institutes, vol. 5 (1942),
pp. 1–33; R. Ousterhout, "Loca Sancta
and the Architectural Response to
Pilgrimmage," in The Blessings of
Pilgrimage (Urbana: University of Illinois
Press, 1990), pp. 311–21; Annabel Jane
Wharton, Selling Jerusalem: Relics,
Replicas, Theme Parks (Chicago: Chicago
University Press, 2006); Alexander
Nagel and Christopher S. Wood,
Anachronic Renaissance (New York: Zone
Books, 2010); Christopher S. Wood,
Forgery, Replica, Fiction: Temporalities
of German Renaissance Art (Chicago:
University of Chicago Press, 2008).

Homi Bhaba on postcolonial hybridity
See his The Location of Culture (London,
New York: Routledge, 1994). On
Agamben's concept of extraterritoriality,
see his State of Exception (Chicago:
University of Chicago Press, 2005).
Marc Augé, Non-Places: Introduction
to an Anthropology of Supermodernity
(London: Verso, 1995).

4. Airplanes and altarpieces

Duchamp on the airplane propeller
Michel Sanouillet (ed.), Duchamp du
signe (Paris: Flammarion, 1975), pp. 242.
Thierry de Duve, Pictorial Nominalism:
On Marcel Duchamp's Passage from
Painting to the Readymade (Oxford,
Minneapolis: University of Minnesota
Press, 1991), chapter 5, quotes

the propeller comment, discusses
Duchamp's interest in Blériot, as
well as the relationship between the
readymade and other avant-garde
attempts to integrate art and society,
such as those of the Bauhaus,
Corbusier, the Futurists, and others.

Brancusi's trial over his Bird in Space
Anna Chave, Constantin Brancusi: Shifting
the Bases of Art (New Haven: Yale
University Press, 1993), pp. 198–223. For
the trial transcript, see Margit Rowell
(ed.), Brancusi vs. United States, the
Historic Trial, 1928 (Paris: Biro, 1999).

Apollinaire on Duchamp and Cimabue
Guillaume Apollinaire, The Cubist
Painters (New York: Wittenborn and
Company, 1944), p. 32.

**Vasari on the procession of Cimabue's
work into Santa Maria Novella**
Giorgio Vasari, Le vite de' più eccellenti
pittori, scultori e architettori: nelle
redazioni del 1550 e 1568: concordanze,
ed. Paola Barocchi, Rosanna Bettarini,
and Giovanna Gaeta Bertelà (Florence:
Sansoni, 1966–87), vol. 2, p. 40.

The procession for Duccio's Maesta
Anonymous, Cronache senesi, ed.
A. Lisini and F. Iacometti, in Rerum
Italicarum Scriptores, n.s., XV, 6, 1
(Città di Castello: Lapi, 1931–9), p. 90;
English translation: John White, Duccio:
Tuscan Art and the Medieval Workshop
(London: Thames & Hudson, 1979),
pp. 96–7. This and the passage
from Vasari are discussed in Dianne
Norman, Siena, Florence and Padua: Art,
Society and Religion 1280–1400 (New
Haven and London: Yale University
Press, 1995), p. 55. On the changing
attribution of the Rucellai Madonna, see
Hayden G. B. Maginnis, Painting in the
Age of Giotto: An Historical Reevaluation
(University Park, Pa.: Pennsylvania State
University Press, 1996), chapter III.

**On the separation of frame and panel
in the fifteenth century**
Creighton Gilbert, "Peintres et
menuisiers au debut de la Renaissance
en Italie," Revue de l'art, no. 37 (1977),
pp. 9–28. On the new language to
describe this shift in fifteenth-century
contracts, see Alexander Nagel, "Art
as gift: liberal art and the discourse of
religious reform in the Renaissance," in
Negotiating the Gift (Paris: Deutsches
Historisches Institut, 2003), pp. 387–413.

Alberti on the use of gold and gems on the frame rather than within the picture plane
Leon Battista Alberti, *On Painting*, trans. Cecil Grayson (New Haven: Yale University Press, 1966), p. 85.

Picasso, Apollinaire, and early film, in particular Méliès
Natasha Staller, *A Sum of Destructions: Picasso's Cultures and the Creation of Cubism* (New Haven: Yale University Press, 2001), pp. 137–54.

François Peyrey on Wilbur Wright
François Peyrey, *Les Oiseaux artificiels* (Paris: Dunod & Pinot, 1909), p. 180. See also Robert Wohl, *A Passion for Wings: Aviation and the Western Imagination 1908–1918* (New Haven: Yale University Press, 1994), chapter 1.

D'Annunzio, Blériot, Icarus
Peter Demetz, *The Air Show at Brescia, 1909* (New York: Farrar, Straus, and Giroux, 2002), p. 58.

Vauxcelles's review, Kahnweiler's clipping, Picasso calling Braque "Wilbourg"
William Rubin, *Picasso and Braque: Pioneering Cubism* (New York: Museum of Modern Art, 1989), pp. 33, 356, 436. For the outings to Issy-les-Moulineaux, see Wohl, *A Passion for Wings*, p. 272. See also Anne Collins Goodyear, "The effect of flight on art in the twentieth century," in Roger D. Launius and Janet R. Daly Bednarek (eds.), *Reconsidering a Century of Flight* (Chapel Hill: University of North Carolina Press, 2003), chapter 11.

Blaise Cendrars's "Contrastes"
Blaise Cendrars, *Dix-neuf poèmes élastiques* (Paris: Gallimard, 1919).

Breton's comparison between Les Demoiselles and Cimabue's Virgin
Letter to Jacques Doucet, December 12, 1924, in John Elderfield (ed.), *Les Demoiselles d'Avignon* (New York: Museum of Modern Art, 1994), p. 182. My thanks to Robert Brennan for bringing this text to my attention.

5. Works become environments and environments become works

Kabakov's historical fantasy
Ilya Kabakov, *Das Leben der Fliegen* (Ostfildern: Cantz, 1992), pp. 189–91.

See also Oskar Bätschmann, "Ilya Kabakov and the 'total' installation," in *Ilya Kabakov Installations 1983–2000* (Düsseldorf: Richter, 2003), vol. I, pp. 16–31.

Domenico Fontana's account of the transportation of the Presepe
Della trasportatione dell'obelisco vaticano: 1590, ed. Adriano Carugo and Paolo Portoghesi (Milan: Il Polifilo, 1978), vol. 1, pp. 501–31.

Horace Walpole's collections at Strawberry Hill
Anna Chalcraft and Judith Viscardi, *Strawberry Hill: Horace Walpole's Gothic Castle* (London: Frances Lincoln, 2007); Michael Snodin and Cynthia E. Roman, *Horace Walpole's Strawberry Hill* (New Haven: Yale University Press, 2009).

Guglielmo Wambel collects sacred objects into a museum-chapel at San Tomà
Pietro Selvatico, Vincenzo Lazari, *Guida artistica e storica di Venezia e delle isole circonvicine* (Venice: Carpano, 1852), p. 191; Giovanni Battista Contarini (ed.), *Menzioni onorifiche de' defunti scritte nel nostro secolo, parte seconda* (Venice: Ancora, 1846), pp. 46–7; Rodolfo Gallo, "Reliquie e reliquiari veneziani", *Rivista mensile della città di Venezia*, no. 13 (1934), pp. 187–214, here p. 193.

Sommerard and Cluny
Stephen Bann, *The Clothing of Clio: A Study of the Representation of History in Nineteenth-Century Britain and France* (Cambridge; Cambridge University Press, 1984), p. 86.

Flaubert's Bouvard and Pécuchet
Eugenio Donato, "The museum's furnace: notes toward a contextual reading of *Bouvard and Péuchet*," in Josué V. Harari (ed.), *Textual Strategies: Perspectives in Post-Structuralist Criticism* (Ithaca: Cornell University Press, 1979), pp. 213–38. They appear as a model of an anti-museology in Douglas Crimp, "On the museum's ruins," in *On the Museum's Ruins* (Cambridge, Mass.: MIT Press, 1993), pp. 44–64.

The Egyptian Hall, Barnum, and Soane
Richard D. Altick, *The Shows of London* (Cambridge, Mass.: The Belknap Press of Harvard University Press, 1978). See also Patricia Falguières, "Catlin, la peinture et 'l'industrie du musée'"

in *Gradhiva, Revue d'Anthropologie et de muséologie*, no. 3 (2006), pp. 39–54, 111–14.

The white cube
Brian O'Doherty, *Inside the White Cube: The Ideology of the Gallery Space* (Santa Monica: Lapis Press, 1986); Lisa Tickner, "The Kasmin Gallery," *Oxford Art Journal*, vol. 30, no. 2 (2007), pp. 235–68. Andrew McClellan, *The Art Museum from Boullée to Bilbao* (Berkeley: University of California Press, 2008), chapter 3, shows that the move to "abstraction" in museum display was a phenomenon of the 1920s and '30s, in dialogue with currents in modern art.

Marinetti on museums
Le Figaro, February 20, 1909: "Musei: cimiteri!... Identici, veramente per la sinistra promiscuità di tanti corpi che non si conoscono. Musei: dormitori pubblici in cui si riposa per sempre accanto ad esseri odiati o ignoti! Musei: assurdi macelli di pittori e scultori che vanno trucidando si ferocemente a colpi di colori e di linee, lungo le pareti contese! Che ci si vada in pellegrinaggio, una volta all'anno, come si va al Camposanto nel giorno dei morti ... velo concedo. Che una volta all'anno sia deposto un omaggio di fiori alla Gioconda, ve lo concedo.... Ma non ammetto che si conducano quotidianamentee a passeggio per i musei le nostre tristezze, il nostro fragile coraggio, la nostra morbosa inquietudine. Perchè volersi avvelenare? Perchè volere imputridire?"

Kandinsky on museums
Wassily Kandinsky, *Concerning the Spiritual in Art* (1911), trans. Michael Sadler (New York: Dover Publications, 1977), p. 3.

The functional site
James Meyer, "The functional site," in *Platzwechsel*, exhibition catalogue (Zurich: Kunsthalle Zurich, 1995), p. 27; reprinted as "The functional site; or, the transformation of site-specificity," in Erika Suderberg (ed.), *Space, Site, Intervention: Situating Installation Art* (Minneapolis: University of Minnesota Press, 2000), pp. 23–37, here p. 25. See also Miwon Kwon, "One place after another: notes on site specificity," *October*, no. 80 (Spring 1997), pp. 85–110 and *One Place After Another:*

Site-specific Art and Locational Identity (Cambridge, Mass.: MIT Press, 2004), pp. 29–31. See also Kwon, "Promiscuity of space: some thoughts on Jessica Stockholder's scenographic compositions," Grey Room, no. 18 (2005), pp. 52–63.

Leonardo da Vinci on the superiority of painting
Claire J. Farago, Leonardo da Vinci's Paragone: A Critical Interpretation with a New Edition of the Text in the Codex Urbinas (New York: E. J. Brill, 1992).

Masaccio's Trinity fresco as a virtual view into the Holy of Holies
Paul Joannides, Masaccio and Masolino: A Complete Catalogue (London: Phaidon, 1993), pp. 356–68; John Shearman, Only Connect: Art and the Spectator in the Italian Renaissance (Princeton: Princeton University Press, 1992), pp. 62–7.

The emergence of the post-Renaissance "picture"
See in particular the literature on the transition from altarpiece to easel painting. Hans Belting, "Vom Altarbild zur autonomen Tafelmalerei," in Werner Busch and Peter Schmoock (eds.), Kunst: Die Geschichte ihrer Funktionen (Winheim-Berlin, 1987), pp. 128–52; Christa Gardner von Teuffel, "From polyptych to pala: some structural considerations," in From Duccio's Maestà to Raphael's Transfiguration: Italian Altarpieces and their Settings (London: Pindar Press, 2005), pp. 183–210; Alexander Nagel, Michelangelo and the Reform of Art (Cambridge: Cambridge University Press, 2000), chapter 4; Sylvia Ferino Pagden, "From cult images to the cult of images: the case of Raphael's altarpieces," Peter Humfrey and Martin Kemp (eds.), The Altarpiece in the Renaissance (Cambridge and New York: Cambridge University Press, 1990).

The formalization of the discipline of art history in the eighteenth and nineteenth centuries
Heinrich Dilly, Kunstgeschichte als Institution: Studien zur Geschichte einer Diziplin (Frankfurt am Main: Suhrkamp, 1979).

Scipione Borghese's removal of Raphael's Entombment
R. W. Lightbown, "Princely Pressures I: Raphael and the Spoliators," Apollo, no. 78 (1963), pp. 98–101. For a recent

account of the original setting of the work and its status upon removal, see Donal Cooper, "Raphael's altar-pieces in S. Francesco al Prato, Perugia: patronage, setting and function," Burlington Magazine, vol. 143, no. 1182 (September 2001), pp. 554–61.

Raphael's Entombment appreciated by art tourists in the sixteenth century
Alexander Nagel, Michelangelo and the Reform of Art (Cambridge: Cambridge University Press, 2000), p. 137, note 54; the primary sources are collected in Paola della Pergola, Galleria Borghese. I Dipinti, II (Rome: Istituto Poligrafico dello Stato, Libreria dello Stato, 1959), pp. 195–215.

The removal of panels from original ensembles and their reconstitution as gallery pictures
R. W. Lightbown, "Princely Pressures II: Francesco I d'Este and Correggio," Apollo, no. 78 (1963), pp. 193–9; Wolfram Prinz, Die Entstehung der Galerie in Frankreich und Italien (Berlin: Mann, 1970).

Reflections on sitedness and substitutability in the age of the art market
Amy Powell, "Painting as blur: landscapes in paintings of the Dutch interior," Oxford Art Journal, vol. 33, no. 2 (2010), pp. 143–66.

6. The history of the museum is the history of modern art

Quatremère de Quincy
Quatremère de Quincy, Lettres à Miranda sur le déplacement des monuments de l'art de l'Italie, ed. Édouard Pommier (Paris: Macula, 1989).

The founding of the Musée Central des Arts in 1793 and the origins of the Musée du Louvre
Andrew McClellan, Inventing the Louvre: Art, Politics, and the Origins of the Modern Museum in Eighteenth-Century Paris (Cambridge: Cambridge University Press, 1994).

Winckelmann and archeology
Adolf H. Bornbein, "Winckelmann und die klassische Archäologie," in Thomas W. Gachtgens (ed.), Johann Joachim Winckelmann, 1717–1768 (Hamburg: Felix Meiner, 1986), pp. 289–99; Alex Potts, Flesh and the Ideal:

Winckelmann and the Origins of Art History (New Haven and London: Yale University Press, 1994), pp. 13–15.

Quatremère and the economy of speculation
Nina Dubin, Futures and Ruins: Eighteenth-Century Paris and the Art of Hubert Robert (Los Angeles: Getty Research Institute, 2010), especially chapter 4.

Clement Greenberg and the medium
The clearest, most far-reaching statement of Greenberg's aesthetics of medium specificity is perhaps "Modernist painting" (1960), reprinted in Clement Greenberg: The Collected Essays and Criticism, vol. 4: Modernism with a Vengeance, 1957–1969, ed. John O'Brian (Chicago and London: University of Chicago Press, 1993), pp. 85–93.

Adorno and aesthetic autonomy
Theodor Adorno, Aesthetic Theory, trans. Robert Hullot-Kentor (Minneapolis: University of Minnesota Press, 1998).

For a prominent Adornian reading of Warhol, see Benjamin H. D. Buchloh, "Andy Warhol's one-dimensional art, 1956–1966" (1989), reprinted in Neo-Avantgarde and Culture Industry: Essays on European and American Art from 1955 to 1975 (Cambridge, Mass. and London: MIT Press, 2000), pp. 461–530.

Marx on commodity fetishism
Karl Marx, Capital, Volume One, reprinted in The Marx-Engels Reader, 2nd edition, ed. Robert C. Tucker (New York and London: W. W. Norton & Co., 1978), part 1, chapter 1, section 4, pp. 321–7. For a reading of Quatremère in light of Marx, see Daniel J. Sherman, "Quatremère/Benjamin/Marx: art museums, aura, and commodity fetishism," in Daniel Sherman and Irit Rogoff (eds.) Museum Culture: Histories, Discourses, Spectacles (Minneapolis: University of Minnesota Press, 2000), pp. 123–43

Andrea Fraser's Untitled (2003)
Guy Trebay, "Sex, art and videotape," New York Times, June 13, 2004, http://www.nytimes.com/2004/06/13/magazine/13ENCOUNTER.html?pagewanted=all. See also, George Baker, "Fraser's form," in Yilmaz Dziewior (ed.), Andrea Fraser,

Works: 1984 to 2003 (Cologne: Dumont, Kunstverein in Hamburg, 2003), p. 72.

Guy Debord, *La Société du spectacle* (1967); English edition: *Society of the Spectacle* (New York: Zone Books, 1994).

Damien Hirst's *For the Love of God*
Damien Hirst, Rudi Fuchs, and Jason Beard, *For the Love of God: The Making of the Diamond Skull* (London: Other Criteria/White Cube, 2007).

The Saint Yrieix bust
H.W. Os et al., *The Way to Heaven: Relic Veneration in the Middle Ages* (Baarn: de Prom, 2000), pp. 104–6. The emphasis on the light that emanates from relics through their reliquaries runs through the medieval accounts of relic worship. See above all Arnold Angenendt, *Heilige und Reliquien: Die Geschichte ihres Kultes vom frühen Christentum bis zur Gegenwart* (Berlin: Beck, 1997). On the dialectic of beauty and ugliness in the relation of relic and reliquary, see Cynthia Hahn, "What do reliquaries do for relics?," *Numen*, no. 57 (2010), pp. 284–316.

Guibert of Nogent's critique of relics
Guibert of Nogent, "On saints and their relics," trans. Thomas Head, in *Medieval Hagiography: An Anthology* (New York and London: Routledge, 2000), p. 418. "These things are clearly done by those who, according to the Apostle [1 Tim. 6:5], 'suppose gain to be godliness' and turn those very things which should serve for the salvation of their souls into the excrement of bags of money."

7. Painting as second-order observation

The presentation of chapels as models or representations of other sacred places
Richard Krautheimer, "Introduction to an iconography of medieval architecture," *Journal of the Warburg and Courtauld Institutes*, vol. 5 (1942), pp. 1–33; Alexander Nagel and Christopher S. Wood, *Anachronic Renaissance* (New York: Zone Books, 2010), especially chapters 6 and 15.

Niklas Luhmann
For Niklas Luhmann's definition of the concept of "reentry" as "das Hineincopieren einer Unterscheidung als dieselbe in eine andere," see *Die Gesellschaft der Gesellschaft* (Frankfurt am Main: Suhrkamp 1997), p. 796.

The concept is invoked frequently throughout his *Art as a Social System* (Stanford: Stanford University Press, 2000), in particular in the final chapter, "Self-description."

Gentile da Fabriano's *The Crippled and the Sick Cured at the Tomb of Saint Nicholas*
Lionel Cust and Herbert P. Horne, "Notes on pictures in the Royal Collections, article VII: The Quaratesi altarpiece by Gentile da Fabriano," *Burlington Magazine*, vol. 6, no. 24 (March 1905), pp. 470–5. For the altarpiece, see Keith Christiansen, *Gentile da Fabriano* (Ithaca, N.Y.: Cornell University Press, 1982), pp. 43–9, 102–5.

On the oil of Saint Nicholas's tomb
Jacobus de Voragine, *The Golden Legend: Readings on the Saints*, trans. William Granger Ryan, vol. I (Princeton: Princeton University Press, 1993), p. 25.

The symbolic status of mosaic in the fifteenth century
Alexander Nagel and Christopher S. Wood, *Anachronic Renaissance* (New York: Zone Books, 2010), chapters 10, 12, and 27.

On the removal of Saint Nicholas's body in 1087
"Translatio Barim Graece," in G. Anrich, *Hagios Nikolaos*, vol. I (Leipzig, 1913–17), pp. 435–9. See also Clive Foss, "The Lycian Coast in the Byzantine Age," *Dumbarton Oaks Papers*, vol. 48 (1994), pp. 34–5.

The history of the architecture of the Basilica di San Nicola in Bari
Francesco Nitti di Vito, *La basilica di S. Nicola di Bari: guida storico-artistica* (Bari: G. Laterza, 2007); Franco Schettini, *La basilica di San Nicola di Bari* (Bari: Laterza, 1967); Richard Krautheimer, "San Nicola in Bari und die apulische Architektur des 12. Jahrhunderts," *Wiener Jahrbuch für Kunstgeschichte*, no. 9 (1934), pp. 5–42.

The Greek connotation of the mandorla
For examples from Thessalonica, see Christa Belting-Ihm, *Programme der christlichen Apsismalerei vom vierten Jahrhundert bis zur Mitte des achten Jahrhunderts* (Wiesbaden: Steiner, 1960), figs. 13.1, 20.1, 23.1, 25.1; see also her "Theophanic images of divine majesty in early medieval Italian church

decoration," in William Tronzo (ed.), *Italian Church Decoration of the Middle Ages and Early Renaissance* (Bologna: Nuova Alfa, 1989), pp. 43–58.

Gentile and intermediality
Alexander Nagel and Christopher S. Wood, *Anachronic Renaissance* (New York: Zone Books, 2010), pp. 336–7.

Luhmann's concept of "second-order observation"
Niklas Luhmann, *Art as a Social System*, trans. Eva M. Knodt (Stanford: University of Stanford Press, 2000), chapter 2, "Observation of the first and second order," pp. 54–101.

Medieval liturgical drama
Sandro Sticca, *The Latin Passion Play: Its Origins and Developments* (Albany: SUNY Press, 1970); Dunbar H. Ogden, *The Staging of Liturgical Drama in the Medieval Church* (Newark: University of Delaware Press; London and Cranbury, NJ: Associated University Presses, 2002); Peter Meredith and John E. Tailby, *The Staging of Religious Drama in Europe in the Later Middle Ages: Texts and Documents in English Translation* (Kalamazoo, Mich.: Medieval Institute Publications, Western Michigan University, 1983).

Examples of the screens separating worshipers from the chancel in Italian churches
Marcia Hall, "The ponte in S. Maria Novella: the problem of the rood screen in Italy," *Journal of the Warburg and Courtauld Institutes*, vol. 37 (1974), 157–173. On the removal of such screens by Vasari, see Hall, "The operation of Vasari's workshop and the designs for S. Maria Novella and S. Croce," *Burlington Magazine*, vol. 115, no. 841 (April, 1973), pp. 204–209.

The choir screen at San Niccolò sopr'Arno in Florence, removed by Vasari
Walter and Elisabeth Paatz, *Die Kirchen von Florenz*, 6 vols. (Frankfurt: Klostermann, 1952), vol. IV, pp. 359–65.

The Mantegna pictures in Tours and London
Giovanni Agosti, Dominique Thiébaut, et. al. *Mantegna: 1431–1506* (Milan: Officina libraria, 2008), pp. 156–7 and 162–6. Pages in French edition: pp. 158–9 and 164–67.

The titulus
Alexander Nagel and Christopher S. Wood, *Anachronic Renaissance* (New York: Zone Books, 2010), chapter 14.

The blood of Christ as source of redemption
1 Peter, 1:2.19; 1 John, 1:7; Apoc. 1:5; Paul, Rom. 3:25; Eph. 1:7; Heb. 9:10. On the later cult and theology of the holy blood, see Caroline Walker Bynum, *Wonderful Blood: Theology and Practice in Late Medieval Northern Germany and Beyond* (Philadelphia: University of Pennsylvania Press, 2007).

Rubens's work in the chapel and its replacement by an ancient Roman statue
Irving Lavin, "An ancient statue of the Empress Helen reidentified(?)," *Art Bulletin*, vol. 49, no. 1 (March 1967), p. 58; see also Hans Vlieghe, *Saints II*, part VIII in *Corpus Rubenianum Ludwig Burchard* (London, New York: Phaidon, 1973), cat. 110, pp. 58–61.

10. Non-site-specificity

Smithson, Heizer, and Holt's trip to Franklin
Smithsonian Institution, Washington, D.C., Archives of American Art, Robert Smithson and Nancy Holt Papers, reel 3834, frame 176. Hereafter cited as AAA, RSNHP.

"If one visits the site, he will see nothing resembling a 'pure object.'" "both sides are present and absent at the same time."
AAA, RSNHP, reel 3834, frame 405 and 407.

Logical pictures
Robert Smithson, *The Collected Writings*, ed. Jack Flam (Berkeley, 1996), p. 364. Hereafter cited as CW.

Ludwig Wittgenstein
Ludwig Wittgenstein, *Tractatus Logico-Philosophicus*, 4.01–4.03, also 2.18.

"the caretaker said he had seen the springs break before on other cars"
AAA, RSNHP, reel 3834, frame 177.

The Palestine box
Cristine Sciacca, "Reliquary box with stones from the Holy Land," in Martina Bagnoli, Holger A. Klein, C. Griffith Mann, and James Robinson (eds.), *Treasure of Heaven: Saints, Relics, and Devotion in Medieval Europe* (New

Haven, London: distributed by Yale University Press, 2010), cat. 13, 36. In a paper given at a symposium held at Dumbarton Oaks on the occasion of the "Treasures of Heaven" exhibition of 2011, Derek Krueger noted that in its present arrangement the rocks would prevent the lid from sliding in over them, and suggested that the plaster in which they are currently embedded belongs to later centuries. He proposed that the rocks originally would have been placed inside a sack in the box.

"Between the *actual site* in the Pine Barrens and *The Non-Site* itself exists a space of metaphoric significance"
CW, p. 364.

Milwaukee Art Center questionnaire
AAA, RSNHP, reel 3835, frame 528.

Audio recording of interview with Tony Robbin, 1968
AAA, RSNHP. The quoted statements are made between minute 5:20 and minute 7:50.

Ubaldo Lanfranchi, Pisa, and the Camposanto
Diane Cole Ahl, "Camposanto, Terra santa: picturing the Holy Land in Pisa," *Artibus et Historiae*, no. 24 (2003), pp. 95–122.

Borgo San Sepolcro
An excellent review of the legends surrounding the town of Borgo San Sepolcro can be found in Christa Gardner von Teuffel, "Niccolò di Segna, Sassetta, Piero della Francesca and Perugino: cult and continuity at Sansepolcro," *Städel-Jahrbuch*, no. 17 (1999), pp. 163–208.

On the *Non-site* quality of the Sainte-Chapelle
Daniel H. Weiss, "Architectural symbolism and the decoration of the Ste.-Chapelle," *Art Bulletin*, vol. 77, no. 2 (June 1995), pp. 308–20.

Special properties of the Franklin rocks
AAA, RSNHP, reel 3834, frame 176: "The only other site in 'the mineral world' that equals Franklin is a site in Sweden. In Franklin one may find an excess of 194 types different types of minerals, 26 of these are found nowhere else in the world. Its most common metals are zinc, manganese, and iron. On June 14, 1968 my wife Nancy, Michael Heizer, and I took a trip

to Franklin to collect mineral fragments for the containers. Near the Buckwheat Dump is the Franklin Mineral Museum which is connected to a 'Mine Replica' and 'Fluorescent Display Room'. A false cave simulating a mine shaft lead [sic] to the 'black-lit display'." Also, this personal communication from Nancy Holt, April 17, 2011: "The Franklin Non-Site rocks are very special since they glow bright fluorescent colors under black light. Quite amazingly I happened upon a display of these rocks at the Meadowlands Museum, which strangely is in a house once owned by Charles Smithson, RS's great grandfather (see attachment). In what might have been his grandfather Samuel's bedroom is a large, rock display with a black light."

Smithson's 1969 memorandum from the Jewish Museum
The Jewish Museum, Mr. and Mrs. Albert A. List New Year's Graphic Archive.

Michel Foucault
Michel Foucault, *The Order of Things* (New York: Pantheon Books, 1970). In his copy of that book, Smithson underlined a relevant passage from the Introduction, p. xxiii:

Strangely enough, man—the study of whom is supposed by the naïve to be the oldest investigation since Socrates—is probably no more than a kind of rift in the order of things, or, in any case, a configuration whose outlines are determined by the new position he has so recently taken up in the field of knowledge. Whence all the chimeras of the new humanisms, all the facile solutions of an 'anthropology' understood as a universal reflection on man, half-empirical, half-philosophical.

Nancy Holt's statement about Smithson's doubt in making the poster
Personal communication to the author from Holt, May 20, 2011.

"There are no mysteries in these vestiges, no traces of an end or a beginning":
"A sedimentation of the mind: earth projects" (1968), CW, p. 111.

"The artifice is plainly an artifice"
Interview with Tony Robbin cited above, minute 27.

BIBLIOGRAPHICAL SOURCES

Smithson's desire to see Cavallini in Rome, the "insipid equine figures of the Florentines," and Botticelli
AAA, Smithson Letters to George Lester, reel 5438, frames 1280–5. (Hereafter cited as AAA, RSLGL.) The letter is undated but was certainly written in May 1961.

Letter to Nancy Holt, Monday July 24, 1961
AAA, RSNHP, reel 3832, frame 745: "The dark Roman churches appeal to me because much of the art can not be defiled by vulgar liberal eyes. The paintings and mosaics shrouded by deep shadow bring on a the [sic] Peace of the Unknown. The drapes and rich ornamentation covered with soot, crawling around the pillars remind me of the Serpent in the Lost Eden. Each church is a jungle and a desert smothered with cherubs and relics, offering up prayers to the mystery of the Virgin. The glow from the 17th century candles on the faces of the saints hidden in secret shrines evoke the invisable [sic] worlds of dreams within dreams."

Smithson "exposed to all the church architecture and enjoyed all the labyrinthine passageways"
Interview with Paul Cummings, in CW, p. 286. Earlier in the interview, p. 282, he says, "I was very interested in the Byzantine. As a result I remember wandering around through these old baroque churches and going through these labyrinthine vaults."

Smithson transcribes Beckett
AAA, RSNHP, reel 3834, frame 165.

11. The Mannerist Inhuman

All underlinings and annotations in Smithson's books are to be found in the boxed contents of his library now at the Archives of American Art, Smithsonian Institution, Washington, D.C. (over eighty boxes, as yet uncatalogued at the time of writing).

Smithson on Worringer
"Frederick Law Olmsted and the dialectical landscape," in Robert Smithson, *The Collected Writings*, ed. Jack Flam (Berkeley: University of California Press, 1996), pp. 162–3. Hereafter cited as CW.

Smithson's anti-humanist language
"A refutation of historical humanism," CW, p. 337, and "The pathetic fallacy in esthetics," CW, p. 338

"Practically, the whole history of modernism ...'
Unpublished interview, March 20, 1968; questions composed by Irving Sandler and interview conducted by Carol Ross as part of an NYU course organized by Irving Sandler and kindly made available to me by him.

T. E. Hulme's medievalism
See his *Speculations: Essays on Humanism and Philosophy*, ed. Herbert Read (New York: Harcourt Brace, 1924). The first and last essays, "Humanism and the religious attitude" and "Cinders," received underlinings by Smithson in his copy of the book. More recently, see the essays in Edward P. Comentale and Andrzej Gasiorek (ed.), *T. E. Hulme and the Question of Modernism* (London: Ashgate, 2006).

Smithson's notes on Stoer and Jamnitzer
Archives of American Art, Robert Smithson Nancy Holt Papers, reel 3834, frame 80. Hereafter cited as AAA, RSNHP. The treatises are Lorenz Stoer, *Geometria et perspectiva* (Augsburg, 1567), and Wentzel Jamnitzer, *Perspectiva corporum regularium* (Nuremberg, 1568). For Stoer see, Christopher Wood, "The perspective treatise in ruins: Lorenz Stoer, I, 1567," in Lyle Massey (ed.), *The Treatise on Perspective, Published and Unpublished*, Studies in the History of Art, Symposium Papers XXXVI, Washington, National Gallery of Art, CASVA, 2003, pp. 235–57; republished with CD-ROM edition of Lorenz Stoer, *Geometria et perspectiva* (Erlangen: Harald Fischer, 2006). On Jamnitzer, see Albert Flocon, "Wentzel Jamnitzer: orfèvre de la rigueur sensible, étude sur la *Perspectiva corporum regularium*," which serves as preface to his edition of the *Perspectiva* (Paris: Brieux, 1964, and often reprinted).

In an insightful article, Patricia Falguières intuited a connection between the logic of Jamnitzer's progressions and those of Sol LeWitt, via Lewis Carroll's logical games: "Le Théâtre des opérations: notes sur l'index, la methode, et la procédure," *Les Cahiers du Musée National de l'Art*

Moderne, no. 48 (1994), pp. 65–71. That there was a concrete link here is strongly suggested by the fact that in "Entropy and the new monuments," published in 1966 in *Artforum*, Smithson puts his friend LeWitt's art in "Manneristic frames of reference" and sees it in relation to "the highly ordered nonsense" of Lewis Carroll; see CW, pp. 19–20. The unpublished notes on Stoer and Jamnitzer cited above confirm the connection. On the *Enantiomorphic Chamber*s, see the lucid analysis of Anne Morris Reynolds, *Robert Smithson: Learning from New Jersey and Elsewhere* (Cambridge, Mass.: MIT Press, 2003), chapter 3.

"abstraction brings one closer to physical structures within nature itself"
"Frederick Law Olmsted and the dialectical landscape" (1973), CW, p. 162.

Smithson underlines Hauser
Arnold Hauser, *Mannerism: The Crisis of the Renaissance & the Origin of Modern Art*, vol. 1 (New York: Knopf, 1965), 24.

Smithson's mirror works
Jennifer Roberts, *Mirror Travels: Robert Smithson and History* (London: Yale University Press, 2004), pp. 36–9, offers a highly suggestive reading of Pontormo's 1526 *Deposition* in the church of Santa Felicità in Florence in relation to Smithson's interest in rotating crystal formations, a connection corroborated by the materials brought together here.

Smithson and Brecht
The essay by Bertolt Brecht that mattered most to Smithson was "On the alienation effect in the narrative pictures of the elder Brueghel," *Brecht on Theater*, ed. John Willett (New York: Hill and Wang, 1964), pp. 157–9. For Smithson's discussion of it and related alienation effects in Mannerist art, as well as the mention of de Kooning, see "From Ivan the Terrible to Roger Corman or paradoxes of conduct in Mannerism as reflected in the cinema," CW, pp. 350–1.

Bartholomäus Stroebel
The book owned by Smithson on the *Beheading of the Baptist* in the Prado by Bartholomäus Stroebel is *Europäische Allegorie, Prado Nr. 1940, ein Meisterwerk des Manierismus* (Munich: Bruckmann, 1961).

Smithson's 1961 letters describing
"Ikons infused with the feelings of the
Aztec human sacrifice"
Quoted in Thomas Crow, "Cosmic exile:
prophetic turns in the life and art of
Robert Smithson," in Eugenie Tsai (ed.),
Robert Smithson (Berkeley: University of
California Press, 2004), p. 41, note 36.

Judd's anti-humanism as a form of
Pragmatism
Richard Shiff, "Safe from birds," in
Nicholas Serota (ed.), *Donald Judd*
(New York: D.A.P., 2004), pp. 29–61.

"[T]he modern Isms are the result
of the Failure of the 'humanism'
of the Renaissance."
"The deadly effect of despair breaks
down or distorts, ie, Picasso, all vision,
confounding divine and worldly into
a horrible mire. Jackson Pollock, for
example, died of modern demonic-
possession. All the Psychoanalysis in
the World couldn't save him. Action
Painting is the Art of Despair." As well as
Happenings as the "'The Black Mass' for
the retarded [sic]": AAA, Robert Smithson
Letters to George Lester, reel 5438, frame
1280. Hereafter cited as AAA, RSLGL.

"Seething underneath all those masses
of paint"
The 1972 interview where he discusses
his earlier efforts to "overcome a lurking
pagan religious anthropomorphism"
is with Paul Cummings, CW, p. 283.

"Hot" / "cool" Smithson
For a series of important reflections on
the various constructions of the artist,
see Caroline A. Jones, "Preconscious/
posthumous Smithson: the ambiguous
status of art and artist in the
postmodern frame," *RES: Anthropology
and Aesthetics*, no. 41 (2002), pp. 16–37.

"Against backgrounds of dead-space
and no-time, I painted ikons bleeding
from every stroke.... I am a Modern
artist dying of Modernism"
AAA, RSLGL, reel 5438, frame 1256.

The drawing of a female figure in a
landscape and accompanying text is
in AAA, RSLGL, reel 5438, frame 1294.

Smithson and Michelangelo
"What really spoils Michelangelo's
sculpture," CW, pp. 46–8. The non-
footnoted quotation from Panofsky
comes from the essay "The Neoplatonic
movement and Michelangelo," in

*Studies in Iconology: Humanistic
Themes in the Art of the Renaissance*
(New York: Harper Torchbooks, 1962),
p. 177, Smithson's copy of which shows
underlining here and elsewhere.

"Unless the artist has the gift
of exorcism ..."
AAA, RSLGL, reel 5438, frames 1282–3.

Harold Bloom on "the inverted vortex
of Newtonian vision" in Blake
Harold Bloom, *Blake's Apocalypse:
A Study in Poetic Argument*
(London: Victor Gollanz, 1963), p. 295.

"The art of perspective and the
deliberate artifices"
March 20, 1968, unpublished interview
for Irving Sandler's course, cited above.

"Aerial Art," airports,
galactic distance, etc.
CW, pp. 116–19.

Pascal
For Smithson's interest in Pascal's
dictum "Nature is an infinite sphere
whose center is everywhere and whose
circumference is nowhere," see Crow,
"Cosmic exile," in Eugenie Tsai (ed.),
Robert Smithson, cited above, p. 46.

Rotational crystal formation and the
Spiral Jetty
Roberts, *Mirror-Travels*, cited above,
chapter 2 and throughout.

Literature on crystals and ice read
by Smithson
Charles Bunn, *Crystals: Their Role
in Nature and Science* (New York:
Academic Press, 1964); L. K. Runnels,
"Ice," *Scientific American*,
December 1966, pp. 118–24.

Mannerism and Minimalism
Sydney Freedberg, *Parmigianino:
His Works in Painting* (Cambridge,
Mass.: Harvard University Press, 1950),
p. 14; Smithson, "Entropy and the
new monuments," CW, pp. 19–20.

Smithson on the "physical abyss of
raw matter" and Ehrenzweig's
dissolution of self and non-self
"A sedimentation of the mind:
earth projects" (1968), reprinted
in CW, pp. 103–4.

Discarded systems as armatures, in
the manner of Borges
See the 1972 Cummings interview with
Smithson, cited above, CW, p. 292.

Hans Sedlmayr
Hans Sedlmayr, *Art in Crisis: The Lost
Center* (Chicago: Regnery, 1958), especially
chapter 8, "'Autonomous' man."

Nathan A. Scott
Nathan A. Scott, *The Broken Center:
Studies in the Theological Horizon of
Modern Literature* (New Haven: Yale
University Press, 1966). Smithson's
copy is the third printing, 1968.

"Theology: literature in the divinity
school," *Time*, December 22, 1967.

Smithson's wife Nancy Holt has
suggested to me that though the
underlinings in the book by Scott
are clearly Smithson's she believes
the annotations pointing to Richard
Serra and Carl Andre are hers. Email
communication of June 9, 2011: "RS
and I shared interest in this area. I also
remember reading a review of this book,
maybe the one in *Time*. I would have
wanted to read it, and so would RS."

"The 'materialist' Carl Andre calls
his work a 'flight from the mind.'"
"A museum of language in the
vicinity of art" (1968), CW, p. 84.

Smithson on Oldenburg
Smithson's Claes Oldenburg quotation
is in the unpublished March 20, 1968
interview conducted as part of Irving
Sandler's seminar, cited above.

Nancy Holt on the year 1968
Interview with James Meyer,
September 7–9, 2007, in
Alena Williams (ed.), *Nancy Holt:
Sightlines* (Berkeley: University of
California Press, 2011), p. 224.

Scholarly and critical discomfort
with the "metaphysical" dimension
of Smithson's art and thought
See Crow, "Cosmic exile," cited above,
p. 50, note 79.

12. The year 1962: Mosaic resonance

Klein's ex-votos
Pierre Restany, "Yves Klein: *The Ex-Voto
for Saint Rita of Cascia*," in *Yves Klein,
1928–1962: A Retrospective* (Houston:
Institute for the Arts, Rice University,
1982), pp. 255–7; for their connection
with the *Zones of Immaterial Pictorial
Sensibility*, see Thierry de Duve,
"Yves Klein, or The Dead Dealer,"
October, no. 49 (1989), pp. 72–90.

Warhol
Andy Warhol's gold-ground Marilyn
paintings at the Stable gallery in 1962
were described enthusiastically as
"beautiful, vulgar, heartbreaking icons"
by Michael Fried in an article published
in *Art International* that year. Reprinted
in Fried, *Art and Objecthood: Essays
and Reviews* (Chicago and London:
University of Chicago Press, 1998),
p. 287. Pasolini compared Warhol with
the famous mosaics at Ravenna in
Écrits sur la peinture, ed. Hervé Joubert-
Laurencin (Paris: Carré, 1997), pp. 88–9;
English translation, "Andy Warhol's
Ladies and Gentlemen" (1975);
reprinted in *Andy Warhol Ladies and
Gentlemen* (New York: Skarstedt
Gallery, 2009), p. 5.

Newman's *Stations of the Cross*
Mark Godfrey, *Abstraction and the
Holocaust* (London: Yale University
Press, 2007), pp. 51–78.

Ad Reinhardt's Greek crosses
Alexandra Munroe, "Art of perceptual
experience: pure abstraction and
ecstatic minimalism," in *The Third
Mind: American Artists Contemplate Asia,
1860–1989* (New York: Guggenheim
Museum, 2009), pp. 287–8. The
relationship was made overt from
an early date: "Is today's artist with
or against the past?" *Artnews*,
vol. 57, no. 5 (September 1958),
pp. 28, 56.

Flavin's icons
Jeffrey Weiss, "Blunt in bright repose,"
in Weiss and Briony Fer, *Dan Flavin:
New Light* (New Haven: Yale University
Press; Washington: National Gallery
of Art, 2006), pp. 60–4; Corinna
Thierolf and Johannes Vogt, *Dan Flavin:
Icons* (Munich: Schirmer/Mosel and
Pinakothek der Moderne, 2009).

**Goeritz's work at the the Chapel of
the Capuchinas**
Luis Barragán, Alvaro Siza, Antonio
Toca, José María Buendía Júlbez,
and Raúl Rispa, *Barragán: The
Complete Works* (New York: Princeton
Architectural Press, 2003), pp. 147–55.

The Rothko Chapel and premodern art
Sheldon Nodelman, *The Rothko Chapel
Paintings: Origins, Structure, Meaning*
(Austin: University of Texas Press,
1997), pp. 302–4.

**Responses to radical developments
in art and culture in 1962**
Leo Steinberg, "Jasper Johns,"
Metro (Milan), no. 4/5 (May 1962)
and "Contemporary art and the plight
of its public," *Harper's Magazine*, vol.
224, no. 1342 (March 1962), pp. 31–9.
Both reprinted in Steinberg, *Other
Criteria: Confrontations with
Twentieth-Century Art* (New York:
Oxford University Press 1972).

Umberto Eco's *Opera aperta* (Milan:
Bompiani, 1962); English edition,
The Open Work (Cambridge, Mass.:
Harvard University Press, 1989).

Marshall McCluhan, *The Gutenberg
Galaxy: The Making of Typographic Man*
(Toronto: University of Toronto Press,
1962).

Leo Steinberg's thesis
"Borromini's San Carlo alle Quattro
Fontane" (1960), published as
*Borromini's San Carlo alle Quattro
Fontane: A Study in Multiple Form
and Architectural Symbolism*
(New York: Garland, 1977).

Umberto Eco's thesis
"Sviluppo dell'estetica medievale"
(1959), reprinted as *Art and Beauty in
the Middle Ages*, trans. Hugh Bredin
(New Haven: Yale University Press,
2002).

McLuhan's thesis on Nashe
"The place of Thomas Nashe in the
learning of his time" (Cambridge
University Ph.D. dissertation, 1943).

McLuhan and Parker
Marshall McLuhan and Harley Parker,
*Through the Vanishing Point:
Space in Poetry and Painting*
(New York: Harper & Row, 1968).

Acoustic resonance
Georg von Bekesy, *Experiments in
Hearing* (Oxford: McGraw-Hill, 1960).

McLuhan's *Counterblast*
Marshall McLuhan, *Counterblast* (New
York: Harcourt, Brace & World, 1969).

**Hall of Fossil Invertebrates,
Royal Ontario Museum**
All Parker quotes on his Hall of Fossil
Invertebrates from Harley Parker,
"New Hall of Fossil Invertebrates,
Royal Ontario Museum," *Curator:
The Museum Journal*, vol. 10, no. 24
(December 1967), pp. 284–96.

Albers at Black Mountain College
Harry Seidler's 1946 notes from
Albers's class at Black Mountain
College are in the possession of the
Museum of Modern Art, New York
(accession number: SC87.2009.2).

Eric Mottram's memoirs
Eric Mottram, *"Live All You Can":
American Experience, 1965–6* (Middlesex:
Solaris in Twickenham, 1992), p. 39.

McLuhan's *Understanding Media*
Marshall McLuhan, *Understanding
Media: The Extensions of Man*
(New York: McGraw-Hill, 1964).

McLuhan's quote from *Finnegan's Wake*
Counterblast (London: Rapp &
Whiting, 1970), p. 24.

**McLuhan and Fiore on time ceasing,
space vanishing, and Joyce**
Marshall McLuhan and Quentin Fiore,
The Medium is the Massage (New York:
Simon and Schuster, 1967), p. 63.

**13. The year 1962: "Aux frontières de
l'illimité et de l'avenir"**

**The uncited quotation from Apollinaire
in Eco's dissertation**
Umberto Eco, *Art and Beauty in the
Middle Ages*, trans. Hugh Bredin (New
Haven: Yale University Press, 2002),
p. 118. The same quote from Apollinaire
is the epigraph of *Opera aperta* (Milan:
Bompiani, 1962). Apollinaire's poem
is quoted as reprinted in *Selected
Writings of Apollinaire* (New York:
New Directions, 1971), p. 194.

**Eco's statement that Joyce's work offers
"an implicit definition of the situation
of contemporary art"**
Umberto Eco, *The Aesthetics of
Chaosmos: The Middle Ages of James Joyce*
(Cambridge, Mass.: Harvard University
Press, 1989), p. 85. (This essay was
originally part of the first 1962 Italian
edition of *Opera aperta*.)

**Eco on the univocality of medieval
exegesis**
Opera aperta (cited above), pp. 31, 285.
None of this has prevented medievalists
from reimporting the idea of the open
work and applying it to their material,
such as, for example, reliquaries. See,
for example, Beate Fricke, *Ecce fides:
Die Statue von Conques, Götzendienst
und Bildkultur im Westen* (Munich: Fink,
2007), pp. 300–11. See also

Ittai Weinryb, review of "Treasures of
Heaven: saints, relics, and devotion
in medieval Europe," *West 86th:
A Journal of Decorative Arts, Design
History, and Material Culture*, no. 18
(2011), pp. 281–6.

**Recent insight on the flexibility of
medieval exegesis**
Alastair Minnis and Ian Johnson (eds.),
*Cambridge History of Literary Criticism:
The Middle Ages*, vol. 2 (Cambridge:
Cambridge University Press, 2008), p. 5.

Eugenio Battisti
Eugenio Battisti, "Pittura e
informazione," *Il Mondo*, July 7, 1962,
p. 15. Eugenio Battisti, *L'antirinascimento,
con una appendice di manoscritti inediti*
(Milan: Feltrinelli, 1962).

**Eco cites Edmond Faral on
medieval *romans***
Eco, *Opera aperta* (cited above), p. 290;
Edmond Faral, *Les Arts poétiques du XIIe
et du XIIIe siècle; recherches et documents
sur la technique littéraire du moyen âge*
(Paris: É. Champion, 1924), p. 60.

Narrative and medieval image programs
For a good overview of the narrative
theories applied by modern scholars
of medieval art, and their intersections
with the experience of modern filmic and
photographic techniques, see Suzanne
Lewis, "Narrative," in *A Companion to
Medieval Art: Romanesque and Gothic Art
in Northern Europe*, ed. Conrad Rudolph
(Oxford: Blackwell, 2006), pp. 86–105.

Eco and Cage in Italy
Romy Golan, "La doppia scommessa
dell'Italia: dalla 'Sintesi delle Arti'
all'Opera Aperta," *Il Caffè Illustrato*,
no. 33 (2006), pp. 60–72, offers an
excellent analysis of Eco's activity in
the context of the debate over the
synthesis of the arts and the arrival
of Cage in Italy in the 1950s.

**14. Environments, flatbeds, and other
forms of receivership**

**The relevance of Fontana's zig-zags to
Cage's *Fontana Mix***
Romy Golan, "La doppia scommessa
dell'Italia: dalla 'Sintesi delle Arti'
all'Opera Aperta," *Il Caffè Illustrato* 33
(2006), pp. 60–72.

Kaprow on Pollock
Allan Kaprow, "The legacy of Jackson
Pollock," *Artnews*, vol. 57, no. 6 (October

1958), pp. 24–6, 55–7. Reprinted with
revisions in Allan Kaprow, *Essays on the
Blurring of Art and Life*, ed. Jeff Kelley
(Berkeley: University of California Press,
1993), pp. 1–9. In this discussion I cite
only the original version.

Kaprow's draft of "The legacy of Jackson
Pollock": Getty Research Institute, Allan
Kaprow Papers, Series I, Box 2, Folder 2.

**Kaprow's notes in Meyer Schapiro's
course on Romanesque art**
Getty Research Institute, Allan Kaprow
Papers, Series I, Box 2, Folder 1,
unpaginated.

Schapiro and images of the Ascension
Meyer Schapiro, "The image of the
disappearing Christ: the ascension in
English art around the year 1000" (1943),
reprinted in *Late Antique, Early Christian
and Medieval Art: Selected Papers*, vol. 3
(New York, 1979), pp. 266–87.

**Kaprow's early "action collages" and
their relation to his environmental works**
Paul Schimmel, "'Only memory can
carry it into the future': Kaprow's
development from the Action-Collages
to the Happenings," in Eva Meyer-
Hermann, Andrew Perchuk, Stephanie
Rosenthal (eds.), *Allan Kaprow: Art
as Life* (Los Angeles: Getty Research
Institute, 2008), pp. 8–19.

**Steinberg on de Kooning and Kline
"tossed into one pot with Rembrandt
and Giotto"**
Leo Steinberg, "Jasper Johns" (1962),
reprinted in *Other Criteria: Confrontations
with Twentieth-Century Art* (New York:
Oxford University Press 1972), pp. 12–13.

**Steinberg asking Johns if his works
were "about human absence"**
Leo Steinberg, *Other Criteria* (cited
above), p. 52 (quotes following in
text from within pp. 50–4).

Steinberg's 1968 lecture
Leo Steinberg, "Other criteria," based
on a lecture given at the Museum
of Modern Art, New York, in 1968,
reprinted in *Other Criteria*, pp. 55–91.

Leo Steinberg's thesis
"Borromini's San Carlo alle Quattro
Fontane" (1960), published as
*Borromini's San Carlo alle Quattro
Fontane: A Study in Multiple Form
and Architectural Symbolism*
(New York: Garland, 1977).

Steinberg's concept of the "multiplex"
Other Criteria (cited above), p. 208;
*Borromini's San Carlo alle Quattro
Fontane ...* (cited above, 1977),
pp. 207, 415.

Giambono and Giovanni di Tano Fei
Leo Steinberg, "Observations in the
Cerasi Chapel," *Art Bulletin*, vol. 41,
no. 2 (June 1959), pp. 183–190.

"Ineluctable modality of the visible"
Opening words of the third episode in
James Joyce, *Ulysses*, ed. Hans Walter
Gabler (New York: Vintage Books, 1986),
p. 31; for Steinberg's quotation of the
phrase, see for example, *Other Criteria*
(cited above), p. 293; "Leonardo's Last
Supper," *Art Quarterly*, vol. 36, no. 4
(1973), pp. 297–410, here p. 379.

15. Inside and out

**Clement Greenberg on modernist
abstraction and Byzantine art**
Clement Greenberg, "Byzantine
parallels," *Art and Culture* (Boston,
Mass.: Beacon Press, 1961), pp. 167–70.

Giotto as the threshold of modernity
For Yeats, Giotto initiated a decisive
turn toward the body, away from the
Byzantine spiritualist mode: "The
Censorship and St. Thomas Aquinas"
(1928) in *The Collected Works of W. B.
Yeats*, vol. X: *Later Articles and Reviews*,
ed. Colton Johnson (New York: Scribner,
1989), pp. 211–13; Elizabeth Bergmann
Loizeaux, *Yeats and the Visual Arts*
(New Brunswick: Rutgers University
Press, 1986), p. 153. On his distinction
between the Renaissance and Byzantium
more generally, see ibid., p. 157.

In 1911 Hulme visited the Basilica of San
Francesco in Assisi and wrote his sister:
"This church in Assisi is very interesting,
for it was practically the beginning of
all modern art." Quoted in Edward P.
Comentale and Andrzej Gąsiorek,
*T. E. Hulme and the Question of
Modernism* (Aldershot: Ashgate,
2006), p. 62. For Hulme on the
relation between Byzantium and the
Renaissance see ibid., pp. 159–60.

McCluhan wrote "whereas till
Giotto a painting was a thing, from
Giotto till Cézanne painting became
the representation of things": *The
Gutenberg Galaxy: The Making of
Typographic Man* (Toronto: University

of Toronto Press, 1962), p. 51. On his notion of the Byzantine mosaic as the paradigmatic premodern medium, see chapter 12 above.

Reinhardt's "How to Look" cartoons
Thomas B. Hess, *The Art Comics and Satires of Ad Reinhardt* (Düsseldorf: Kunsthalle, 1975). On the influence of studies under Schapiro on Reinhart, see Michael Corris, *Ad Reinhardt* (London: Reaktion, 2008), chapter 2, pp. 33–61.

The Nazarenes and subsequent nineteenth-century cases
Cordula Grewe, *Painting the Sacred in the Age of Romanticism* (Farnham: Ashgate, 2009).

Didi-Huberman on the "tyrannie du visible"
Georges Didi-Huberman, *Confronting Images: Questioning the Ends of a Certain History of Art* (University Park, Pa.: Pennsylvania State University Press, 2005).

Belting on the onset of the "era of art"
Hans Belting, *Likeness and Presence: A History of the Image Before the Era of Art* (Chicago: University of Chicago Press, 1994); on our departure from that era: Belting, *Bild-Anthropologie: Entwürfe für eine Bildwissenschaft* (Munich: W. Fink, 2001), translated as *An Anthropology of Images*, trans. Thomas Dunlap (Princeton and Oxford: Princeton University Press, 2011).

Printmaking in the Renaissance
David Landau and Peter W. Parshall, *The Renaissance Print, 1470–1550* (New Haven: Yale University Press, 1994).

The binding of Columbus's print collection with the word "Pinturas"
Mark P. McDonald, *The Print Collection of Ferdinand Columbus (1488–1539): A Renaissance Collector in Seville*, vol. 1: *History and Commentary* (London: British Museum Press, 2004), p. 63.

The extraction of works from their original settings and translocation elsewhere
R. W. Lightbown, "Princely Pressures II: Francesco I d'Este and Correggio," *Apollo*, no. 78 (1963), pp. 193–9; Wolfram Prinz, *Die Entstehung der Galerie in Frankreich und Italien* (Berlin: Mann, 1970). On the formation of the picture gallery: Marc Fumaroli, "Rome 1630: L'Entrée au scène du spectateur," in

Roma 1630: Il trionfo del pennello (Milan: Electa, 1994), pp. 53–82; Victor I. Stoichita, *The Self-Aware Image: An Insight into Early Modern Meta-Painting*, trans. Anne-Marie Glasheen (Cambridge: Cambridge University Press, 1997); the essays in Oliver Impey and Arthur MacGregor (eds.), *The Origins of Museums: The Cabinet of Curiosities in Sixteenth and Seventeenth-Century Europe* (Oxford: Clarendon Press; New York: Oxford University Press, 1985); Krzysztof Pomian, "De la collection particulière au musée d'art," P. Bjurström (ed.), *The Genesis of the Art Museum in the Eighteenth Century* (Stockholm: Nationalmuseum, 1994), pp. 9–27, and also his *Collectors and Curiosities: Paris and Venice 1500–1800* (Cambridge: Polity Press, 1990), especially chapters 1–3; Luigi Salerno, "The picture gallery of Vincenzo Giustiniani," *Burlington Magazine*, vol. 102, nos. 682, 684, 685 (January, March, April 1960), pp. 21–37, 93–105, 135–48; Salvatore Settis, "Origini e significato delle gallerie in Italia," P. Barrochi and G. Ragioneri (eds.), *Gli Uffizi, quattro secoli di una galleria*, vol. 1 (Florence: L. S. Olschki, 1983), pp. 309–17.

Napoleon's acquisition of paintings as spoils of war
Édouard Pommier, *L'Art de la liberté: Doctrines et débats de la Révolution française* (Paris: Gallimard, 1991).

Revisionist reading of French academic painting
Abigail Solomon-Godeau, *Male Trouble: A Crisis in Representation: On the Imagery of Masculinity in French Neoclassicism* (London: Thames & Hudson, 1997).

Translation of Gersaint's account of the painting of the *Enseigne*
Anita Brookner, *Watteau* (Twickenham, England: Hamlyn, 1967), p. 22.

Hubert Robert's painting of the Pont Nôtre-Dame and the physical status of Watteau's work
See the technical report, infrared reflectography and x-radiographs published by Hélène Adhémar, "'L'Enseigne de Gersaint', par Antoine Watteau: aperçus nouveaux," *Bulletin du Laboratoire du Musée du Louvre*, no. 9 (1964), pp. 7–16. An announcement for the engraving after the picture in the *Mercure de France*,

November 1732, p. 249, says that the picture spent only fifteen days on the outside of the shop: "Ce Morceau qu'a 9 pieds de large, sur 5 pieds de haut, a toujours été regardé comme le Chef-d'oeuvre de cet excellent Peintre. Il représente le Magasin d'un Marchand, qui est rempli de différens Tableaux des plus grands Maîtres; on y reconnoît le caractère de et le goût de chacun de ces Maîtres. Cette fameuse Enseigne ne fut exposée que quinze jours; elle fit l'admiration de tout Paris Elle fut vendue à M. Glucq. On la voit à présent dans le cabinet de M. Julienne." Cited in Paul Alfassa, "L'Enseigne de Gersaint," *Bulletin de la société de l'histoire de l'art français* (1910), p. 136.

Hacks as sign painters
Le Roux, *Dictionnaire comique, satirique, critique, burlesque, libre et proverbiale*, 1735. Cited by Julie Anne Plax, *Watteau and the Cultural Politics of Eighteenth-Century France* (Cambridge: Cambridge University Press, 2000), p. 166, who also discusses the organization of the profession of painters and art as a means of cultural capital and class mobility in eighteenth-century France, pp. 171–3.

Rigaud's royal portraiture
Stéphan Perreau, *Hyacinthe Rigaud, 1659–1743: le peintre des rois* (Montpellier: Presses du Languedoc, 2004).

The identification of Marie-Louise Sirois in the painting
Guillaume Glorieux, *À l'Enseigne de Gersaint: Edme-François Gersaint, marchand d'art sur le Pont Notre-Dame, 1694–1750* (Seyssel: Champ Vallon, 2002), p. 82. On the identities (or non-identitities) of the paintings in the background, see ibid., p. 81.

Alberti on Narcissus as inventor of painting
On Painting, trans. Cecil Grayson (New Haven: Yale University Press, 1966), p. 64. I recall Hubert Damisch connecting the Alberti passage to this motif in Watteau's painting in a lecture at University of California, Berkeley in 1986.

Narcissus' recognition of the medium of his reflection
Ovid, *Metamorphoses*, Book III, lines 462–63.

The *"franchise du pinceau"* and the *"coups de maître"*
Donald Posner, "Concerning the 'mechanical' parts of painting and the artistic culture of seventeenth-century France," *Art Bulletin*, vol. 75, no. 4 (December 1993), pp. 583–98; here p. 584, note 5.

The history of the reception of Watteau's *Embarkation from the Isle of Cythera*
Margaret Morgan Grasselli and Pierre Rosenberg, *Watteau 1684–1721* (Washington: National Gallery of Art, 1984), pp. 396–406. For an excellent contextualization of these works, see Sarah R. Cohen, "Un Bal continuel: Watteau's Cythera Paintings and aristocratic dancing in the 1710s," *Art History*, vol. 17, no. 2 (1994), pp. 160–81. I am grateful to Professor Cohen for a very informative exchange about dress and social status in this and other paintings by Watteau.

16. Limits of the diaphane

Steinberg on the flatbed picture plane
Leo Steinberg, *Other Criteria: Confrontations with Twentieth-Century Art* (New York: Oxford University Press, 1972), pp. 82–91, see chapter 14 above.

Joshua Shannon on the antiquated quality of Johns's and Rauschenberg's found objects
Joshua Shannon, *The Disappearance of Objects: New York and the Rise of the Postmodern City* (New Haven: Yale University Press, 2009).

Steinberg on art of the 1950s and '60s having "let the world in again"
Other Criteria (cited above), p. 90.

On the index
Charles Sanders Peirce, *Collected Papers*, ed. Charles Hartshorne and Paul Weiss, vol. 1 (Cambridge, Mass.: Harvard University Press, 1960), pp. 156–73; see also Peirce, "Index," entry in *Dictionary of Philosophy and Psychology*, vol. 1, ed. James Mark Baldwin, (New York and London: Macmillan, 1901), pp. 531–2.

Rosalind Krauss, "Notes on the index," parts 1 and 2 (1977); reprinted in *The Originality of the Avant-Garde and Other Modernist Myths* (Cambridge, Mass.: MIT Press, 1985), pp. 196–220.

Kaprow's early "action collages" and their relation to his environmental works
Paul Schimmel, "'Only memory can carry it into the future': Kaprow's development from the Action-Collages to the Happenings," in Eva Meyer-Hermann, Andrew Perchuk, Stephanie Rosenthal (eds.), *Allan Kaprow: Art as Life* (Los Angeles: Getty Research Institute, 2008), pp. 8–19.

Artist's body as medium
Nauman's *Self-Portrait as a Fountain* and related works: Coosje van Bruggen, *Bruce Nauman* (New York: Rizzoli, 1988), pp. 48, 105–19.

Mendieta's *Sweating Blood* (1973): Julia P. Herzberg, "Ana Mendieta's Iowa Years, 1970–1980," in Olga M. Viso (ed.), *Ana Mendieta: Earth Body, Sculpture and Performance, 1972–1985* (Washington, D.C.: Hirshhorn Museum and Sculpture Garden in association with Hatje Cantz, 2004), p. 150.

Alvin Lucier's *I am Sitting in a Room* (CD) (New York: Lovely Records, 1990).

Video art's reconception of the image as signal
David Joselit, *Feedback: Television Against Democracy* (Cambridge, Mass.: MIT Press, 2007). Drawing on its capacity for simultaneous feed, Rosalind Krauss posited the essence of video art as narcissism in an oft-cited essay: "Video: the aesthetics of narcissism," *October*, no. 1 (1976), pp. 50–64.

Rosalind Krauss on *Tu m'*
"Notes on the index," part 1 (1977), cited above, pp. 198–9.

Didi-Huberman's attempts to recuperate the modality of the index against the post-Renaissance dominance of the distanced visual image
Georges Didi-Huberman, *Confronting Images: Questioning the Ends of a Certain History of Art* (University Park, Pa.: Pennsylvania State University Press, 2005). See also his *La Ressemblance par contact: Archéologie, anachronisme et modernité de l'empreinte* (Paris: Éditions de Minuit, 2008).

Schwitters and Moholy-Nagy's socks
Gwendolen Webster, *Kurt Merz Schwitters* (Cardiff: University of Wales Press, 1997), p. 220.

The tactile emphasis in the early twentieth-century avant-gardes
Janine Mileaf, *Please Touch: Dada and Surrealist Objects after the Readymade* (Hanover, N.H.: Dartmouth College Press and the University Press of New England, 2010).

Peirce on the fluidity of the categories ("But it would be difficult, if not impossible ...")
"Index. A sign, or representation, which refers to its object not so much because of any similarity or analogy with it, nor because it is associated with general characters which that object happens to possess, as because it is in dynamical (including spatial) connection both with the individual object, on the one hand, and with the senses or memory of the person for whom it serves as a sign, on the other hand.... Indices may be distinguished from other signs, or representations, by three characteristic marks: first, that they have no significant resemblance to their objects; second, that they refer to individuals, single units, single collections of units, or single continua; third, that they direct the attention to their objects by blind compulsion. But it would be difficult if not impossible, to instance an absolutely pure index, or to find any sign absolutely devoid of the indexical quality." Peirce, "Index" (cited above), pp. 531–2.

Duchamp: "painting had other functions: it could be religious, philosophical, moral"
Pierre Cabanne, *Dialogues with Marcel Duchamp* (New York: The Viking Press, 1971), p. 43. See also, Marcel Duchamp, interview with James Johnson Sweeney, in "Eleven Europeans in America," *Bulletin of the Museum of Modern Art*, no. 13 (1946), pp. 19–21, reprinted as "The great trouble with art in this century," in Michel Sanouillet and Elmer Peterson (eds.), *The Writings of Marcel Duchamp* (New York: Oxford University Press, 1973), pp. 123–6, especially p. 125.

Modernism's critique of the "dominance of the visual"
Martin Jay, *Downcast Eyes: The Denigration of Vision in Twentieth-Century French Thought* (Berkeley: University of California Press, 1993).

BIBLIOGRAPHICAL SOURCES

Late-medieval and early modern theories of vision
David C. Lindberg, *Theories of Vision from al-Kindi to Kepler* (Chicago: University of Chicago Press, 1976) and Stuart Clark, *Vanities of the Eye: Vision in Early Modern European Culture* (Oxford: Oxford University Press, 2007), especially the introduction and chapter 1.

Giulio Camillo, *On Human Deification*
Cesare Vasoli, "Uno scritto inedito di Giulio Camillo: 'De l'humana deificatione,'" *Rinascimento*, no. 24 (1984), pp. 225–6.

Mimesis in Plato
Ernst Cassirer, "Eidos und Eidolon: Das Problem des Schönen und der Kunst in Platos Dialogen," *Vorträge der Bibliothek Warburg*, 2, vol. 1 (1922–3), pp. 1–27; Erwin Panofksy, *Idea, ein Beitrag zur Begriffsgeschichte der älteren Kunsttheorie* (Leipzig: B. G. Teubner, 1924), English edition, *Idea: A Concept in Art Theory* (New York: Harper and Row, 1968).

The classicist idea of *"la Belle Nature"*
Ludwig Tavernier, "L'imitation de la belle nature. Zum Verständnis des Künstlers in der Nachahmungstheorie von Charles Batteux," in Hans Körner, Constanze Peres, Reinhard Steiner, Ludwig Tavernier (eds.), *Empfindung und Reflexion: Ein Problem des 18. Jahrhunderts* (Hildesheim, Zürich and New York: Olms 1986), pp. 49–98.

Gombrich's constructivist theory of pictorial naturalism
Ernst Gombrich, *Art and Illusion: A Study in the Psychology of Pictorial Representation* (New York: Pantheon Books, 1960).

Leonardo and Giorgione and the new understandings of the pictorial field:
Alexander Nagel, "Leonardo and sfumato," *RES: Anthropology and Aesthetics*, no. 24 (Autumn 1993), pp. 7–20; Nagel, *The Controversy of Renaissance Art* (Chicago: Chicago University Press, 2011), chapters 3 and 4; David Rosand, *Painting in Sixteenth-Century Venice: Titian, Veronese, Tintoretto*, rev. ed. (Cambridge: Cambridge University Press, 1997).

Marcantanio Michiel's descriptions of collections in Venice and Padua
Jennifer Fletcher, "Marcantonio Michiel: his friends and collection," *Burlington Magazine*, vol. 123, no. 941 (August 1981), pp. 452–67; Fletcher, "Marcantonio Michiel, 'che ha veduto assai,'" *Burlington Magazine*, vol. 123, no. 943 (October 1981), pp. 602–9.

The book in Parmigianino's *Portrait of a Collector*
Beatrice e Raffaella Bentivoglio-Ravasio, "L'offiziolo Durazzo," in A. Bacchi and A. De Marchi (ed.), *Francesco Marmitta* (Turin: U. Allemandi, 1995), pp. 187–254.

Byzantine understanding of sight as the caressing and touching of the optical rays
Charles Barber, *Figure and Likeness: On the Limits of Representation in Byzantine Iconoclasm* (Princeton: Princeton University Press, 2002), p. 136.

Descartes on the image incorporated by the pregnant woman
René Descartes, *Discourse on Method, Optics, Geometry, Meteorology*, trans. Paul J. Olscamp (Indianapolis: Hackett, 2001), p. 100.

Epicurean, Lucretian *eidola*
Cyril Bailey, *The Greek Atomists and Epicurus: A Study* (New York: Russell & Russell, 1964); Titus Lucretius Carus, *De Rerum Natura*, Book IV.

Guido Cavalcanti
An excellent contextualization of Cavalcanti's conceits, which admirably resists seeing them as mere applications of philosophical principles, is Robert Klein, "Spirito Peregrino," Madeline Jay and Leon Wieseltier (trans.), in *Form and Meaning: Essays on the Renaissance and Modern Art* (New York: Viking, 1979), pp. 62–85.

"Ineluctable modality of the visible"
Opening of chapter 3 in James Joyce's *Ulysses*, ed. Hans Walter Gabler (New York: Vintage Books, 1986), p. 31. On the Aristotelian and other sources for the passage from Joyce, see Ernesto Livorni "'Ineluctable modality of the visible': diaphane in the 'Proteus' episode," *James Joyce Quarterly*, no. 36 (1999), pp. 127–69; Joseph E. Duncan, "The modality of the audible in Joyce's *Ulysses*," *PMLA* 72 (1957), pp. 286–95.

"Maestro di color che sanno"
Dante, *Inferno* IV.131, a reference to Aristotle.

Ezra Pound on Cavalcanti
"Cavalcanti," in *Pound's Cavalcanti: An Edition of the Translations, Notes, and Essays*, ed. David Anderson (Princeton: Princeton University Press, 1983), pp. 203–51.

Pound's involvement in Vorticism and other contemporary movements in the visual arts
Richard Humphreys, *Pound's Artists: Ezra Pound and the Visual Arts in London, Paris, and Italy* (London: Tate Gallery, 1985).

On "Vibratory Modernism"
Linda Dalyrmple Henderson, "Vibratory modernism: Boccioni, Kupka, and the ether of space," in Bruce Clarke and Linda Dalyrmple Henderson (eds.), *From Energy to Information: Representation in Science and Technology, Art, and Literature* (Stanford: Stanford University Press, 2002), pp. 126–49; see also Henderson, *The Fourth Dimension and Non-Euclidean Geometry in Modern Art* (Princeton: Princeton University Press, 1983).

Blavatsky's "daguerreotype impressions"
Quoted in Henderson, "Vibratory modernism," (cited above), p. 131.

The alchemical aspects of Duchamp's *Large Glass*
John F. Moffitt, *Alchemist of the Avant-Garde: The Case of Marcel Duchamp* (Albany: State University of New York Press, 2003).

The resolution of three dimensions to two in the *Large Glass*
Linda Dalrymple Henderson, *Duchamp in Context: Science and Technology in the Large Glass and Related Works* (Princeton: Princeton University Press, 1998), chapter 8.

Pound on Picabia and Duchamp
A Guide to Kulchur (originally published 1938; reprinted New York: New Directions, 1970), p. 87.

The line from Pound's letter ("Duchamp wd. Be the most valuable collaborator") is quoted in Rebecca Beasley, *Ezra Pound and the Visual Culture of Modernism* (Cambridge: Cambridge University Press, 2007), p. 168, note 51, who remarks: "Pound's enthusiasm for Duchamp, and also Man Ray, whom he associates with Duchamp, is at its height during the winter of 1922–23."

Duchamp's statement that before it was pleasing and attractive physically, art "had been literary or religious: it had all been at the service of the mind"
Marcel Duchamp, interview with James Johnson Sweeney, in "Eleven Europeans in America," *Bulletin of the Museum of Modern Art*, no. 13 (1946), pp. 19–21, reprinted as "The great trouble with art in this century," in Michel Sanouillet and Elmer Peterson (eds.), *The Writings of Marcel Duchamp* (New York: Oxford University Press, 1973), p. 123–6, here p. 125.

Medieval reliquaries
See Bruno Reudenbach and Gia Toussaint (eds.), *Reliquiare im Mittelalter* (Berlin: Akademie, 2005); Martina Bagnoli, Holger A. Klein, C. Griffith Mann, and James Robinson (eds.), *Treasures of Heaven Saints, Relics, and Devotion in Medieval Europe* (New Haven: Yale University Press, 2010); and Cynthia Hahn, *Strange Beauty: Origins and Issues in the Making of Medieval Reliquaries 400–c. 1204* (University Park, Pa.: Penn State University Press, 2012).

On the relic of Saint Andrew's sandal at Trier and related works
Thomas Head, "Art and artifice in Ottonian Trier," *Gesta*, no. 36 (1997), pp. 65–82, and Cynthia Hahn, "What do reliquaries do for relics?" *Numen*, no. 57 (2010), pp. 284–316, with further bibliography. The relation of relics to commodities, a problem with significant implications for any comparison of relics and readymades, is studied by Patrick Geary, "Sacred commodities: the circulation of medieval relics," in Arjun Appadurai (ed.), *The Social Life of Things: Commodities in Cultural Perspective* (Cambridge: Cambridge University Press, 1986), pp. 169–91.

Duchamp on the readymades and "disorientation for the spectator"
The quotation in the text is taken from the recording of the panel discussion, available on the MoMA website. See Lawrence Alloway, Marcel Duchamp, Richard Huelsenbeck, Robert Rauschenberg, Roger Shattuck, and William C. Seitz, "The art of assemblage: a symposium," in James Leggio and Helen M. Franc (eds.), *Essays on Assemblage, Studies in Modern Art*, vol. 2 (New York: Museum of Modern Art, 1992), p. 144, for a printed text, which interprets the oral delivery

of Duchamp's syntax and meaning somewhat differently: "Very simply, the main point is disorientation for the spectator, as it was for myself when I did it. The surprise comes in as an element. And connotation—meaning that according to the observer's imagination, he can go into any field or any form of imagination and associations of ideas he wants, depending on his own reactions. In other words, my reactions were not to be his reactions at all. It was a sort of catalytic form in itself, ready to be accepted by anybody, or to be interpreted by the different temperaments of all the spectators."

Duchamp's statement that "'intellect' is too dry a word. I like the word 'belief.'"
Marcel Duchamp, interview with James Johnson Sweeney, in "Eleven Europeans in America," *Bulletin of the Museum of Modern Art*, no. 13 (1946), pp. 19–21, reprinted as "The great trouble with art in this century," in Michel Sanouillet and Elmer Peterson (eds.), *The Writings of Marcel Duchamp* (New York: Oxford University Press, 1973), pp. 123–6, here p. 137.

18. Cathedral thinking

William Morris and John Ruskin
On Morris's and Ruskin's roles in the Arts and Crafts movement, Peter Stanksy, *Redesigning the World: William Morris, the 1880s, and the Arts and Crafts Movement* (New Jersey: Princeton, 1985); Gillian Naylor, *The Arts and Crafts Movement: A Study of its Sources, Ideals and Influence on Design Theory* (London: Trefoil, 1990).

Riegl's influence on Art Nouveau
Ákos Moravánszky, *Competing Visions: Aesthetic Invention and Social Imagination in Central European Architecture, 1867–1918* (Cambridge, Mass.: MIT Press, 1998), chapter 4, pp. 105–50.

Worringer's early work in relation to early experiments with abstraction
Neil H. Donahue (ed.), *Invisible Cathedrals: The Expressionist Art History of Wilhelm Worringer* (University Park, Pa.: Pennsylvania State University Press, 1995); J. B. Bullen, "Byzantinism and Modernism 1900–14," *Burlington Magazine*, vol. 141, no. 1160 (November 1999), pp. 665–75; and Hal Foster, *Prosthetic Gods* (Cambridge, Mass.: MIT Press, 2004), chapter 3.

McLuhan, Eco, and Steinberg
See chapters 12, 13, and 14 above.

The Bauhaus manifesto and Feininger's woodcut
Charles W. Haxthausen, "Walter Gropius and Lyonel Feininger, Bauhaus Manifesto, 1919," in Barry Bergdoll and Leah Dickerman (eds.), *Bauhaus 1919–1933* (New York: Museum of Modern Art, 2009), pp. 64–77.

Early Bauhaus, the Arbeitsrat für Kunst, and the post-WWI avant-garde context in Berlin
Joan Weinstein, *The End of Expressionism: Art and the November Revolution in Germany, 1918–19* (Chicago: University of Chicago Press, 1990).

Adolf Behne on the "reawakening of religiosity"
Response to a questionnaire concerning "the position of the artist vis-à-vis the movements of the time (die Stellung der Künstler zu den Bewengungen der Zeit)," in *Ja! Stimmen des Arbeitsrates für Kunst in Berlin* (Berlin: Photographische Gesellschaft, 1919), reprinted in *Arbeitsrat für Kunst, Berlin 1918–1921: Ausstellung mit Dokumentation* (Berlin: Akademie der Künste, 1980), p. 22. See also Arnd Bohm, "Artful reproduction: Benjamin's appropriation of Adolf Behne's 'Das Reproduktive Zeitalter' in the Kunstwerk-Essay," *Germanic Review*, no. 68 (1993), pp. 146–55.

Käthe Kollwitz in 1920 on religion, art, and socialism
"Ich will wirken in dieser Zeit": Auswahl aus den Tagebüchern und Briefen aus Graphikm, Zeichnungen und Plastik (Berlin: Mann, 1952), p. 89, writing on July 8, 1920: "keine Zeit bringt die Einheitlichkeit des katholischen Glaubens wieder. Eine Einheitlichkeit, die über die Völkergrenzen hinausgehend ganz Europa umfaßte. Aus diesem einheitlichen starken Glauben heraus enstanden die Kirchen. In ihnen faßte das Volk die Inhalte aller Künste zusammen, die Künste waren eine Einheit, wie sie es auch in den Religonsstätten früherer Völker waren. Mit dem Verfall der Religionen verfällt dieser Zusammenhang, so daß wir zuletzt in unserem Jarhhundert in der bildenden Kunst zu dem öden Austellungswesen herunterkommen. Wiederkommen kann eine Zeit

solcher Einheitlichkeit nur durch den Sozialismus. Sie kommt sicher durch ihn wieder—aber wann? Wie viele Generationen werden noch darüber vergehen?" My thanks to Robert Brennan for bringing this quotation to my attention.

Piet Mondrian
Mondrian's "The new plastic in painting" (1917) is reprinted and translated in Harry Holtzman and Martin S. James (eds.), *The New Art— The New Life: The Collected Writings of Piet Mondrian* (Boston, Mass.: G. K. Hall, 1986), pp. 27–74.

Kazimir Malevich
For Malevich's spiritualism, a pre-revolutionary (that is, the October Revolution) example would be the essay "The artist" (c. 1915) in Malevich, *Essays on Art*, trans. Xenia Hoffmann (Copenhagen: Borgen, 1978), vol. 4, pp. 9–26; for postrevolutionary examples, see "Monuments not made by human hands" (1919) and "God is not cast down" (1922) in *Essays on Art*, trans. Xenia Glowacki-Prus and Arnold McMillin (Copenhangen: Borgen, 1968), pp. 65–7 and 188–223.

Apollinaire on modern art and religion
Guillaume Apollinaire, *The Cubist Painters*, trans. Lionel Abel (New York: Wittenborn and Company, 1944), p. 12.

Walter Gropius
Gropius's text for the "Exhibition of unknown architects" reprinted in Ulrich Conrads, *Programme und Manifeste zur Architektur des 20. Jahrhunderts* (Berlin, Frankfurt am Main, Wien: Ullstein, 1964), pp. 43–4; Ulrich Conrads, *Programs and Manifestoes on 20th Century Architecture* (Cambridge. Mass.: MIT Press, 1970), pp. 46–7.

On the *Gläserne Kette*
O. M. Ungers, et al., *Die Gläserne Kette: visionäre Architekturen aus dem Kreis um Bruno Taut, 1919–1920* (Berlin: Akademie der Künste, 1963); Rosemarie Haag Bletter, "The interpretation of the glass dream: Expressionist architecture and the history of the crystal metaphor," *Journal of the Society of Architectural Historians*, vol., 40, no. 1 (March 1981), pp. 20–43; Maria Stavrinaki, *La Chaîne de verre: une correspondance expressionniste* (Paris: Éditions de la Villette, 2009).

Gropius and the flat roof controversy
Richard Pommer, "The flat roof: a modernist controversy in Germany," *Art Journal*, vol. 43, no. 2 (June 1983), pp. 158–69.

Behne on the end of art as luxury object and its new role among a "once-again productive people"
Adolf Behne, *Die Wiederkehr der Kunst* (Berlin: Wolff, 1919), pp. 104–9. For Schwitters, see chapter 20 below.

19. Instead of cathedrals, machines for living

Behne's articles against Expressionist mannerism
In *Frühlicht*, no. 2, Winter 1921/2, p. 55: "Als nach Kriegsende die Welle des Expressionismus und Romantischen auch die jungen Architekten ergriff (Ausstellungen "Unbekannter Architekten" und "Neues Bauen"), war das als Folge der langen Isolierung, als Reaktion des Gefühls auf die Nutzlosigkeit der geopferten Jahre verständlich. Aber wohl alle Utopisten haben sich inzwischen vom Kult des Phantastischen zum Lebendigen und zur Selbstbesinnung zurückgefunden. Auch steckte unter dem Utopischen der sehr berechtigte Wunsch, das wesentlich Neue, an aller Tradition Befreite zu gewinnen." Also in *Sozialistische Monatshefte*, October 1922, pp. 901–2, he speaks of the "sogennante religiöse Kunst des Expressionismus zum grössten Teil unfrommer Selbstbetrug, ja eine Mode." Behne's *Dombauhütte* was a "wesenlosen ausgedachtes Etwas. Es kann kein Mensch für eine 'Art Dombauhütte' eine Form finden. Form kommt aus Sache. Wo keine Sache, wo statt ihrer ein Wort, ein unklarer abgestorbener Begriff ist, kann keine Form enstehen. Wir sehen also statt einer komplizierte, willkürliche sinnlose Künstlichkeit, nicht Haus, nicht Halle, nicht Zelt, nicht Hütte, nicht Bude, nur ein Gehirn abgequälte unfruchtbare Dekoration." Cited in Manfred Speidel, Karl Kegler, and Peter Ritterbach, *Wege zu einer neuen Baukunst: Bruno Taut Frühlicht. Konzeptkritik Hefte 1–4, 1921–22 und Rekonstruktion Heft 5, 1922* (Berlin: Mann, 2000), p. 45. See also Johannes Werner, "Die Kathedrale des Sozialismus: Erinnerung an eine Utopie," *Zeitschrift für Aesthetik und Allgemeine Kunstwissenschaft*, no. 31 (1986), pp. 264–74.

The best study of the post-Expressionist "turn" in Behne's thinking is Maria Stavrinaki's introduction to the French translation of Behne's *Der Moderne Zweckbau*, wrtitten in 1923 and published in 1926 is Maria Stavrinaki, "L'architecture du 'pays du milieu': la solution sublime," in Adolf Behne, *La Construction fonctionnelle moderne* (Paris: Éditions de la Villette, 2008), pp. 7–32.

Peter Behrens's *Dombauhütte*
Ross Anderson, "The medieval mason's lodge as paradigm for Peter Behrens's *Dombauhütte* in Munich, 1922," *Art Bulletin*, vol. 90, no. 3 (September 2008), pp. 441–65.

Oskar Schlemmer against cathedral thinking
Oskar Schlemmer, *Briefe und Tagebücher*, ed. Tut Schlemmer (Munich 1958), p. 132, cited in part by Peter Hahn, "Black box Bauhaus: Ideen und Utopien der frühen Jahre," in *Das Frühe Bauhaus und Johannes Itten*, pp. 13–35, here p. 32: "Abkehr von der Utopie. Wir können und dürfen nur das Realste, wollen die Realisierung der Ideen erstreben. Statt Kathedralen die Wohnmaschine. Abkehr also von Mittelalterlichkeit und vom mittelalterlichen Begriff des Handwerks, und zuletzt des Handwerks selbst, als nur Schulung und Mittel zum Zweck der Gestaltung. Statt Ornamentationen, in die ein unsachliches oder ästhetisches, von mittelalterlichen Begriffen geglleitetes Handwerk notwendig verläuft, sachliche Objekte, die Zwecken dienen."

Worringer's early work
Wilhelm Worringer, *Abstraktion und Einfühlung; ein Beitrag zur Stilpsychologie* (Munich: R. Piper, 1908), translated as *Abstraction and Empathy: A Contribution to the Psychology of Style* (London: Routledge and Kegan Paul, 1953); *Formprobleme der Gotik* (Munich: Piper, 1911), translated as *Form Problems of the Gothic* (New York: G. E. Stechert & Co., 1912).

Worringer signed the founding document of the *Arbeitsrat* in 1918; see the facsimile in *Arbeitsrat für Kunst, Berlin 1918–1921: Ausstellung mit Dokumentation* (Berlin: Akademie der Künste, 1980), p. 87.

Behne keeps up with Worringer
See the letter of March 3, 1921 from Adolf Behne to Gropius, in *Arbeitsrat für Kunst, Berlin 1918–1921: Ausstellung mit Dokumentation* (Berlin: Akademie der Künste, 1980), p. 124: "Ich las Worringers Zeitfragen der Kunst— geistreichelndes Blech." Despite this negative initial reaction, the "turn" clearly made an impact on Behne, who adapted it to his own ends.

Worringer on "Museum air" and the "tragic exploded fragments of a failed [artistic] will [Wollen]"
Wilhelm Worringer, "Künstlerische Zeitfragen" (1921), reprinted in *Fragen und Gegenfragen: Schriften zum Kunstproblem* (Munich: Piper, 1956), p. 112.

On the general shift in Worringer's thought around this time, Charles W. Haxthausen, "Modern art after 'The End of Expressionism': Worringer in the 1920s," in Neil H. Donahue (ed.), *Invisible Cathedrals: The Expressionist Art History of Wilhelm Worringer* (University Park, Pa.: Pennsylvania State University Press, 1995), pp. 119–34.

Wilhelm Worringer, *Die Anfänge der Tafelmalerei* (Leipzig: Insel Verlag, 1924).

Behne's progressivism in 1925
Adolf Behne, *Von Kunst zur Gestaltung: Einführung in die moderne Kunst* (Berlin: Arbeiterjugend-Verlag, 1925), p. 83.

Correspondence between Behne, Moholy-Nagy, and El Lissitzky
Letters to Behne from Moholy-Nagy and El Lissitzky can be found in Stephan Waetzoldt and Verena Haas, *Tendenzen der Zwanziger Jahre* (Berlin: D. Reimer, 1977).

Varvara Stepanova's use of the words composition and construction
"Composition is the contemplative approach of the artist in his work. Technique and industry have confronted art with the problem of construction as an active process and not a contemplative reflection. The 'sanctity' of a work as a single entity is destroyed. The museum which was a treasury of this entity is now transformed into an archive." Statement for a Constructivist show in Moscow in 1921, quoted by Camilla Gray, *The Great Experiment* (London: Thames & Hudson, 1962),

p. 246. Benjamin H. D. Buchloh, "From *faktura* to factography," *October*, no. 30 (1984), pp. 82–119, here p. 91, compared this passage to the well-known passage about the impact of Dadaism from Benjamin's essay "The work of art in the age of its technological reproducibility." The context adduced here suggests that it was the reception of these ideas in the mid-1920s in Germany by Behne, Moholy-Nagy, and others in contact with El Lissitzky that is the strong point of reference for Benjamin's essay, a point effectively argued from another angle also by Frederic J. Schwartz, *Blind Spots: Critical Theory and the History of Art in Twentieth-Century Germany* (New Haven, London: Yale University Press, 2005), chapter 2.

El Lissitzky
El Lissitzky, "Prounen-Raum, Große Berliner Ausstellung, 1923," *G—Material zur elementaren Gestaltung*, no. 1 (July 1923), p. 4.

On the *Abstract Cabinet*, see Dietrich Helms, "The 1920's in Hannover: an exhibition in Hannover, Germany," *Art Journal*, vol. 22, no. 3 (Spring 1963), pp. 140–4, here p. 144.

Alexander Dorner disgusted by the *Merzbau*
Samuel Cauman, *The Living Museum: Experiences of an Art Historian and Museum Director, Alexander Dorner* (New York: NYU Press, 1958), p. 38. Quoted by Patricia Falguières, "Désoeuvrement de Kurt Schwitters," in *Kurt Schwitters* (Paris: Centre Georges Pompidou, 1994), pp. 152–8, here p. 152.

Moholy-Nagy
László Moholy-Nagy, *Malerei, Photographie, Film* (Passau: Passavia, 1925), second edition, 1927.

The 1920s antecedents to Benjamin
Frederic J. Schwartz, *Blind Spots* (cited above), pp. 37–102, who shows how important *Malerei, Photographie, Film* was to Benjamin at the moment of its appearance, and how deeply Benjamin's 1927 essay in typographical experimentation, *Einbahnstrasse*, was informed structurally and in content by Moholy-Nagy's book (see in particular pages pp. 37–55). He does not, however, concentrate on Moholy-Nagy's remarks on serial production.

The failure to exhibit Moholy Nagy's *Licht-Raum-Modulator* in Dorner's "Contemporary Room"
Joyce Tsai, "Excavating surface: on the repair and revision of László Moholy-Nagy's *Z VII* (1926)," in Jeffrey Saletnik and Robin Schuldenfrei (eds.), *Bauhaus Construct: Fashioning Identity, Discourse and Modernism* (London and New York: Routledge, 2009), p. 154.

Schwitters and El Lissitzky's double issue of *Merz*
Merz (Nasci), vol. 2, no. 8–9 (April–July 1924).

Moholy-Nagy on stained glass
László Moholy-Nagy, *Malerei, Photographie, Film* (1925, cited above), p. 15, a passage that remained unchanged in the second edition, *Malerei, Fotografie, Film* (1927, cited above), p. 18: "Das mittelalterliche Glasfenster allein zeugt von einer anderen, wenn auch nicht konsequent durchgeführten Auffassung. Hier wirkt neben der Farbigkeit der Flächen auch eine gewisse räumlich-reflektorische Strahlung mit. Die heute bewußt reflektorisch oder projektorisch geworfene bewegliche farbige Gestaltung (kontinuierliche Lichtgestaltung) öffnet dagegen neue Ausdrucksmöglichkeiten und damit neue Gesetzmäßigkeiten."

Behne on the dynamic god
Adolf Behne, "Kunst, Handwerk, Technik," *Die neue Rundschau*, no. 33 (1922), pp. 1021–37, here p. 1030. On this essay, see Stavrinaki, "L'architecture du 'pays du milieu'" (cited above), and Frederic J. Schwartz, "Form follows fetish: Adolf Behne and the problem of *Sachlichkeit*," *Oxford Art Journal*, vol. 21, no. 2 (1998), pp. 47–77.

Nikolaus Pevsner, *Pioneers of the Modern Movement from William Morris to Walter Gropius* (London: Faber & Faber, 1936).

Pinder's observation that "behind the earlier sculpture we feel the presence of the art of architecture; behind the later sculpture we feel the presence of painting"
Wilhelm Pinder, *Die deutsche Plastik vom ausgehenden Mittelalter bis zum Ende der Renaissance*, vol. I, Handbuch der Kunstwissenschaft (Wildpark-Potsdam: Akademische Verlagsgessellschaft Athenaion, 1924), p. 13. On the transformation of the church space

from kinaesthetic to visual, see p. 66: "Aber die Geschichte der deutschen Architektur selbst verzeichnet gegen die Mitte des Jahrhunderts eine beginnende Abkehr vom rhythmisierten zum einheitlich gesehenen, vom motorisch erlebten zum ruhend hingebreiteten Raum. Auch in ihr kennt man, daß nunmehr das Ganze vor seinen Teilen da sein wollte, nicht mehre durch sie."

Riegl's basic distinction between the haptic and optic modes in artistic experience
Alois Riegl, *Spätrömische Kunstindustrie* (two volumes, the first published in 1901, the second in 1923); English edition, *Late Roman Art Industry*, trans. Rolf Winkes (Rome: G. Bretschneider, 1985).

Schmarsow's theory of architectural space and bodily movement
August Schmarsow, *Das Wesen der architektonischen Schöpfung* (Leipzig: G. B. Teubner, 1893), translated as "The essence of architectural creation," in Harry Francis Mallgrave and Eleftherios Ikonomou (eds.), *Empathy, Form and Space: Problems in German Aesthetics* (Santa Monica: Getty Center for the History of Art and the Humanities, 1994), pp. 281–97. On page 64 of his introduction to this volume, Harry Mallgrave identifies this emphasis as a primary point of difference between Schmarsow and Riegl. On Schmarsow, see also Mitchell W. Schwarzer, "The emergence of architectural space: August Schmarsow's theory of 'Raumgestaltung,'" *Assemblage*, no. 15 (1991), pp. 48–61. I am grateful to Willibald Sauerländer for making clear to me the importance of Schmarsow for Pinder.

Pinder's thesis
Wilhelm Pinder, *Einleitende Voruntersuchung zu einer Rhythmik romanischer Innenräume in der Normandie* (Strasbourg: Heitz, 1904), and *Zur Rhythmik romanischer Innenräume in der Normandie; weitere Untersuchungen* (Strasbourg: Heitz, 1906).

Benjamin's notion of "one hundred percent image space"
Walter Benjamin, "Surrealism: the last snapshot of the European intelligentsia" (1929), in Michael W. Jennings, Howard Eiland, and Gary Smith (eds.),

Selected Writings, Volume 2: 1927–1934 (Cambridge, Mass. and London: The Belknapp Press of Harvard University Press, 1999), p. 217; Benjamin's statement that "what we used to call art begins at a distance of two meters from the body": "Dream kitsch" (1927), in ibid., p. 4. My remarks here are inspired by Miriam Bratu Hansen, "Room-for-play: Benjamin's gamble with cinema," *October*, no. 109 (Summer 2004), pp. 3–45. Many illuminating informal exchanges with Professor Hansen have informed this section, more than I am able to account for.

Benjamin on the origins of panel painting in the Middle Ages
The statement that "architecture has always offered the prototype of an artwork that is received in a state of distraction through the collective," and the reception of buildings "by use and by perception— or rather, by touch and sight" appears in "The work of art in the age of its technological reproducibility," ibid., pp. 119–120.

Frederic J. Schwartz on Benjamin and Linfert
Frederic J. Schwartz, *Blind Spots* (cited above), pp. 64–6, whose translations from Linfert I adopt here. Carl Linfert, "Die Grundlagen der Architekturzeichnung. Mit einem Versuch über französische Architekturzeichnungen des 18. Jahrhunderts," *Kunstwissenschaftliche Forschungen*, no. 1 (1931), pp. 135–246. Benjamin reviewed the collection to which this essay belonged, the *Kunstwissenschaftliche Forschungen* of 1931 and 1933 edited by Otto Pächt and Hans Sedlmayr in "Strenge Kunstwissenschaft. Zum ersten Bande der Kunstwissenschaftlichen Forschungen," which appeared, under Benjamin's pseudonym Detlef Holz, on July 30, 1933 in the literature section of the *Frankfurter Zeitung*, reprinted in Walter Benjamin, *Gesammelte Schriften*, vol. 3 (Frankfurt: Suhrkamp, 1982), pp. 363–74. For an English translation of the review, together with introduction and commentary, see Thomas Levin, "Walter Benjamin and the theory of art history" followed by Walter Benjamin, "Rigorous study of art," *October*, no. 47 (1988), pp. 77–90.

On the interaction of Pinder and Brinckmann in the 1920s
Udo Kultermann, *The History of Art History* (New York: Abaris, 1993), pp. 209–10.

20. Cathedral of Erotic Suffering

Schwitters on remaking art after the war
Kurt Schwitters, "Kurt Schwitters," in *Das literarische Werk*, vol. 5, *Manifeste und kritische Prosa*, ed. Fridhelm Lach (Cologne: DuMont, 1981), p. 335.

Schwitters in 1920
Kurt Schwitters, "Merz [für den *Ararat* geschrieben]," in *Das literarische Werk*, vol. 5 (cited above), p. 79.

Schwitters's series of eight lithographs
Kurt Schwitters, *Die Kathedrale* (Hannover: Paul Steegemann Verlag, 1920).

Spengemann's defense of Schwitters
Christof Spengemann, *Die Wahrheit über Anna Blume* (Hannover: Zweeman, 1920), p. 6: "Die Kathedralenidee ist aus dieser Zeit kosmischen Fühlens organisch wiederstanden. Wir wollen eine Generation, die im bildlichen und wörtlichen Sinne Kathedralen bauen kann."

Schwitters's *Frühlicht* article
Kurt Schwitters, *Das literarische Werk*, vol. 5 (cited above), pp. 95–6. See also Dietmar Elger, "L'oeuvre d'une vie," in *Kurt Schwitters* (Paris: Centre Georges Pompidou, 1994), p. 145.

Schwitters's "Myself and my aims"
Kurt Schwitters, "Ich und meine Ziele," in *Das literarische Werk*, vol. 5 (cited above), pp. 340–8. With a few minor divergences, my translation of passages from this text follows the complete translation offered by Gwendolen Webster, *Kurt Schwitters' Merzbau*, Ph.D. diss, Open University, Milton Keynes, 2007, Appendix A.

Bruno Taut's mobile skin architecture and its reception
Rosemarie Bletter, review of Kurt Junghanns, *Bruno Taut 1880–1938* (Berlin: Henschelverlag, 1970), in *Journal of the Society of Architectural Historians*, vol. 32, no. 3 (October 1973), pp. 255–8, here p. 256.

Ernst Schwitters's account of the origins of the *Merzbau*
John Elderfield, *Kurt Schwitters* (New York: Thames & Hudson, 1985), p. 184.

Mies van der Rohe's story about Schwitters and wooden cathedrals
Robert Motherwell (ed.), *Dada Painters and Poets*, second edition (Boston, Mass.: G.K. Hall, 1981), p. xxvii.

Moholy-Nagy's socks absorbed into the *Merzbau*
Gwendolen Webster, *Kurt Merz Schwitters: A Biographical Study* (Cardiff: University of Wales Press, 1997), p. 220. On the relic-function in the *Merzbau* and processes of absorption and absconding, see Webster, ibid., pp. 344–5
The *Kathedrale* had begun to assume the appearance that we know from the reconstruction now on view in the Sprengel Museum in Hannover (which restored the work to its state in 1933)

after the time of this 1931 description. For a full account, which alters traditional understandings of the chronology of the project, see Gwendolen Webster, "Kurt Schwitters' Merzbau," Ph.D. diss (cited above). See also Webster, "Kurt Schwitters' Merzbau," in Isabel Schulz (ed.), *Kurt Schwitters: Color and Collage* (Houston: Menil Collection, 2010), p. 121–31. I am grateful to Dr. Webster for many helpful exchanges during the writing of this chapter.

For Paul Bowles's description see Webster, "Kurt Schwitters' Merzbau" (cited above), p. 51.

Elizabeth Burns Gamard, *Kurt Schwitters' Merzbau: The Cathedral of Erotic Misery* (New York: Princeton Architectural Press, 2000); Otto von Simon, *The Gothic Cathedral: Origins of Gothic Architecture and the Medieval Concept of Order* (New York: Pantheon Books, 1956).

The importance of the *Kunstkammer* for the *Merzbau*
Patricia Falguières, "Désoeuvrement de Kurt Schwitters," in *Kurt Schwitters* (Paris: Centre Georges Pompidou, 1994), pp. 152–8.

Schwitters as tour guide for the *Merzbau*
Webster, *Kurt Merz Schwitters* (cited above), 222.

On the uncovering of a cistern during construction of the *Merzbau*
Gwendolen Webster, *Kurt Merz Schwitters* (cited above), p. 210; see also Gamard (cited above), pp. 94–5.

ILLUSTRATION CREDITS

ILLUSTRATION CREDITS

Picture Library/Scala, Florence 2012
(one panel)
7.3 National Gallery of Art, Washington,
D.C. Samuel H. Kress Collection.
Inv. 1939.1.268/DeAgostini Picture
Library/Scala, Florence 2012
7.4 Santa Maria dei Servi, Siena
7.5 Photo Dean Christakos 2011
7.6 © Cubo Images/Robert Harding
7.7 National Gallery of Art, Washington,
D.C. Samuel H. Kress Collection.
Inv. 1939.1.268/DeAgostini Picture
Library/Scala, Florence 2012
7.8 © Ian Dagnall/Alamy
7.9 Gallerie dell'Accademia, Venice.
Inv. 91. Photo 2012 Scala, Florence
– courtesy the Ministero Beni e Att.
Culturali

8.1 San Lorenzo, Florence
8.2 San Lorenzo, Florence. Photo 2012
Scala, Florence
8.3 Drawing © Thames & Hudson Ltd,
London
8.4 Drawing © Thames & Hudson Ltd,
London
8.5 San Lorenzo, Florence.
© Summerfield Press/Corbis
8.6 San Lorenzo, Florence.
© Summerfield Press/Corbis
8.7 Dan Flavin © ARS, NY and DACS,
London 2012

9.1 Arena Chapel, Padua
9.2 Musée Maillol – Fondation Dina
Vierny, Paris. Photo Philippe Abergel.
Ilya Kabakov © DACS 2012
9.3 Photo by Hickey-Robertson. Mark
Rothko © 1998 Kate Rothko Prizel
& Christopher Rothko ARS, NY and
DACS, London
9.4 Photo Alexander Nagel
9.5 © Michael DeFreitas/Robert Harding
9.6 © age fotostock/Robert Harding
9.7 Drawing © Thames & Hudson Ltd,
London
9.8 © Godong/Robert Harding
9.9 Photo Alexander Nagel
9.10 Photo Alexander Nagel
9.11 Zentralbibliothek, Zurich.
Ms. B 316, f. 134r
9.12 Photo Alexander Nagel
9.13 Musée du Louvre, Paris.
Inv. MI 690
9.14 © Gari Wyn Williams/Alamy

10.1 Museum of Contemporary Art,
Chicago. Gift of Susan and Lewis
Manilow. Inv. 1979.2.a-g. Photo

Museum of Contemporary Art, Chicago.
© Estate of Robert Smithson/DACS,
London/VAGA, New York 2012.
10.2 Museo Sacro, Vatican City.
Inv. 61883 a-b
10.3 A. D. White Architectural
Photographs, Cornell University Library,
Accession Number 15/5/3090.01473
10.4 The Pierpont Morgan Library,
New York. Gift of J. P. Morgan, 1924.
Ms M.67
10.5 Image courtesy James Cohan
Gallery, New York/Shanghai. © Estate
of Robert Smithson/DACS, London/
VAGA, New York 2012
10.6 Image courtesy James Cohan
Gallery, New York/Shanghai. © Estate
of Robert Smithson/DACS, London/
VAGA, New York 2012
10.7 Library of Congress Prints and
Photographs Division, Washington,
D.C. The G. Eric and Edith Matson
Photograph Collection (LC-M32- A-64)
10.8 Image courtesy James Cohan
Gallery, New York/Shanghai. © Estate
of Robert Smithson/DACS, London/
VAGA, New York 2012
10.9 Santa Cecilia in Trastevere, Rome

11.1 Private collection
11.2 Photo The Jewish Museum/
Art Resource/Scala, Florence.
Robert Smithson © Estate of Robert
Smithson/DACS, London/VAGA,
New York 2012. Judy Chicago © ARS,
NY and DACS, London 2012
11.3 British Library, London
11.4 Collection Nancy Holt. Image
courtesy James Cohan Gallery, New
York/Shanghai. © Estate of Robert
Smithson/DACS, London/VAGA,
New York 2012
11.5 Kunsthistorisches Museum,
Vienna. Inv. GG_1026
11.6 Museo Nacional del Prado,
Madrid. Inv. P-1940
11.7 Museo Nacional del Prado, Madrid.
Inv. P-1940
11.8 © The Willem de Kooning
Foundation, New York/ARS, NY and
DACS, London 2012
11.9 Archives of American Art,
Smithsonian Institution, Washington,
D.C. © Estate of Robert Smithson/
DACS, London/VAGA, New York 2012
11.10 San Lorenzo, Florence
11.11 Gemäldegalerie, Dresden
11.12 Richard Serra © ARS, NY and
DACS, London 2012

12.1 © Yousuf Karsh/Camera Press,
London
12.2 © Yousuf Karsh/Camera Press,
London
12.3 © Photo David Jones
12.4 Permission courtesy the Family of
Harley Parker, 2012, and the Estate of
Corinne McLuhan
12.5 © Photo Mr. L. R. Warren. Royal
Ontario Museum, Toronto
12.6 Photo QT Luong/terragalleria.com

13.1 Photo José Félix Vivas. Alexander
Calder © 2012 Calder Foundation,
New York/DACS, London
13.2 San Vitale, Ravenna, Italy
13.3 San Vitale, Ravenna, Italy
13.4 Courtesy the John Cage Trust

14.1 Photo courtesy Archivio
Fotografico, Triennale Milano. © Lucio
Fontana/SIAE/DACS, London 2012
14.2 © The Pollock-Krasner Foundation
ARS, NY and DACS, London 2012
14.3 Biblioteca Apostolica Vaticana,
Vatican City. Cod. Reg. lat. 12, f.73v
14.4 Museum of Modern Art, New York.
Gift of Mr. and Mrs. Robert C. Scull.
Inv. 8.1958. © Jasper Johns/VAGA,
New York/DACS, London 2012.
14.5 Metropolitan Museum of Art,
New York. Rogers' Fund, Inv. 06.180//
Art Resource/Scala, Florence 2011
14.6 Metropolitan Museum of Art, New
York. Gift of Robert Lehman, 1950, Inv.
50.229.2/Art Resource/Scala, Florence 2012
14.7 Santa Maria del Popolo, Rome.
Photo Alessandro Vasari
14.8 Santa Maria del Popolo, Rome

15.1 Ad Reinhardt © ARS, NY and
DACS, London 2012
15.2 Schloss Charlottenburg, Berlin
15.3 Schloss Charlottenburg, Berlin
15.4 Schloss Charlottenburg, Berlin
15.5 Schloss Charlottenburg, Berlin
15.6 Museum of Modern Art, New
York. Gift of Philip Johnson in honor
of Alfred H. Barr, Jr. Inv. 106.1973. ©
Jasper Johns/VAGA, New York/DACS,
London 2012

16.1 Whitney Museum of American
Art, New York. Purchase, Inv. 70.50.9.
Bruce Nauman © ARS, NY and DACS,
London 2012
16.2 © The Estate of Ana Mendieta
Collection. Courtesy Galerie Lelong,
New York

16.3 Metropolitan Museum of Art, New York. Inv. 14.40.640/Art Resource/ Scala, Florence 2011
16.4 National Gallery, London. Inv. NG6441
16.5 Philadelphia Museum of Art, Katherine S. Dreier Bequest, 1953. © Succession Marcel Duchamp/ ADAGP, Paris and DACS, London 2012
16.6 Royal Collection. Courtesy Her Majesty Queen Elizabeth II/Bridgeman Art Library 2012

17.1 Ufficio delle Celebrazioni Liturgiche del Sommo Pontefice, Vatican City
17.2 Museum of Modern Art, New York.

The Sidney and Harriet Janis Collection. Inv. 595.1967. © Succession Marcel Duchamp/ ADAGP, Paris and DACS, London 2012
17.3 Trierer Domschatz

18.1 Lyonel Feininger © DACS 2012
18.2 Loebermann Collection. Lyonel Feininger © DACS 2012

19.1 Ludwig Gies © DACS 2012
19.2 Photo Felix Wiedler
19.3 Private collection
19.4 Sprengel Museum Hannover
19.5 Sprengel Museum Hannover
19.6 © Hattula Moholy-Nagy/DACS 2012

19.7 © PC Jones/Alamy

20.1 Kurt Schwitters © DACS 2012
20.2 International Dada Archive, Special Collections, Photo The University of Iowa Libraries. Kurt Schwitters © DACS 2012
20.3 Kurt Schwitters © DACS 2012
20.4 Wallraf-Richartz-Museum & Fondation Corboud, Cologne. Inv. Nr. WRM 6
20.5 Kurt Schwitters © DACS 2012

ACKNOWLEDGMENTS

This book took form during a fellowship year in Berlin in 2007–8 at the Wissenschaftskolleg. I wish to thank Luca Giuliani, the institute's director, and all the staff there for their support during that memorable year. This book involved several co-workers. Jacky Klein, my model editor, saw what was there sometimes more clearly than I did, and has cultivated this book like an expert gardener; Robert Brennan took a course with me on this topic and then became a primary interlocutor during the writing, offering critical help in compiling the bibliographic section; Andrew Brown and Maria Ranauro enriched and informed the book with their expert editing and image-research. Nancy Holt and Irving Sandler generously provided me with unpublished materials and facilitated my making them available in these pages. Jess Atwood Gibson, Zan Dumbadze, Pepe Karmel, Robert Slifkin, Maria Stavrinaki, Anne Wagner, and Gwendolen Webster read parts or complete drafts of this book, reshaping it with their responses. Caroline Hayes provided vital assistance throughout the writing and editing.

"What are you working on?" I wish to thank those who took my answer to this question as a prompt to offer examples, divergent views, and related ideas of their own: Jean-Philippe Antoine, Jess Atwood Gibson, George Baker, Mieke Bal, Ian Balfour, Fabio Barry, Claire Brandon, Horst Bredekamp, Anna Bücheler, Colby Chamberlain, Stefano Chiodi, Thomas Crow, Hubert Damisch, Teri Damisch, Thomas Demand, Leah Dickerman, Xavier Douroux, Zan Dumbadze, Miriam Dym, Anne Ellegood, Jas Elsner, Francesca Esmay, Patricia Falguières, Hal Foster, Elyse Goldberg, Amanda Gluibizzi, Blake Gopnik, Gabriele Guercio, Jeffrey Hamburger, Cynthia Hahn, Erlend Hammer, John Harwood, Charles (Mark) Haxthausen, Jonathan Hay, François Hers, Joseph Imorde, Michele Jaffe, Rebecca Jones, David Joselit, Jackie Jung, Bernhard Jussen, Pepe Karmel, Jeffrey Kastner, Christian Kleinbub, Aden Kumler, Rose Logie, Maria Loh, Adam Lowe, Claire MacDonald, Meredith Martin, Paul Melton, Ara Merjian, Sina Najafi, Steven Nelson, Alva Noë, Julie Park, Kris Paulsen, Francesco Pellizzi, Lorenzo Pericolo, Alex Potts, Francisco Prado Vilar, Katherine Rask, Adrian Rifkin, Irving Sandler, Lucy Sandler, Willibald Sauerländer, Bill Sherman, Tatiana Senkevitch, Susan Siegfried, Robert Slifkin, Irene Small, Kiki Smith, Hilary Spann, Maria Stavrinaki, Nicola Suthor, Aurélie Verdier, Anne Wagner, Ittai Weinryb, Jeffrey Weiss, Mike Westfall, Chris Wood, Alexi Worth, and Rebecca Zorach.

Miriam Bratu Hansen and Leo Steinberg were friends and deep wells of inspiration for this book, but are not alive to see it. I dedicate it to their memory.

INDEX